GREEK PAINTING

GREEK PAINTING

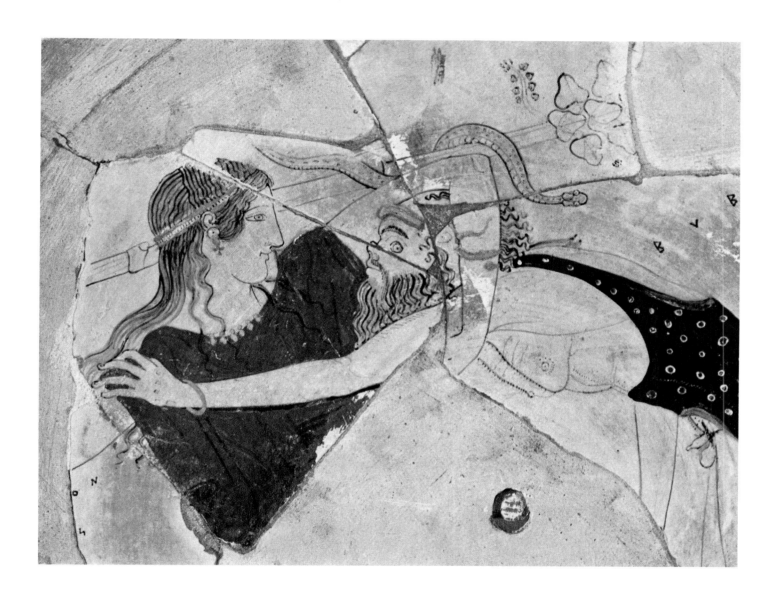

TEXT BY MARTIN ROBERTSON

Lincoln Professor of Classical Archaeology and Art, University of Oxford

SKIRA

RIZZOLI
NEW YORK

Color plate on the title page:

Fragmentary Athenian Cup, from Locri (South Italy). First to second quarter of 5th century B.C.
Once signed by potter, perhaps Euphronios. Satyr and maenad. (Length of detail c. 18 cm.). Museo Nazionale, Taranto.
(Just over natural size. See text p. 114).

*

© 1979 by Editions d'Art Albert Skira S.A., Geneva
First edition © 1959 by Editions d'Art Albert Skira, Geneva

This edition published in the United States of America in 1979 by

Rizzoli INTERNATIONAL PUBLICATIONS, INC.
712 Fifth Avenue/New York 10019

Library of Congress Catalog Card Number: 59-12317
ISBN: 0-8478-0200-0

PRINTED IN SWITZERLAND

THE illustrations of *Roman Painting* belong to a pictorial tradition accepted as normal in Europe from the Renaissance until recent times: surface decoration built up of figures and objects which seem to exist also in a spatial setting where light falls through air. The figures and objects of the pictures in *Egyptian Painting*, without chiaroscuro or spatial constructions, exist only in the decorative surface plane. Stages in the development from the Oriental to the European ideal are seen in *Etruscan Painting*, but Etruscan painters seem not themselves to have been pioneers of this change but to have followed Greek models. In the Hellenistic age (third and second centuries B.C.), a time of aesthetic nostalgia, many Greek artists wrote on the history of Greek art. Their writings are lost, but much is repeated in compilations, guide-books and essays written in Greek or Latin under the Roman Empire between the first century B.C. and the second A.D. The works they wrote about are largely lost too, in the case of painting entirely so; but we have contemporary painting on pottery. That provides the bulk of the illustrations in this volume; its relation to lost painting the main theme of the text, which is not, therefore, a history of vase-painting as such. Much is ignored (for instance the Cycladic and East Greek wares of the seventh century and the 'Chalcidian' of the sixth) and there is a concentration on Athenian vase-painting of the sixth and fifth when the art reached its highest levels. Even here large tracts are omitted from consideration; but the selection of the most significant trends has only been made possible by the marvellous mapping of the field carried out over the past fifty years by Sir John Beazley, isolating artistic personalities and establishing their relation to one another.

Thanks are due to the authorities of the following institutions for permission to reproduce the objects illustrated: the Greek Antiquities Service; the American, French, German and Italian Schools at Athens; the Acropolis, Agora, Kerameikos and National Museums of Athens; the Archaeological Museums of Argos, Corinth, Eleusis and Heraklion; the Excavations at Pella; the National Museums of Naples, Taranto and the Villa Giulia, Rome; the Museo Etrusco Gregoriano of the Vatican; the Kunsthistorishes Museum, Vienna; the Staatliche Antiken-sammlungen, Munich; the Martin von Wagner Museum, Würzburg; the Cabinet des Médailles and the Musée du Louvre, Paris; the Musées Royaux du Cinquantenaire, Brussels; the Rijks-museum van Oudheden, Leiden; the British Museum, London; the Museum of Fine Arts, Boston; the Metropolitan Museum of Art, New York. Among individuals special thanks are due to D. von Bothmer, O. Broneer, P. E. Corbett, P. Courbin, P. Devambez, H. Diepolder, J. R. Green, D. E. L. Haynes, M. S. F. Hood, C. Karouzos, S. Karouzou, D. Levi, C. Makaronas, I. Meliades, H. Möbius, G. Mylonas, D. Ohly, J. Perlschweig, P. Petsas, N. Platon, H. von Schoen, L. Talcott, N. Verdelis, C. Vermeule. I have not consulted Sir John Beazley over this book, but much of any merit it may have must be put down to his influence. I could not possibly have written it without the help of my wife, and my part in the book is dedicated to her.

MARTIN ROBERTSON.

THE GREEK WORLD

showing the principal cities and the places of origin
and discovery of the objects illustrated

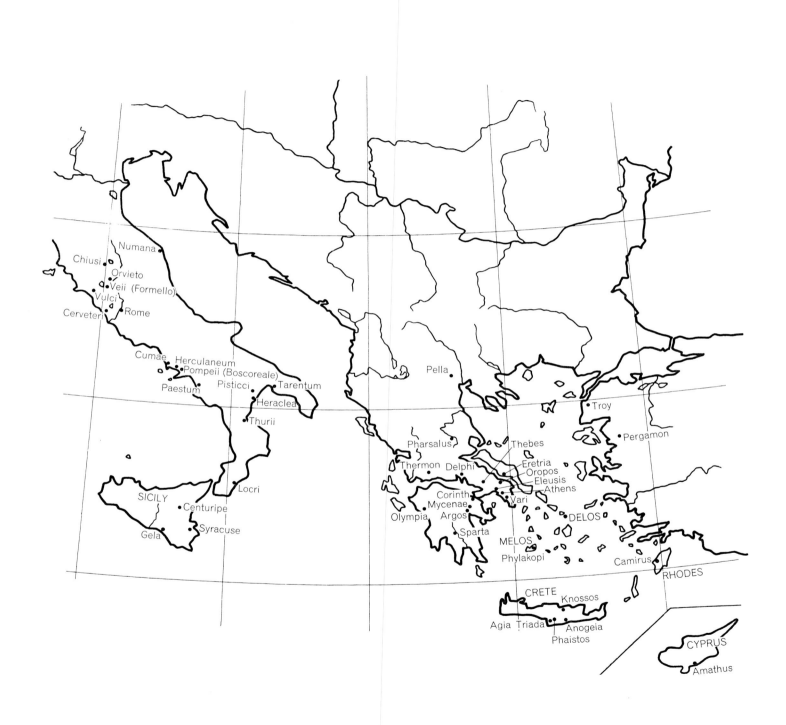

CONTENTS

INTRODUCTION

THERE is less colour in this book than in its fellows; but that is not, or rather not entirely, the Greeks' choice. We do not associate Greek art with colour, or if we do it is with the fortuitous colours of nature. In the clear air of Greece broken temples stand white or golden against a sky of dazzling blue, under which even grey or brown rock is bright. There are green pines, pearly olives, red earth, and in season flowers of primary brilliance, or green vines or yellow corn; and always the colours of the sea. The marble ruins and those of quieter stone take their place in this range; but in the muted light of museums the ranks of statues are pallid, and if they have a warmer hue it is because, like the ruined temples, centuries of weather have rusted them so. Under the craftsman's chisel buildings and statues were white, but they were not left just like that. Both alike were touched with bright colours and gilding: on marble figures hair, eyes and lips, patterns and washes on the clothes, at some periods a wash of thin colour over the flesh, while limestone figures were similarly but more thickly and completely coloured; on buildings patterns defining the mouldings and washes of colour, generally red or blue, as a background to the reliefs. The bronze statues, too, which like the marbles stood mainly in the open air, though their greens and blues are the work of time were bright before. The brown metal was burnished, and enhanced with gilding and with copper and silver inlay, the eye-sockets filled with coloured stone or glass. Then there were paintings; many of course within temples and other buildings, but the long porticoes which were a feature of Greek cities and sanctuaries were often adorned with paintings along their back walls, visible between the columns to the passers in the open air.

Except in rare cases the colours are gone from buildings and statues, or abraded to a shadow. The wall-paintings from porticoes, temples and palaces are gone absolutely; and easel-pictures too, almost, though not quite, without trace. To build our idea of Greek painting we have to turn from these to painted pottery. That is not at all the same thing; but it is a very much better substitute than it would be in almost any other time or place. Painted pottery in Greece is a special case of that universal craft, its relation to other painting exceptional. That relation is not, however, easy to define with assurance, nor is it the same at all periods, nor, when vase-painting is nearest in quality and spirit to what we have lost, does it necessarily reflect so directly as at some other times the problems that were preoccupying contemporary workers on wall and

panel and the solutions they were finding. Before we begin to trace in vase-painting the history of Greek painting (which is what we shall mostly have to do) we must examine and justify these statements and try to establish the nature of this long and curious relationship of art and craft.

Perhaps because the country is well supplied with deposits of exceptionally fine potters' clay, the craft flourished in Greece from Neolithic times through the Bronze Age with a consistent richness which is hardly maintained in any of those countries of the Near East which reached high civilization while Greece was still barbarous. Greece itself in the course of that time developed a fine and strange culture, centred first in Crete and later in the Peloponnese (the southern mainland), which perhaps because of its position on the edge of the civilized world—an outpost on the confines of barbarous Europe—shows a certain independence and freedom of development. In this world painted pottery is a humble craft among the great new developments of architecture, wall-painting and metal- and stone-work, but it remains consistently fine and interesting, potters absorbing into the tradition of their own craft influences from the newer arts.

In the centuries before 1000 B.C., the time of transition from the Bronze to the Iron Age, this civilization broke down in obscure circumstances to poverty and isolation. Large-scale and fine building gave way to primitive constructions in poor materials, in which wall-painting had no place, and representational art in any medium seems virtually to have died out. Metal-working continued, and new techniques were learned for the forging of iron, but the whole basis is utilitarian and the decorative element impoverished in the extreme. Though no doubt other crafts with a tradition of adornment (weaving, for instance, and woodworking) were in continuous use, for us only painted pottery remains a coherent series in which we can trace the artistic history of this dark age; and there does seem evidence that for those too who lived then it became a leading, if not the leading, means of aesthetic expression.

The decorative motives of pottery in the high time of the Bronze-Age civilization had been predominantly natural (flowers, shells and the like). In its later phases they become progressively stylized, and eventually approximate to abstract designs or are replaced by designs that are purely abstract in origin. There is, along with this, a falling off in quality; but an improvement which begins in Athens in perhaps the tenth century B.C., and marks the turn of the cultural tide, is accompanied by the disappearance of the old motives of natural origin and the evolution of a highly complex system of purely abstract design, built up of geometrical elements, which has given its conventional name, 'Geometric', to this art and its period. When figure-work begins to be introduced on this pottery, the figures are drawn in silhouette and made to conform to the thin, angular configuration of the Geometric ornament that surrounds them; they are also extremely primitive in their conceptual vision.

Among the earliest of these Geometric vases with figures are huge jars, five or six feet high (a remarkable technical achievement), on which the principal scene is concerned with death—keening round the bier, funeral procession—and which themselves stood on graves (p. 34). They are sometimes made without floors, or have the floors broken

through, and liquid offerings were no doubt poured into them which sank through to the dead below, but clearly also they served the purpose of monumental tombs. Sometimes undecorated stones stood beside them on the grave; and one is brought to the conclusion that, after the breakdown of tradition in the figurative arts and in the techniques of stone-carving and painting, reviving prosperity's demand for figured monuments found itself forced to monumentalize one of the few crafts with aesthetic possibilities that still flourished—painted pottery.

From these beginnings, fertilized in the late eighth century and throughout the seventh by influences from the East, Greek art in all its manifestations developed. Monumental architecture and sculpture began again in the middle and later seventh century, taking the forms which are the basis of their future development, and there is reason to think, as we shall see, that wall-painting flowered again at the same time. We can trace its influence on certain classes of vase-painting; but, perhaps because of its early importance, painted pottery (particularly in Athens), instead of dropping to its usual position of a more or less humble craft, developed alongside the new major arts as something on the same footing as they, a fine art in its own right. The distinction could hardly have been expressed by a Greek, but it is present in their works. There is plenty of mass-production, plenty also of good pottery coloured plain black or with purely formal decoration; but till far down into the fifth century the figure-work on fine pots is conceived in the same spirit, has the same character and attains the same quality, as the relief-sculpture of its time and as panel-painting (for which we have a little independent evidence); only strictly controlled by its primary rôle (never forgotten) of decoration for a pottery vessel.

The thing that seems most sharply to distinguish most vase-painting from what we can discern of painting on flat surfaces is the constant use of the silhouette principle. During the seventh century there is much experiment in techniques and styles of pottery decoration (pp. 39 ff.), including what seem clear imitations of the methods of painting on wall or panel; but the accepted decorative scheme for most figured vases by the end of the century is the so-called 'black-figure' technique (pp. 52 ff., 86 ff). In this the figures are painted in shiny black silhouette on the clay surface, the detailed drawing engraved on that, with the addition of other colours, limited in the developed stage of the technique to a form of red which ranges from cherry to violet, and white, used especially for women's skin. In Athens, where the style developed in this technique reached its perfection during the sixth century, the colour of the clay is an orange which varies from almost yellow to almost red. Silhouette was preferred to outline drawing by vase-decorators because it tells better on the curved surface of the pot and emphasizes its form.

In the later part of the sixth century a new silhouette-technique was devised at Athens (by then the only important producer of figured vases), the so-called 'red-figure' (pp. 82 ff.), a reversal of black-figure, in which the background is painted in the shiny black, leaving the figures in the colour of the clay, details drawn with a brush or a pen-like instrument in the bright black or a dilution of it which gives various shades of brown and gold. This invention, which flourished beside black-figure for twenty or

thirty years and superseded it for fine work by the beginning of the fifth century, takes us in one respect still further away from painting in other media. Wall and panel painting in archaic Greece were certainly, like vase-painting and relief-sculpture, strictly surface-bound: figures in outline and colour-wash, without shading or torsion, grouped against a neutral background. There would be overlapping, and no doubt sometimes indications of setting (found also in some vase-pictures)—a tree, a column, even the simplified elevation of a building; but all flat against a flat ground in no way intended to suggest depth. This background will, however, normally have been light, like the ground against which the dark silhouettes are set on black-figure vases; the shiny black background of red-figure has a positive quality which, besides emphasizing the surface of the pot, isolates the figures with an effect that can never have been normal in other painting. On the other hand the character of the actual figure-drawing, fluent brush-work, is undoubtedly much closer to that of painting in its ordinary media than is the sharp rigidity of black-figure engraving. We have comparatively large clay plaques, of the later seventh century and the end of the sixth (pp. 50 and 94), painted in a technique not normal to vase-decoration, which give valuable evidence on this relation.

Then, towards the end of the sixth century, some Athenian vase-painters begin to make occasional use of a technique which abandons the principle of silhouette and brings us at once far closer to independent painting than anything since some of the experimental work of the seventh. This is the practice of covering the orange clay with a creamy slip and drawing on it in outline with colour wash (pp. 97, 107 ff., 125 ff.). It is never a popular vase-technique, lacking not only the peculiar decorative quality of silhouette which Greek potters evidently found so satisfying, but also the immutable toughness which makes many black- and red-figure vases look even now almost as good as new. The white slip and the colours laid on it were more easily damaged. Nevertheless, on a limited range of shapes (at first especially the interior of the *kylix*, a wide, shallow drinking-vessel; later the *lekythos*, a tall, narrow oil-flask placed in graves), it is practised as a side-line by a number of the best red-figure painters over the whole length of the fifth century.

This covers the period of the classical revolution. At the beginning of the century the Persian empire, having advanced to the Aegean and absorbed the Greek cities of Asia Minor and the islands off its coast, threatened to engulf mainland Greece also. The defeat of this threat at Marathon, Salamis and Plataea seems to have had a liberating effect on the Greek spirit; at least it can hardly be chance that completest flowering of that spirit comes in the generations immediately following. In sculpture and painting this takes the form of the sloughing by Greek artists of those elements in the archaic tradition which, inherited from older civilizations, did not really express their own meanings, and the evolution in place of these of the ideals and conventions of classical art. The white-ground vase-paintings of fifth-century Athens (the head and heart of classical Greece) are thus, besides being often of great intrinsic beauty, most important documents for the history of the lost art we are pursuing; and a high proportion of the pictures in this book is therefore given to them. There are, however, two important caveats.

First (and less important) these are, like the rest, vessels of baked clay decorated by potter-painters with colours largely on a clay base, and they cannot therefore be taken without question as true echoes of the colouring of lost paintings. Most show in fact a very limited range of colour. Outlines and details are normally in the black glaze, on the earliest pieces often in its undiluted form, later always thinned; later still a matt black or red is used. The thinned glaze is also used for washes; an extra white is sometimes found on earlier pieces; and the colour washes range over brown, from yellowish to reddish, rose and violet. Only on the late lekythoi with matt outline are blue and green not uncommonly found. There is, however, evidence that painters in other media sometimes limited their colouring in very much this way. In Roman wall-decorations of the first century B.C. little pictures of pictures sometimes appear, standing on the feigned cornices. A number of these (one is illustrated in *Roman Painting*, p. 29) are in colour, composition and (by intention, at least) style very close indeed to the type of vase-picture we are considering. They must be imitated from works contemporary with the vases, and show that the latter do truly reflect one aspect of the small panel-painting of their time.

There is a strong tradition in the various writers of the first century B.C. and later, whose works are our authority for statements about the lost painting of Greece, that certain artists practised 'four-colour-painting': white, black, yellow and red and their combinations; excluding the blues and greens. The passages are confused and contradictory, some suggesting that it was only early painters who used the limited range and only later ones polychromy. We know, however, from traces of paint on architecture and sculpture that blue and green were available from the archaic period; and the only Greek panel-pictures we possess (late archaic works which will be mentioned in their context but which are awaiting publication and cannot be shown here) make free use of a light, bright blue though not of green. At the other end, the Alexander Mosaic (*Roman Painting*, p. 69) is a copy of a work painted in the limited range at the end of the fourth century B.C. or the beginning of the third. It seems that it was throughout a matter of choice rather than necessity, and that fifth-century paintings of this type must have closely resembled the white-ground vase-pictures in colour as well as drawing. The range of colour on red-figure and black-figure vases is not very different, but its application and effect markedly so: the simple unmixed colours used decoratively to emphasize and adorn the silhouette.

There remains a second and more important point to be considered in assessing the white-ground vase-pictures as representatives of classical painting, a point which concerns the historical development of the art. It appears that the classical revolution in its artistic manifestation took complete effect more quickly in sculpture than in painting. The new world of painting towards which Greek artists were feeling their way was a more complex and more subtle thing than the new world of sculpture, and the process of its perfect achievement was more gradual. The revolution in art was, as we have seen, an accompaniment of the general freeing of thought, revealed equally in literature and in the developments of philosophy and science (not then distinguished)

and of political ideas and practice; a sense among the Greeks of having found themselves. Precipitated, it seems, by the repulse of the Persians, the new world certainly appears in its most complete form in Athens during the ascendency of Pericles, the generation after the middle of the fifth century. It was accepted throughout antiquity that the greatest of Greek sculptors—his works the type of what Greek sculpture set out to be—was Pheidias, Pericles' contemporary and friend; but the greatest painter was Apelles, court-artist and indulged favourite of the god-king Alexander more than a century later, when the classical idea had failed to maintain the character promised in its brief realization in fifth-century Athens (where indeed the seeds of its corruption can already be observed). For this reason there was never, perhaps, in Greek painting the 'classical moment' which the ancients felt in the works of Pheidias and his Argive contemporary Polykleitos, and which we still feel in the sculptures of the Parthenon.

Polygnotos, Panainos, Parrhasios, Zeuxis and other painters of the fifth century were immensely admired, and what we have lost in their works was no doubt as great as what we have lost in the works of Apelles and his peers, and some of it perhaps would have been more to our taste; but it is evident that they had not the full command of the medium of expression that contemporary sculptors had. The wall-paintings executed in Rome and the cities of Campania in the first century B.C. and later show us the world familiar to us in Renaissance and post-Renaissance painting: figures modelled with shadows and high-lights and set in an illusory space—the picture not only formal decoration of a surface (as all painting of course by its nature primarily is) but also a feigned window on to a three-dimensional world. In archaic Greek painting up to the early fifth century, as in all its predecessors, there is neither modelling nor depth.

The course of exploration of the new world can be charted, though imperfectly, with the help of accounts in ancient writers. Before the middle of the fifth century Polygnotos and Mikon had begun to break ground in the realization of space, and in the later part of it Agatharchos made further progress there while Apollodoros and Zeuxis experimented in chiaroscuro. In both fields, particularly perhaps the last, their advances were evidently extremely cautious (this, it is easy to forget, was not a Renaissance but a beginning: *terra incognita* truly), and the reflection in white-ground vase-painting is certainly more cautious still; or rather the vase-painters adhered for the most part to the still living tradition of purely linear drawing, exemplified also in the painting on a marble tombstone (p. 157). The great developments in chiaroscuro (high-lights and cast shadows added to simple shading) were made in the fourth century, at a time when white-ground vases had ceased to be made. These advances are reflected to some degree in red-figure vase-painting and variations on that technique (pp. 162-163) as the primitive spatial constructions of the fifth century were by certain red-figure painters of that time (pp. 123-124), but the bright black surface silhouetting the figures runs directly counter to the new intention. Moreover, during the fourth century the art of vase-painting declines in intrinsic quality, and peters out almost entirely in the early part of the Hellenistic age; and the few original paintings which we have from this period (on marble tombstones or the plastered walls of tomb chambers) are very inferior work.

The Alexander mosaic shows us that by the end of the fourth century, the time of Apelles, the world had been essentially won. The artist's interest in the setting is, however, minimal; he indicates only, and that with the most economical means, just as much space as he needs for his complex figure-composition. This contrasts with the practice of Roman wall-painting; and it seems to have been the achievement of Hellenistic painters in the third and second centuries to give more reality to the setting, developing systematic perspective and a sense of atmosphere, though ancient art always remained man-dominated.

There is no doubt that Greek painting reached its apogee in the late fourth century and the Hellenistic age, nor that it is there lost to us. We illustrate a few contemporary echoes, painted vases and tombstones (pp. 171-174), and Roman adaptations (pp. 177, 178); and one can remember that its achievements lie behind all Roman painting as well as the paintings in the later Etruscan tombs. We concentrate our pictures, however, on the sixth and particularly the fifth century, when the quality of what we have is supreme and therefore in its own way not inferior to what we have lost, in whatever varying degrees it departs from that in scale and character. Our pictures can claim to illustrate both the beauty and the development of Greek *drawing*, from its Geometric beginnings to the end of the fifth century when European *painting*, as we normally understand the word, has already begun for the first time to emerge. In trying to imagine behind these works the scale and colour of lost wall-painting we may be helped by looking once more at the paintings in Etruscan tombs; but for the last word we must look back again, not accept the one for the other. Even the most Hellenizing of Etruscan works have a flavour or slant of their own; the best of the vase-pictures are great Greek drawing.

A word is in place here about the scale of the illustrations. Some of them are enlarged, a few very considerably so, above the size of the originals. This does the vase-painter the disservice of coarsening his generally very delicate line; but the quality of the drawing is such that it triumphantly accepts this treatment, and the effect does help the imagination away from the vase towards bigger fields. We are used to the practice in the lantern lecture, and in books do not question the converse distortion by which the Christ of the Sistine Judgement is presented to us the size of a post-card. The loss there is far more severe, and the advantage only the negative but overriding one that otherwise one could not reproduce it at all. Since the most accurate reproduction is a world away from the original, it is sometimes better to depart deliberately in one respect for the sake of gain in another.

The first few pages that follow are devoted not to the Greek painting which we have been discussing, but to the remains of monumental painting that survive from the Aegean Bronze Age. These are not part of Greek art in the ordinary sense, any more than the paintings of Pompeii are part of what we mean by Italian art; and yet, in this case as in that there is something in common and a value in showing them together. These works were buried and forgotten before the Greek painters began their slow movement from compositions organized in surface pattern alone, such as they saw in all the

arts around them, to the realization of a surface pattern that should also suggest the world where light falls through space. Cretan painters of the so-called 'Minoan' civilization in the first half of the second millennium B.C., surrounded like the classical Greeks by formal, hieratic arts, seem to have leapt intuitively to their own expression of an idea not unlike that which the Greeks achieved so slowly, step by cautious intellectual step. These 'Minoans' almost certainly did not speak Greek and were unrelated to the Achaeans, intrusive tribes already settled in Mycenae and the other citadels of the mainland, who certainly did. The Achaeans learnt painting, with the other arts of civilization, from the Minoans whom they later seem to have conquered. In their hands the arts moved towards formalization and the common conventions of the time, before their final collapse already recorded. The blood of the old stocks, however, including the first Cretans, as well as of the Achaeans and of later invaders, must have run in the veins of the historical Greeks; and of that happy mixture the Minoan genes seems not to have counted for least in their artistic development.

GREEK PAINTING

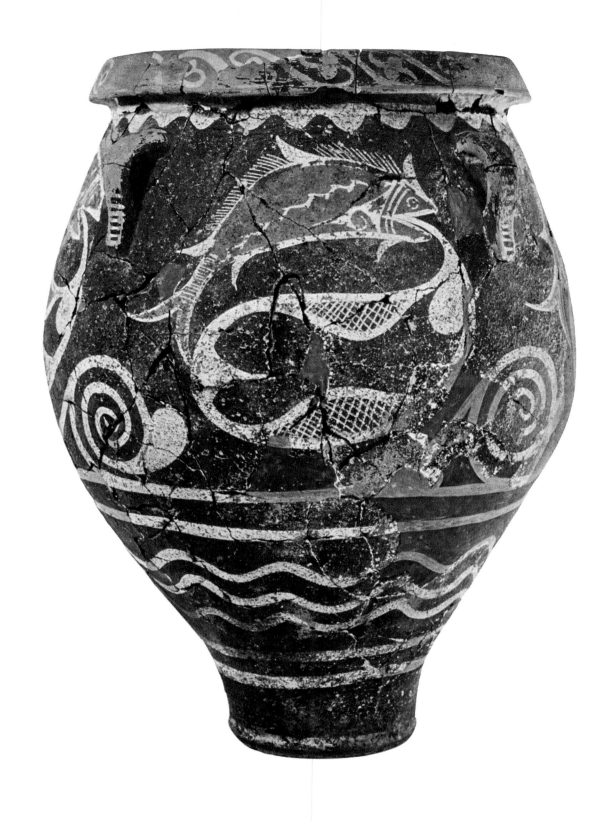

CRETAN JAR, FROM PHAISTOS. EARLY 2ND MILLENNIUM B.C. FISH. (H. 50 CM.)
10 679, ARCHAEOLOGICAL MUSEUM, HERAKLION.

THE BRONZE AGE

THE first people in Greek lands to leave us clear evidence of a developed civilization are the Cretans of the early second millennium B.C. We know nothing of them beyond what we can glean from their material remains, from the faint echoes they left in Greek legend, and from their traces, at present still fainter, in the historical records of their near-eastern contemporaries. They were in contact from early times with Egypt and with Asia Minor, from one or both of which it is possible that they originally came, but in their remote island they developed an art (which seems to imply an outlook) all their own.

The most notable feature of this world is the great palaces, the biggest at Knossos near the centre of the north coast, which lived in legend as the capital, its palace (a warren of rooms and corridors on several storeys in conjoined blocks round a central court) as the Labyrinth, home of the man-eating Minotaur with his human body and bull's head. Such creatures are found in the art of Bronze-Age Crete, and other similar mixtures; and bulls too often appear, especially in the strange 'bull-jumping' scenes, where youths and girls catch the creature by the horns and somersault over its back. What these things meant in their own time we can hardly guess, but it is interesting to notice that later Greek tradition is curiously ambivalent about this remote world. On the one hand we have the horror-figure of the Minotaur. He was the fruit of unnatural lust planted in Pasiphae by divine vengeance for her husband Minos's failure to sacrifice a most beautiful bull sent him by Poseidon for the purpose; and he was fed yearly on the flesh of seven youths and seven girls requisitioned from Athens by Minos in vengeance for a son murdered in Attica, till Theseus, the king's son of Athens, volunteered to be of the number, slew the monster, and carried off king Minos's daughter. On the other side Minos and his brother Rhadamanthys, sons of Zeus by Europa, were such paragons of justice on earth that they were made judges among the dead. Minos is also remembered in legend as the first master of the sea; and the archaeological finds suggest that during much of the first half of the second millennium B.C. Crete was itself at peace and prosperous and was also the dominant power in the Aegean. It seems possible that the good and the bad tradition in later story reflect respectively the Cretan and the mainland view of the same set of historical circumstances.

The material remains from the Aegean area throughout the Bronze Age are divided for convenience into conventional periods: Early, Middle and Late Minoan in Crete,

approximately corresponding to Early, Middle and Late Cycladic and Helladic in the islands of the Cyclades and on the mainland; each period subdivided into three, some with further subdivisions. The remains are ordered by stratified excavation and stylistic development; and absolute dates in round numbers are given to these periods, arrived at through material contacts between this area and near eastern civilizations, especially Egypt, which have left more articulate records. Such contacts give no precision, while arrangements by stratification and style are necessarily schematic. Dates given in this context are guides only, indications of an area in time, with no absolute validity.

Cretan civilization reaches its greatest heights in the Third Middle Minoan and First Late Minoan periods, dated between about 1800 and about 1500 B.C. It was then that the palaces took approximately the form which their ruins reveal today, and that their walls were covered with the paintings whose remains show them to have been the most remarkable artistic achievement of the culture. These paintings, on plaster and apparently in true fresco, were found fallen from the walls, and only fragments survive. It has unfortunately been the practice to embed the more important pieces so saved in gaily coloured reconstructions, and this makes it difficult to illustrate the uncontaminated work of Cretan painters. They are best known through reproductions of water-colour copies after these reconstructions. Our pictures are all from originals, avoiding so far as possible the impingement of modern work. They do not show the range of the art, nor some of its most individual manifestations, but they do allow direct appreciation of this style of painting.

The idea of wall-painting, which seems to come into Cretan art during the early centuries of the second millennium, was probably taken from Egypt, but its character is very different from anything in Egyptian art and is to some degree led up to in painted pottery. This craft, practised in the island from its earliest habitation in Neolithic times, develops a great richness and variety during the later Early Minoan and earlier Middle Minoan periods, in the second half of the third millennium B.C. Its most exciting form is the style called 'Kamares', from a cave-shrine where specimens of it were found, but also known at Knossos and at Phaistos, the second great palace in the southern centre of Crete. In this style the surface of the pot is dark (black or near-black) and the decoration applied in white and a colour varying from red to brown or mauve. Some of the vessels so decorated are small drinking-cups of almost egg-shell thinness and splendid precision of make, but more aesthetically satisfying are some of the big, heavy store-jars, like that illustrated (p. 18). The decoration is in curvilinear patterns, sometimes of purely abstract origin but often based on flower or plant forms; and the disposition, though never following nature, has more often than not a dynamic swing about it which suggests life and growth. On the pot shown the introduction of fish is exceptional (interesting as anticipating a fashion in wall- and vase-painting of some centuries later). Typical, however, is the feeling of life achieved in the fine formal design of the fish and the complicated unrepresentational bubble-pattern combined with them; an effect of watery existence carried on in the wavy lines above and below. It seems already a sophisticated art.

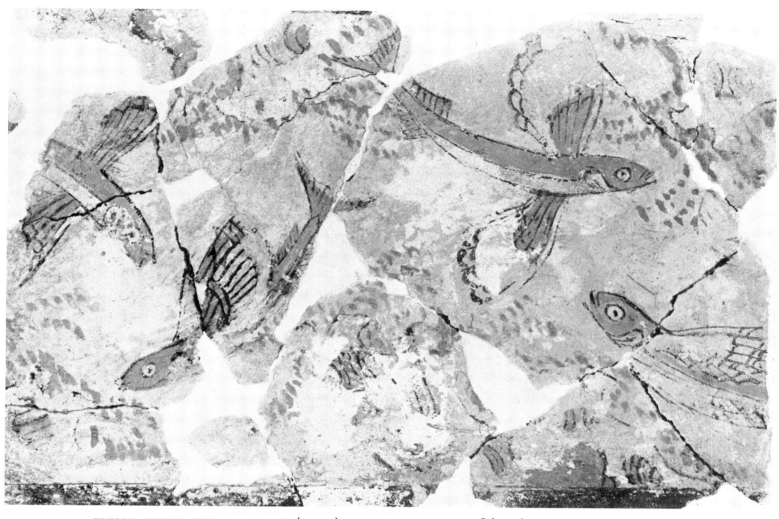

FRESCO, DETAIL, FROM PHYLAKOPI (MELOS), IN CRETAN STYLE. C. 18th-17th CENTURY B.C.
FLYING FISH. (H. 23 CM.) 5844, NATIONAL MUSEUM, ATHENS.

The observation of nature implied in such works becomes much more directly transcribed in the succeeding centuries which see the growth of wall-painting, but the character of the transcription is unparallelled elsewhere at this period. In the paintings and reliefs of Egypt one finds exquisite renderings of beasts, birds and fishes, plants and flowers, but a comparison of these with those from Crete reveals two profound differences. In the Egyptian, detail is minutely recorded and exploited with wonderful decorative effect; and natural life is related to human activity and subordinated to it. In Crete we find quite often scenes of nature shown for their own sake. Such are a frieze of partridges and hoopoes from round a room in a house outside the palace at Knossos; monkeys gathering flowers from the palace itself; and a cat stalking a bird in a bush, as well as other fragments, from Agia Triada, a small palace on the south coast near Phaistos. The Knossos pieces are exceedingly fragmentary and made up in the manner described. Those from Agia Triada are more substantial and are unrestored, but they

are severely darkened and discoloured. To illustrate the 'naturalism' of this art, we may turn to the flying fish of p. 21, which are not from Crete itself but from Phylakopi on the island of Melos in the southern Cyclades, though certainly of Cretan workmanship. This is a detail from a small panel entirely occupied by fish, as the other pieces cited are entirely occupied by birds and beasts, plants and rocks. It shares too with them the quick, nervous, sketchy handling and selective detail, which set off this art from the exquisite precision of Egyptian. It has been remarked that both birds and plants are sometimes difficult to identify with certainty, although so convincing in appearance, as they seem to combine elements from various originals in nature—a phenomenon of the 'impressionist' approach. In the fish scene this ambiguity pervades the setting. Some of the creatures, one would say, are thought of as skimming the waves, others as plunged beneath them. The breaking of the background with groups of dark flecks serves either view satisfactorily, as does the framing by rock or coral formations along the bottom and repeated upside-down along the top. Rocks so disposed are found equally to frame the landscape scenes, and the idea is borrowed from Egypt.

The new naturalism of the frescoes finds an echo on the painted pottery of these centuries, but the differences are interesting. The tuft of leafy shoots or grasses vividly realized round the jug shown on p. 22 (which comes, like the earlier jar, from Phaistos) makes at the same time an effect of abstract pattern repeated over the surface of the vessel. The dark ware with its decoration in lighter colours is out of fashion now, and the wide range of abstract and naturalistic design is generally laid, as here, in dark on a light ground. The big jar from Knossos illustrated on p. 23 shows a very different treatment from the jug. The theme is a favourite—a cuttlefish among rocks; and both the observation of the creature itself and its irregular placing on the pot-surface, set aslant with tentacles waving, have a vivid relation to nature which puts this work in the same world as the wall paintings. There is, however, nothing of the soft, modulated colouring

of the fish-fresco. The polyp stands out boldly silhouetted in vase-painter's black; and, though the rock is stippled within its black outline in a lighter colour, the pleasing effect is simpler, more purely decorative in character. The painter is plainly conscious that the primary purpose of his design is to be effective decoration for the curved surface of the pot.

CRETAN JAR, FROM KNOSSOS. C. 15th CENTURY B.C. CUTTLEFISH AND ROCKS. (H. OF DETAIL C. 58 CM.)
ARCHAEOLOGICAL MUSEUM, HERAKLION.

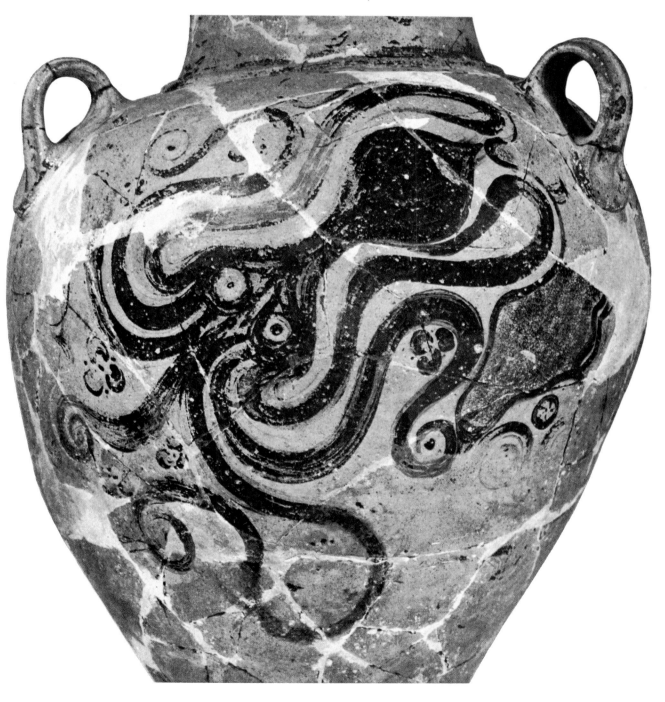

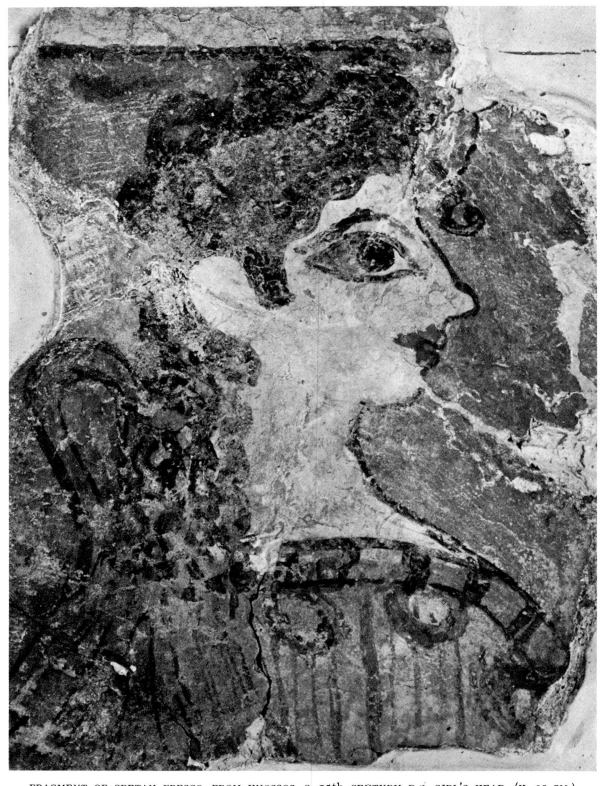

FRAGMENT OF CRETAN FRESCO, FROM KNOSSOS. C. 15th CENTURY B.C. GIRL'S HEAD. (H. 20 CM.)
II, ARCHAEOLOGICAL MUSEUM, HERAKLION.

The polyp with its embracing tentacles is eminently suited to this end; and the decorative character is emphasized by simplifications of drawing as well as of colour. These are more marked on this jar than in earlier versions of the subject; for this is somewhat later than anything else we have looked at. In earlier renderings the suckers, omitted here, are drawn along the edge of the tentacles, which are then always given their full number and often cross one another in a more lifelike manner; but the principle of simplification is always there. The more stylized character of the later work illustrates a general tendency to which we shall return.

In the landscape paintings human figures are sometimes introduced, and other frescoes are entirely devoted to their activities. I have already mentioned the bull-jumping scenes. The creature there is always shown in the 'flying gallop', with legs outstretched front and back and head flung up; again not a transcription of any position found in actual movement, but a synthetic impression, a symbol of speed and violence. Various moments of the action are shown, often in the same representation (we know the scene not only from paintings but in other arts too, such as intaglios on seal-stones and the bezels of gold rings). The jumper, boy or girl, stands before the bull; grips its horns; somersaults on to its back; a companion waits with outstretched arms to catch him. This delicate operation is almost always shown as successfully performed, without a hint of danger. It can hardly have been so in reality. The legend of the youths and maidens of Athens sacrificed to the Minotaur suggest that it was perhaps done by slaves and prisoners; but the ideal character of the representations probably implies a ritual activity. Dances, too, seem to be shown, which might well be also ritual; and worshippers, sometimes with the deity appearing before them. No temples have been found in Bronze-Age Crete; but besides the holy caves there are shrines in the palaces, and it is likely that here, as elsewhere at the time, there was an intimate connection between royalty and religion, and that the painted decorations have often a religious character.

Such one would certainly suppose for the processions with which the corridors of the palace at Knossos were decorated. These in their nature, a frieze-like row of figures on a neutral background, reaching from bottom to top of the field, have more in common with the formal, hieratic arts of most Bronze-Age civilizations. Related to these was a picture at Knossos, dated in the first Late Minoan period (around the middle of the second millennium), with pairs of youths and girls seated on stools. The charming fragment shown on p. 24 belongs to it. This girl, like all the figures in Cretan frescoes, shares certain conventions with those in Egyptian and Near Eastern painting and relief: the face drawn in profile but the eye as though in full view. The effect, however, is very different. The broad handling, with its suppression of detail, giving an impression of quick execution, links this to the pictures of wild life. Another aspect of the same spirit is seen in the lively individuality of the girl: tip-tilted nose, full lips and small chin, even the unnatural bigness of the unnaturally rendered eye, all contribute. The enormous kiss-curl dangling almost to the nose recurs constantly, and so does the curious loop of stuff behind neck and shoulder, variously worn and also found in independent models. It must have had some religious significance.

These Cretan paintings share with Egyptian the convention of showing men's skin red or brown and women's white. A very remarkable example of Cretan 'impressionism' is in a miniature fresco (a type of which there are many fragments from Knossos) showing a crowd of men and women sitting in front of a building, perhaps watching some performance—a similar picture showed people among trees watching women dancing. The figures are grouped together by sex, and the artist, instead of painting each one separately, has divided the field into irregular areas of red and white on which he has drawn the figures in black outline.

The latest Cretan frescoes belong to the Second Late Minoan period, dated in the second half of the fifteenth century B.C., and only distinguishable as a separate phase at Knossos. This seems to reflect changing historical conditions. The fresco with flying fish shows Cretan artists at work in the island of Melos in the third Middle Minoan period; and during the succeeding phase Cretan artistic ideas spread over the whole Aegean area, largely absorbing or obliterating earlier local traditions, though in its turn affected by them in some degree. The mainland of Greece was controlled at this time by Greek-speaking rulers who had come in, from the North perhaps, in the later third millennium and planted their castles about the country; the ancestors of Homer's

CRETAN SARCOPHAGUS IN ALABASTER, DETAIL, FROM AGIA TRIADA. C. 14th CENTURY B.C. SACRIFICE. (H. OF PICTURE 26.5 CM.) 396, ARCHAEOLOGICAL MUSEUM, HERAKLION.

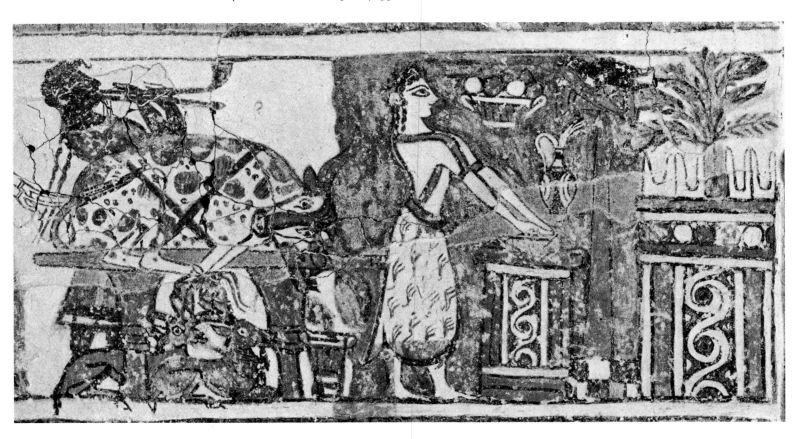

26

Achaeans. They now became civilized through contact with Crete; and in art at least Cretan domination is so strong that a Cretan conquest is sometimes postulated. The mythological evidence perhaps suggests rather that some mainland cities were at one time tributary to Crete; the archaeological that the more important at least, especially Mycenae, were ruled by independent kings who patronized Cretan art and artists. Certainly in the later Bronze Age, if there was any rule of one from the other it was Mycenae on the mainland that ruled Crete; at least throughout the Third Late Minoan period Crete is comparatively unimportant and Mycenae the dominant power in the Aegean. The Second Late Minoan period seems to show a transitional stage, when Knossos was still important but, unlike the rest of the island, was ruled by Achaeans. Inscribed clay tablets found there are identical with those found in later mainland palaces and have been read as Greek, while those of earlier periods and from other parts of the island show an undeciphered tongue. The wall-paintings of this time are more formal than the earlier ones, and this possibly reflects mainland influence; at least it is a general tendency in the art of the area in the succeeding period of mainland domination. At the end of this phase Knossos was sacked, in what circumstances we cannot say, but the city was never important again.

CRETAN SARCOPHAGUS IN ALABASTER, DETAIL, FROM AGIA TRIADA. C. 14th CENTURY B.C. RELIGIOUS CEREMONY. (H. OF PICTURE 26.5 CM.) 396, ARCHAEOLOGICAL MUSEUM, HERAKLION.

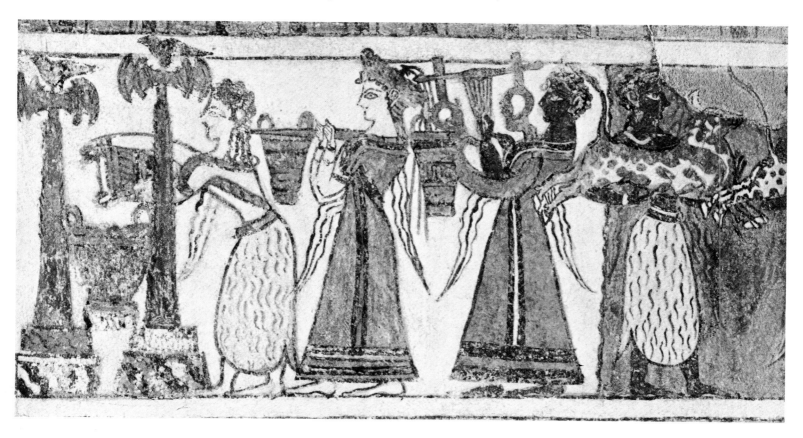

Whatever the exact political relation of the island to the mainland during the Third Late Minoan period (roughly from the fourteenth century into the twelfth), when Mycenae was unquestionably mistress of the area, the Cretan artistic tradition retained a certain independence. From the beginning of it comes a painted alabaster sarcophagus, found at Agia Triada, whose fascinating pictures (pp. 26-29) are closely linked in style to earlier fresco-painting and give us completer compositions than any of those that survive. Remains of wooden coffins with painted patterns have been found, and there may have been more elaborate ones with figure-work, but in general there is little evidence for the Cretans before this period making much of their dead. That they do so now is perhaps due to influence from the mainland, whose rulers in this as in other things (subordination of nature in their art to human activities like hunting and war) stand closer to the normal character of the Bronze Age.

The subjects of the pictures of the sarcophagus are religious. The better preserved of the long sides (p. 29) shows two scenes. At the left (p. 27) stand two double axes, their shafts closely sheathed in greenery. This weapon is a favourite religious symbol in Crete. In these each of the two blades is double, perhaps indicating that each shaft supports two double heads at right angles to each other. On top of each sits a bird, real or image, and these too are of frequent occurrence in apparently religious contexts. Here, oddly, they are facing out of the picture, away from the action. Between the axes, which have elaborate bases, a sort of pail stands on a block, and into it a girl empties a smaller vessel of similar form, while behind her another girl carries two more on a pole over her shoulder. This must be a religious offering, and it is done to the music of the lyre, played by a man behind the second girl. This episode occupies less than half the length. At the right-hand end is a small construction suggesting a building, in front of which is apparently an image: a head on a roughly shaped trunk, with waist but no arms or, probably, legs (the lower part is modern). Close in front of this is a tree and close again three steps. The steps do not lead up to anything, and perhaps one should regard these elements as the painter's way of indicating a shrine, image within, steps leading up to it, tree outside. Since this is a sarcophagus it might be that the shrine is also a tomb and the figure that of the dead man, but one cannot be sure. Approaching this is a procession of three, backing on the lyre-player, all men carrying offerings, the foremost a boat, the other two animals. (The heads of the central man and his animal, and part of that of the animal behind, are modern.) These three are against a dark background, that of the two ends being light. The animals are shown in the 'flying gallop', not suitable to their circumstances and perhaps an indication that they are models, like the ship, not living creatures.

The other long side (p. 26) shows a single procession to the right, approaching a shrine of yet another form: an altar, crowned by four pairs of 'horns' (another favourite religious motive), with a small tree or branch between them. There is a second altar or offering table, with a jug and basin standing on it, and between them a double or quadruple axe, just like those on the other side, again with a bird on it which this time faces into the picture. Facing this shrine stands a girl, eyes raised, arms stretched forward

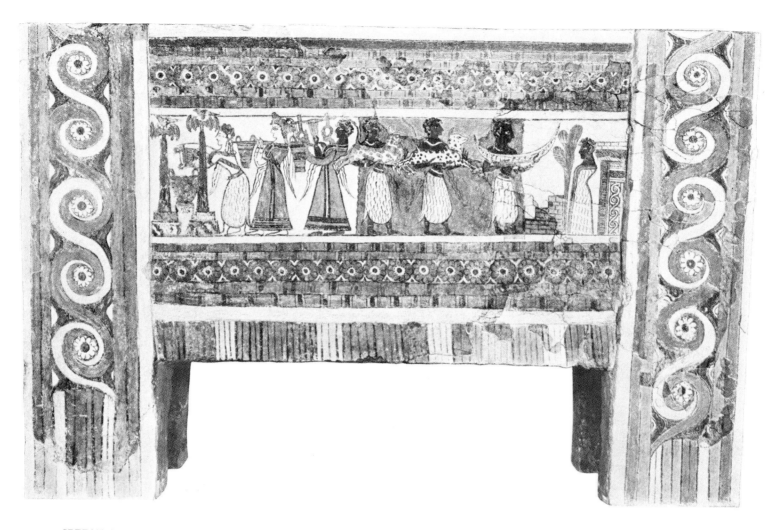

CRETAN SARCOPHAGUS IN ALABASTER, FROM AGIA TRIADA. C. 14th CENTURY B.C. RELIGIOUS SCENES. (L. 137.5 CM.) 396, ARCHAEOLOGICAL MUSEUM, HERAKLION.

and down. Behind her is a bull trussed on a table, its throat bleeding into a pail on the ground. Under the table lie two goats. Beyond these, partly concealed by them, a man stands playing the double pipe. At the back, which is damaged, comes a procession of girls (not illustrated), only the lower parts preserved, a leader in the posture of the one at the shrine (the upper part of this figure has been restored, but the hands are ancient) followed by two pairs. Again there is a variation in the colour of the background. Here the central part behind the piper and the victims is light, the rest, so far as preserved, dark, except at the top right above the altar.

The figures are all drawn in full profile, except for the three carrying offerings to the image, whose shoulders are turned square to the spectator. In some earlier bull-jumping scenes there is a remarkable attempt to show a twist on the body, hard to parallel before the late archaic art of historical Greece, the best part of a millennium

later, but not seeming, as there, the careful record of intellectual observation so much as the unconsidered noting of a direct visual impression. Limitation here to the simple elevations might be a sign of development towards formalism but need not be more than an accompaniment of the more formal subject. Certainly what seems another instance of intuitive anticipation of a much later intellectual achievement appears in both pictures: a more distant object shown as smaller than a nearer one.

The arms and vessel of the girl pouring the offering are crossed by the swathed shaft on one of the double axes, which is therefore the nearer to us; and it is shown as taller than the other. Its blades touch the bottom of the narrow white strip which frames the picture at the top, and the bird is painted on that; the bird on the other only just reaches to the height of this one's blade-tops. That the painter has not thought out the relation is shown by the lower part where the vessel between the shafts, the block on which it stands, and the bases are schematically related in a purely frontal elevation. The difference in size, on the other hand, can hardly be due to chance, since the effect is repeated in the other picture. There the second altar, or offering table, is markedly smaller than the principal one at the extreme right; and in this case the smaller one is overlapped by the base of the double axe between. Diminution with distance is a visual fact, normally obscured for a primitive artist by intellectual preconceptions and only rediscovered by further and prolonged intellectual effort; but there is no reason why it should not occasionally be apprehended directly by the innocent eye.

The drawing of the faces is less irregular and vivid than in the earlier fresco, but exceedingly like; the difference is perhaps due largely to scale. The big kiss-curl is worn by both sexes. The girl with the offering-vessels has a flat-topped hat with streamers and a long-skirted dress. A similar dress is worn by the procession of girls on the other side and by the male lyre-player; the piper has a shorter tunic. The two girls confronting the shrines and the three men with offerings have odd skirts with rounded bottoms and little tails which, with the markings, suggest that they are meant for animal-skins.

Masquerading in animal-skins is often shown in Minoan and Mycenaean art, perhaps always in a religious connection; we shall meet an example in a moment. It was also practised in historical Greece, perhaps particularly in connection with revels in honour of Dionysus, such as led to the development of Attic drama, and left its mark in the often animal choruses of comedy. This kind of ritual practice may well have been continuous through the intervening dark ages; and it is noteworthy that the musical instruments shown in use here (the double pipe and the seven-stringed lyre) are the two key instruments of classical Greek music, itself closely associated with religion.

The short ends of the sarcophagus have pictures of pairs of women in chariots, one drawn by two horses, the other by two winged griffins. Both the subject and the stiffer, more conventional treatment relate these scenes less to earlier frescoes from Crete than to later ones in the palaces of the mainland. The spirals and rosettes of the pattern-bands are common to all phases of Minoan and Mycenaean painting.

As the palaces of Crete took shape in the seventeenth and sixteenth centuries B.C., the fourteenth and thirteenth saw those of the mainland acquire the form whose splendid

ruins still remain. Like those of Crete, these have a central court, but opening from it through a porch and ante-room a big hall with central hearth on the axis of the entrance doors. Both hall itself and its direct approach are un-Cretan features; and if there is sometimes a labyrinthine indirectness of approach to the court from the outside, that is part of an elaborate defence system, for several of these palaces are fortified like mediaeval castles, as the Cretan ones are not. In detail of architectural form and decoration, however, they owe a great deal to Cretan tradition, and they are adorned with frescoes in a style of purely Cretan origin though with a growing tendency to formalism. Processional scenes occur, as well as pairs in chariots, reminiscent of the end panels of the Agia Triada sarcophagus, and pictures of hunting and warfare.

The same problem of illustration arises here as with Cretan work. I show an amusing fragment of a miniature fresco from Mycenae with masqueraders. The long-eared heads, tongue lolling, seem those of donkey or mule, and the pelt hangs down the back. I do not understand the pointed object (hardly a horn) on the brow, nor the little hook in front

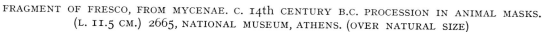

FRAGMENT OF FRESCO, FROM MYCENAE. C. 14th CENTURY B.C. PROCESSION IN ANIMAL MASKS. (L. 11.5 CM.) 2665, NATIONAL MUSEUM, ATHENS. (OVER NATURAL SIZE)

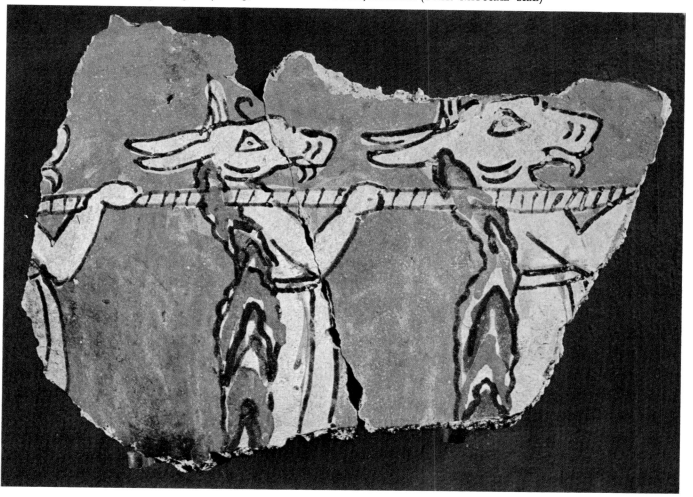

31

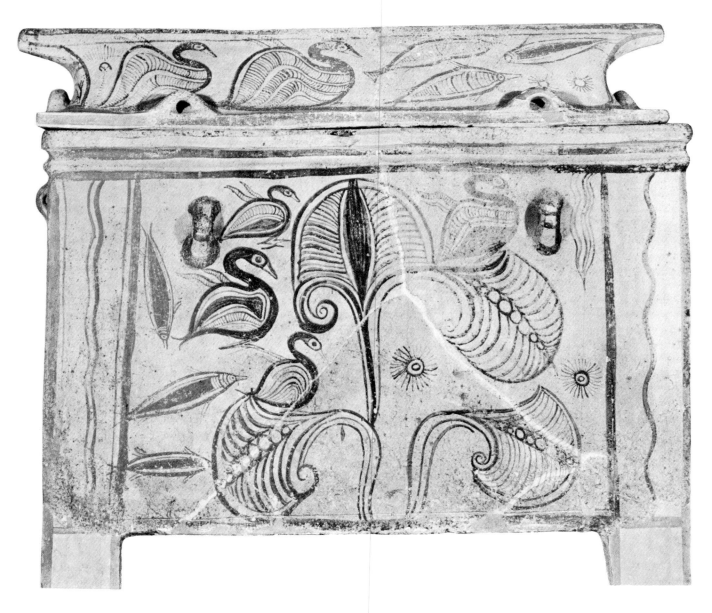

CRETAN SARCOPHAGUS IN CLAY, FROM ANOGEIA. C. 13th CENTURY B.C. BIRDS, PLANTS, FISH.
(L. 99 CM.) 1612, ARCHAEOLOGICAL MUSEUM, HERAKLION.

of it, curiously reminiscent of the Cretan girls' kiss-curl; nor do I know what they are carrying. Very similar characters, sometimes in procession, appear on rings and other objects from Crete; and these more than anything else seem to look forward to the choruses of fifth-century Attic comedy.

In this period a unified culture with its centre at Mycenae is spread over the Aegean and beyond. Some of the islands of the eastern Aegean were settled at this time, most importantly Rhodes, and perhaps some cities on the west coast of Asia Minor;

and there were Mycenaean colonies in Cyprus and a trading-post in Syria. Painted pottery was produced in many centres, with local variations but all in the same general style of ultimately Cretan derivation. Already in the sixteenth and fifteenth centuries fine vessels decorated with floral and marine motives, as well as abstract and other designs, in a style evolved in Crete, were also being produced on the mainland; only differences of fabric distinguish them. In the Mycenaean period the repertory of decorative motives remains for the most part the same, but increasing stylization makes those of natural origin approximate to the purely abstract. For a brief spell human figures become popular on mainland and especially Cypriot pots, perhaps because in the schematic formulae of the time the potter no longer rejects such subjects as unsuitable for decoration. The Cretans stand out against this innovation, but introduce birds, hardly known in their work before, perhaps under the influence of pottery from the Cycladic islands, where the motive had always been popular. They place them also, very effectively, on large clay coffers and bath-tubs, both used as coffins at this time. One of the handsomest of these coffers is shown on p. 32. In the underwater picture on an earlier jar (p. 23) we noticed already a tendency towards formalism. If one compares the treatment there, however, to that of this waterside scene (birds, plants, fish) one sees an increase in stylization amounting to a profound change in the artist's vision of nature. In the last phase of the Mycenaean style potters use largely abstract motives and ciphers based on the old designs of flower, shell and polyp drained of almost any reminiscence of their natural character; and in the collapse of the culture this schematization is accompanied by a decline in technical quality.

In the middle centuries of the second millennium, the eastern Mediterranean had been a flourishing entity, the rulers of Egypt, the Hittite empire in Asia Minor, and Knossos or Mycenae all in contact with one another. The collapse that followed was not only in Greece. The Hittite empire too broke up, and it is over the whole area a time of impoverishment and isolation. Achaean Greece, the south and central part of the peninsula, that is, was invaded by further Greek-speaking tribes, the Dorians, still barbarous; perhaps those who had settled in the North when the Achaeans first came in. Mycenae and all the great citadels were sacked, except the hitherto comparatively unimportant Athens, and the invaders pressed on to Crete and Rhodes. Mythological and archaeological evidence agree that Athens became a centre of refuge for Achaeans, some of whom afterwards emigrated to the islands and coasts of the east Aegean, which thus became the Greek lands they remained through historical times. Later Greeks attached importance to the distinction of Dorian, the descendants of the invaders, and Ionian and Aeolian, descendants of the older stocks. In artistic development, however, the distinction has little validity, differences being mainly geographical and cutting across divisions of stock.

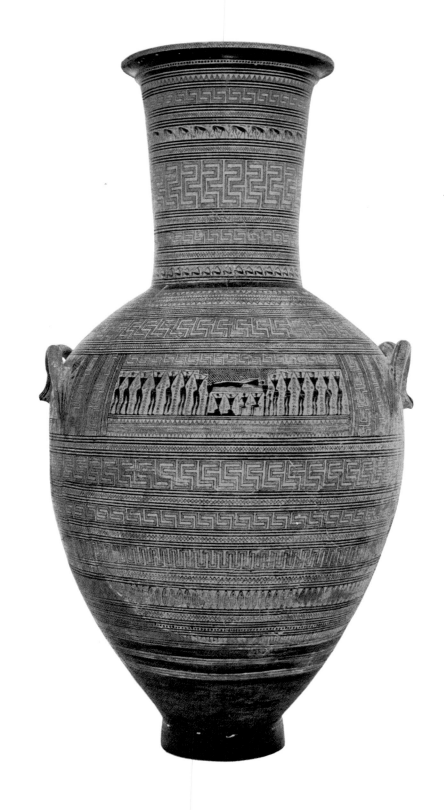

ATHENIAN JAR, FROM GRAVE IN ATHENS. C. 9th CENTURY B.C. GEOMETRIC ORNAMENT; BETWEEN HANDLES, FUNERAL SCENE. (H. 155 CM.) 804, NATIONAL MUSEUM, ATHENS.

34

THE BEGINNINGS OF GREEK PAINTING

THE collapse of civilization in Greece in the centuries before 1000 B.C. was very serious. The inhabitants appear to have lost the art of writing, a most exceptional cultural set-back which perhaps implies that literacy in Mycenaean times was not general but confined to a small clerical class. At least there is a gap of several centuries between the latest possible date for the last examples we have of the clumsy syllabary which the Achaeans derived from the Cretans, and the earliest for the first of the alphabet adapted by the Greeks from the Phoenicians. There was continuity of habitation and of language; probably, too, to a considerable extent of religious practice; certainly of utilitarian crafts; but almost none of representational art. There seems to have been no place for wall-painting in the humble buildings erected during this time; stone sculpture certainly ceased; and if small figures continued to be made occasionally in terracotta and bronze, they were of a degenerate, styleless character. We have noticed the limited range of design in painted pottery and its qualitative decline.

Owing to the country's isolation, dating in this period is even less sure than in earlier ages. In the eighth century we come to the beginnings of Greek historical record: traditional dates for the founding of colonies in the West, with which can be associated the earliest objects found in their excavated remains; but even this only gives us dates of a most general kind. For the intervening time, by stratified excavations and stylistic development, we can arrange the objects that survive in a tolerably convincing and perhaps approximately correct order, but the absolute dating is entirely schematic. We shall indeed find that even in the fully historical period surviving works of art are seldom documented, and their dating remains imprecise, only the possible range is narrowed. We may take for convenience the round figure of 1000 B.C. as the approximate time for the revival and change of aesthetic which marks the beginning of a development leading directly on to the art of historical Greece. The new movement evidently begins in Athens; but it spreads, quickly it seems, over all Greece, and it could hardly have started until the invaders had settled down beside the invaded, and a new unity had begun to form.

The change is first apparent to us in Athenian pottery, and is marked in shapes and decorative schemes as well as motives. Mycenaean pottery, including the 'sub-Mycenaean' of its latest phase, has generally profiles in continuous curves, and most of the surface not adorned with patterns or stripes is normally left in the pale colour

of the clay. Potters in the new movement often favour sharp divisions: neck or tall foot set off from the body at an angle; and they like to cover areas with plain black. Both these tendencies remain important in Greek pottery throughout its history, and the clear definition of the elements that make up the whole is a fundamental principle of Greek art. The same new precision is brought into decorative motives. Concentric semicircles drawn free-hand are found on some sub-Mycenaean pots; drawn with a compass, they become, with concentric circles, the principal decorative motive of the new style in its earliest phase. Other abstract forms, the wavy line and the chequer, are taken over likewise, but the schematized versions of old naturalistic motives go out of the repertory.

The early stage of the new style, known as 'Protogeometric', develops imperceptibly into the full 'Geometric' style. This is characterized by the covering of the surface with graded bands of close-set, angular patterns, a strictly limited repertory richly and subtly varied, making a skin of pattern which defines and emphasizes the clear-cut form of the pot. The big jar illustrated on p. 34, to which we shall return for its figure-work, shows the treatment: the repetition and variation of patterns in zones of different breadth, and particularly the use of the 'maeander' or key-pattern in every stage of simplicity or complication. This, which is almost a hall-mark of the style, scarcely appears in Protogeometric, while in full Geometric concentric circles and semicircles are comparatively rare. Some vases show some of the principal bands divided into panels, each with a geometric motive; the swastika then is the usual panel-version of the maeander. It is noticeable that the maeander and similar motives are hardly ever drawn in a single line or in solid black, but always in two fine lines filled with hatching. This is a further expression of the desire for an even network over the whole surface, avoiding emphasis on any one element in the decoration, which is an essential characteristic of this art.

Protogeometric vase-decorators make one occasional concession to representation: a little figure of a horse drawn in thin silhouette with a few quick curving strokes, schematic but not 'geometric'. In the early phases of fully developed Geometric decoration figure-work seems completely absent; and when it reappears it is in a new style most carefully adapted to fit into the general decorative scheme without disturbing the total harmony: the figures are as 'geometric' as the ornament. Sometimes there are rows of deer, grazing or reclining, as on the neck of the vase on p. 34, or of birds, or a single such creature in a panel; sometimes larger scenes of human activity, generally concerned with death: the wake, as pp. 34 and 38; the procession to the grave; or battles by land or sea.

These pictures are markedly conceptual in character; the painter, that is, does not draw for the most part what he sees, or remembers to have seen, but rather puts down an itemized account of what he knows. In the chariots of processional scenes the two wheels are drawn separately, two circles side by side, the car unattached above them, the driver standing clear in the air above that. So the body does not lie on the bier but is a standing figure turned horizontally and placed above it, the chequered pall that

should cover it set clear above again. This conceptual approach is not consistent; there are sudden surprising compromises with appearance. The two horses that pull the chariots are drawn as a single body with two heads and necks and eight legs growing out of it; and the bier is sometimes given only two legs (p. 34), sometimes the second pair is drawn smaller between the others (p. 38), giving an effect of observed recession oddly at variance with the general treatment. There are like compromises in the drawing of individual figures. Legs and feet are always in profile: easiest to draw, and showing the typical action of walking; breast and shoulders frontal: again easiest to draw, and showing the completest, most typical elevation; the head in profile. The most typical elevation of the human face is from the front, showing all its features; but it is not easy to draw, and side-view is the consistent convention for heads in drawing and relief in all the early arts of this part of the world. A statue is frontal, because it is a being whom you meet face to face; figures in narrative scenes are concerned with one another and the action, not with the spectator, and so they are in profile.

Such a basically conceptual vision as this is often found in children's drawing: the circle for the face with two circles for eyes, the hat set above the head instead of down on it; yet shot like these with unforeseen shafts of observation. That these vase-pictures do not at all resemble the drawings of children is due to the fact that they are the work of highly skilled hands trained in the drawing of geometric ornament, and are made as like elements in that ornament as possible. The two approaches which meet to give this art its character—the conceptual and the geometric—have no inevitable connection with one another.

The figures are drawn in thin silhouette with occasional use of outline. The upper part of the body forms an isosceles triangle with the apex at the wasp waist; the arms, unmodulated matchstick lines, make in the mourners either a continuation of this triangle (p. 34) or a rectangle set upon it (p. 38), in either case neatly enclosing the head. The legs are rounded towards a living shape, but even they are hardly more organic or irregular than those of the furniture. Figures in more complicated action, like those sprinkling the corpse with twigs on p. 38, and even more the fighters on other vases, depart thereby from the formal pattern, but always as slightly as the movement allows. Even in the mourning scenes men are sometimes distinguished by wearing swords, women by longer hair and by breasts: two little ticks, sometimes on opposite sides of the triangle, sometimes, as on p. 38, on the same side, this indicating that the figure is really in profile. Children are miniature versions of the adult formula: one in this picture is seated on a woman's knee (this group is a good example of how little the conceptual and geometric conventions need be compromised by observation even in a complicated pose), two more of differing ages up on the bier.

The interstices of the background are filled with patterns and sometimes animals. This practice, with the thin silhouette of the figures, helps the pictures to merge into the general decorative scheme of the pot which is the potter-painter's primary concern.

The pot on p. 34 is some five feet high. Clay, and paint or glaze (actually, as throughout Greek ceramics, a clay mixture), are of fine quality, and the accurate potting of a

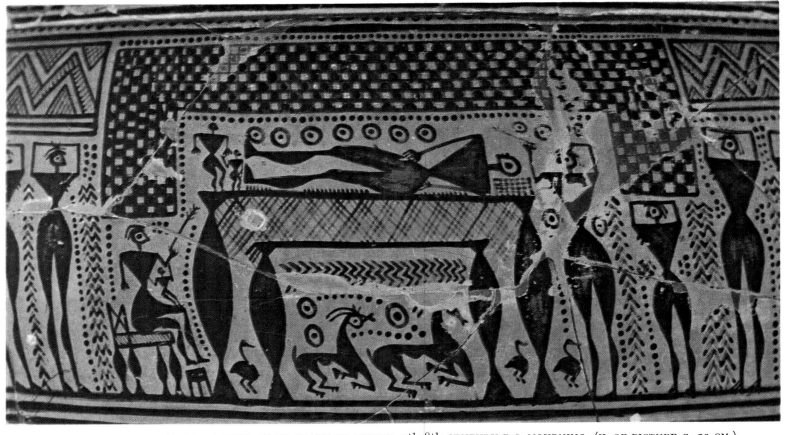

ATHENIAN JAR, DETAIL, FROM GRAVE IN ATHENS. 9th-8th CENTURY B.C. MOURNING. (H. OF PICTURE C. 20 CM.) 14.15, METROPOLITAN MUSEUM OF ART, NEW YORK.

vessel this size shows great technical competence. It stood on a grave, and was certainly in the nature of a tomb-monument. As a piece of painted pottery in the Geometric style it is a very sophisticated work, the acme of a long tradition; but as a representational picture the central scene is in a high degree unsophisticated and primitive: a beginning.

Whether this beginning (which is probably to be dated at some point in the ninth century) was actually made on pots like this cannot be certainly determined, but several things suggest that it was so. Firstly, the geometrical character of the drawing seems dictated by the tradition of pot-decoration; yet the same thing is found in little bronze figurines, especially of horses, that are made at this period. That can in part be accounted for by the undoubted taste of the time for schematic design and thin angular forms; but the best of the bronze horses (which are also the most 'geometric'), conceived almost entirely as two profiles joining at a sharp angle, with necks that make perfect triangles like the breast and shoulders of human figures on the pots, look like imitations of the vase-figures which took their forms from the abstract pattern surrounding them. Then, at the end of this period, during the eighth century, the geometric style of decoration evidently begins to cease to satisfy potters. More and more of the vessel is covered with simple stripes varied with a few bands of zig-zag; and when there is a picture it is given

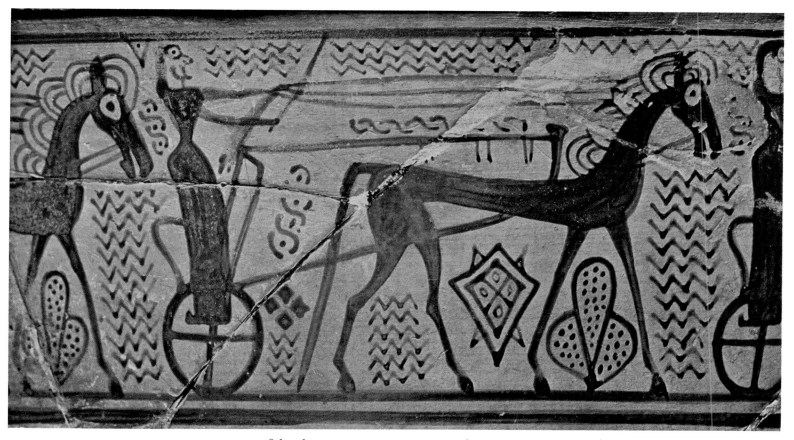

ATHENIAN BOWL, DETAIL. 8th-7th CENTURY B.C. CHARIOTS. (H. OF FRIEZE C. 10 CM.)
1351, STAATLICHE ANTIKENSAMMLUNGEN, MUNICH.

more prominence and complexity; yet the painter never departs from his inherited geometric conventions, though he clearly finds them hampering. Had painting existed independently of pottery decoration at this time, one would expect its practitioners to have developed a new style, which in turn would have helped the vase-painters to resolve their dilemma. As it is, a change only comes under the influence of objects in foreign styles imported from the East in the late eighth and seventh centuries. Lastly, the singular character of painted pottery in archaic and even classical times, especially in Athens, is perhaps best accounted for as a heritage from its position in the past as the first art of Greece. For us, in any case, it is the first.

Big figured vases in the Geometric style are confined to Athens, beside whose products all other versions of the style tend to look provincial. The swift spread of the style over Greek lands, however, and the appearance of fine bronze-work in other centres, indicate, like the great Athenian grave-vases, revived prosperity. Conditions were similarly improving further east. The kingdoms of Phrygia and Urartu and the Phoenician trading-cities of Tyre and Sidon rose and flourished in the ruins of the Hittite empire until they were conquered or overshadowed by the new empire of Assyria in the later eighth century or, in the case of Phrygia, broken by the Cimmerian invasions

from the north in the seventh. During the eighth and seventh centuries both Greeks and Phoenicians were trading and colonizing throughout the Mediterranean, the Greeks so thickly in southern Italy and eastern Sicily that this area became known as 'Great Greece'. The traditional dates for the earliest colonies are in the third quarter of the eighth century, but a Greek trading-post apparently active before the middle has been found at Al Mina in northern Syria. Through such contacts as these, works of oriental art began to be brought into Greece, and opened Greek artists' eyes to new forms of vision and expression.

Painted pottery was of comparative unimportance in these eastern countries. It was not exported, and the influence came through metal and ivory-work, and no doubt also through textiles with woven or embroidered designs. In Greek bronzes and ivories of this time one consequently finds some direct imitation of oriental models: for instance great cauldrons on conical stands with griffin-heads on the shoulder, of Urartian origin. Even here, however, Greek craftsmen soon develop their own style; in vase-painting, where the strong native tradition is absorbing influence from works in other media, the imitation is less direct and the breach with Geometric tradition less sharp.

The Athenian vase shown on pp. 39 and 41 of the early seventh century follows that tradition in the disposition of the decoration in zones of pattern and figure-work round the pot, and in the still rather thin silhouette of the figures. There is more curve and swing to this, however, and it is combined with an increased use of detailed outline drawing; the two figure-zones occupy together most of the pot-surface; and among the narrow bands of impoverished geometric pattern stand out the stout spirals at foot and handles, wholly foreign to the Geometric repertory. The lions of the body-zone are creatures unknown to Geometric, and the chariots on the neck are treated in quite a new way. They are no longer dismembered, but a short-hand impression of the thing as actually observed, only one wheel showing and the driver standing down in the car. Again, in the interests of convincing appearance the artist has substituted a single horse for the actual pair (or four—the four-horse chariot replaces the two-horse in seventh-century representations). The intervals in the pictures are filled with zig-zags, not in the neat formations of Geometric but in irregular masses which form a shimmering background to the figures.

During this century Athenian vase-decorators experimented much. In general the figures become larger and the ornament is further subordinated, and many techniques are tried: fuller silhouette, with details engraved or painted on in thin white lines; outline, often filled with white; and often decorative enhancements in white, yellow and purple-red. Several of these techniques can be seen on the big pot shown on pp. 42 and 45, which probably belongs somewhere about the middle of the seventh century and retains no more of Geometric tradition than was to be the common heritage of Greek vase-painting: sharp definition of parts; disposition of the decoration in horizontal zones; some use of silhouette.

This is a huge vessel, a few inches short of the great Geometric tomb-jar and like that associated with a grave. It did not, however, at least in its final use, stand above

ground as a monument. It had been buried, and part of the side had been broken away to insert the body of a child, but this cannot have been its original purpose. It is decorated on one side only (the back has a pattern of loops), and must have been designed to stand as an ornament, very probably on a tomb. Other such big pots, often with decoration on one side only, are associated with Athenian graves throughout the seventh century (we shall meet one of the last in the next chapter), and it is likely that the practice continued of standing them on top as monuments, but the evidence is inconclusive. This vase is not from Athens itself but from Eleusis, the holy place of Attica.

The pictures here are mythological. So possibly were those on Geometric vases: the warriors in processions and battles carry shields of a form apparently not in use at that time and perhaps echoing a Bronze-Age type; and that may indicate that the fight

ATHENIAN BOWL. 8th-7th CENTURY B.C. CHARIOTS; LIONS. (H. 40 CM.)
1351, STAATLICHE ANTIKENSAMMLUNGEN, MUNICH.

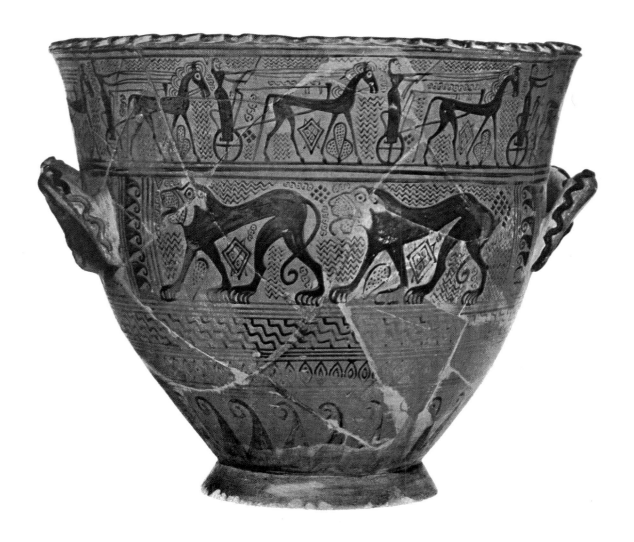

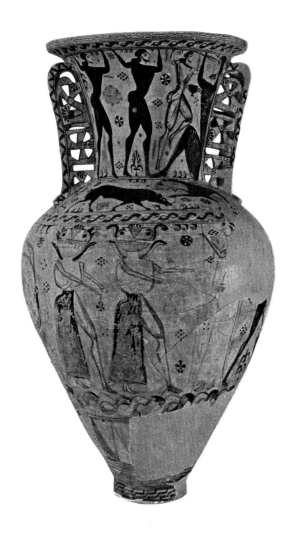

ATHENIAN JAR, FROM GRAVE AT ELEUSIS (ATTICA).
MID 7th CENTURY B.C. BLINDING OF POLYPHEMUS;
LION AND BOAR; GORGONS CHASING PERSEUS.
(H. 142 CM.) MUSEUM, ELEUSIS.

or funeral shown is a mythological antetype of the contemporary death. A few scenes on Geometric vases can be interpreted, though none with certainty, as illustrating specific stories from legend; but it is only in the seventh century that such scenes become certain, and from then on they are immensely popular and very various.

There are three pictures on the vase, the smallest on the shoulder: a lion attacking a boar. Geometric fauna was extremely limited, but in the period of oriental influence innumerable creatures appear, real and imaginary, the distinction at first perhaps not present to the Greek craftsmen and their patrons. Heroes who free the world from monsters are a favourite theme of Greek story. Herakles is the great performer in this line; but the beheading of the Gorgon Medusa by Perseus is also popular, and for us the first representation of it is in the principal picture on the body of this vase. The Gorgons were three hideous and terrible sisters, spawned among other such monsters in the early days of time. Stheno and Euryale were immortal; Medusa could die, but whoever looked at her face was turned to stone. Perseus, helped by Athena, patroness of heroes, and (like the prince in the fairy-story, which indeed he is) by various magic properties laboriously acquired, contrived without looking at her to cut off her head while she slept. The sisters gave chase, but he escaped—in the ordinary version through the possession of a cap of darkness and winged shoes; here his feet are bare, but Athena stands between him and the pursuing fiends, upright and still. The upper part of the hero is now missing, but the picture must always have been dominated by the Gorgons, behind whom lies their sister's huge headless trunk.

The artist has taken great pains with their faces. The Gorgon-mask takes soon an accepted form which becomes a favourite motive in archaic art by itself or in the story (p. 55): huge eyes, huge grinning mouth with boar's tusks, tongue protruding far between closed teeth, beard. The canonical version is exceedingly close to the mask of a Mesopotamian male demon, Humbaba, and is almost certainly influenced by it.

The painter of this vase is still experimenting; most of the canonical features are there, but not the general effect. The mouth cuts straight across the face from edge to edge, without a curve and without tusks; only the tip of the tongue protrudes between the teeth; and it is doubtful if he intended a beard. Moreover the extraordinary shape of the broad face seems closely modelled on a bronze cauldron, thick snakes, natural or lion-headed, growing from it like handles at the sides. Similar snakes grow from the sisters' shoulders where in later times they have wings.

The artist experiments in techniques as in representation. The animals on the shoulder are largely in black silhouette with engraved details and some addition of colour, but the lion's head is elaborately drawn in outline. Black silhouette is likewise used for what remains of Perseus. The other figures in the main picture are in a mixture of silhouette, outline and outline filled with white. The white, as often, has not worn well.

The figures in this picture are about eighteen inches high. On the neck is a smaller but still large representation of a scene from the Odyssey: Odysseus and his companions, caught in the cave of the one-eyed ogre Polyphemus, blinding him after making him drunk. The Cyclops' face is drawn like that of the other figures, but the convention of a large frontal eye occupying a disproportionate amount of the profile face serves almost as well to represent the monster's deformity as the normal human countenance. The heads are in outline, the bodies of Polyphemus and two of the Greeks in black silhouette; that of the foremost was white, but the colour has mostly perished revealing the lively sketch in black over which it was painted. The distinction is here a purely decorative variation, and the whole picture is conceived strictly in decorative terms. Seated giant and standing Greeks all reach from bottom to top of the picture, and are disposed at more or less even intervals.

A striking contrast is made by the composition of another picture (p. 44): the same scene painted about the same time at Argos in the Peloponnese. The design, of which part is missing, adorned a krater (mixing-bowl; Greek wine was normally drunk mixed with water). There is no white here, and the figures are drawn on the pale clay in black outline filled with a brownish-yellow colour on which details are added in black. There is, however, a profounder difference. One feels here for the first time since the Bronze Age that one is looking at a picture rather than the decorative scheme for a vessel. This effect is mainly produced by the irregular disposition of the figures. The Greeks hold the sloping stake above their head. The two that survive are of unequal height; they are close together, but the leg of a third appears at a wider interval behind. The picture is bordered below by three lines, but the feet of Polyphemus conceal the top one and rest on the next. They overlap the legs of the foremost Greek, but the forward foot of the second overlaps the giant's who, fumbling to thrust the weapon from his bloody face, sprawls on an irregular mound conventionally patterned to represent rocky ground or his rustic couch. All heads are in profile. The Greeks, like those in the Athenian picture, are drawn with legs in profile and breasts full-face. On the giant's figure in both some attempt is made to suggest torsion, but the Argive painter's outline is better adapted to show it than the Athenian's silhouette.

Simply on a confrontation of the two pictures one would say, I think, that the Attic was a vase-painter's creation, the other inspired by a wall-painting; and there is confirmatory evidence that the difference is essentially that. Brown flesh for men, outlined in black, is a convention of Egyptian painting, and is found too in some ruins of independent painting in Greece that survive from the later part of the seventh century and to which we shall return. This is the time when monumental sculpture and architecture

FRAGMENT OF ARGIVE BOWL, FROM ARGOS. MID 7th CENTURY B.C. BLINDING OF POLYPHEMUS. (H. OF PICTURE 11 CM.) MUSEUM, ARGOS.

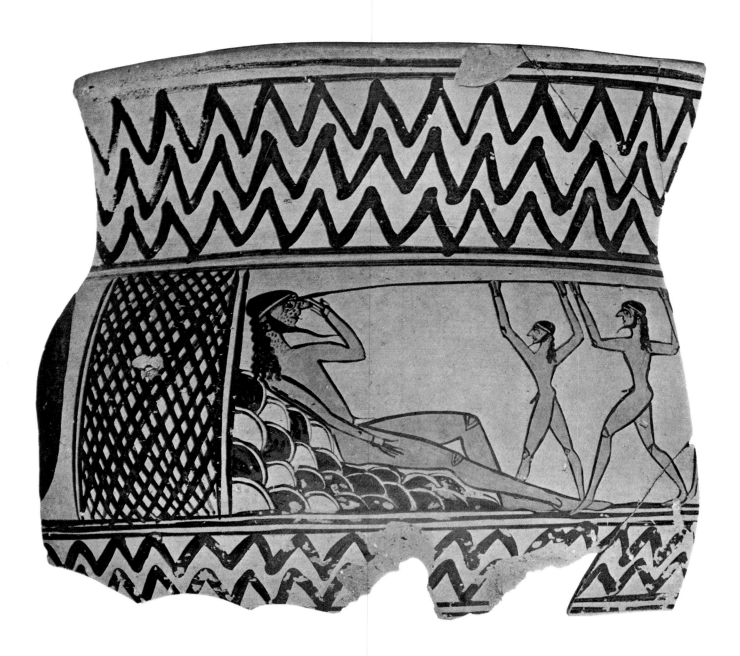

ATHENIAN JAR, DETAIL, FROM GRAVE AT ELEUSIS (ATTICA). MID 7th CENTURY B.C. POLYPHEMUS BLINDED BY ODYSSEUS. (H. OF PICTURE 38 CM.) MUSEUM, ELEUSIS.

begin again in the land; and while the architects seem to derive inspiration from the surviving remains of Mycenaean palaces, the earliest sculptors certainly take ideas from Egyptian statues. This is a second phase of oriental influence, no longer exerted through imported small works but through the visits of Greek artists to other countries where they saw the great monuments standing. That panel and wall-painting should have begun under the same inspiration at the same time is intrinsically likely; and it is confirmed by the Argive Polyphemus fragment, some other works to which we shall come, and later Greek tradition, as it has come down to us, about the origins of their painting. This tradition suggests that the earliest schools arose in Sicyon and Corinth (in the north-east Peloponnese, the general area to which Argos belongs), while Athens only figures later. The surviving fragments of painting from the later part of the century are from Aetolia, north of the Corinthian gulf but at this time a dependency of Corinth; and after the Argive piece the vase-paintings that seem to tell us most about lost painting were produced at Corinth itself. This area had not, like Athens, an important tradition of figure-painting on pottery. It seems, therefore, that during the seventh century, while here the new art of wall-painting was developed, and sometimes directly imitated by vase-painters, in Athens painters neglected the new development and tried instead to monumentalize the traditional native craft of painted pottery. Not only in scale but in their bold handling the pictures on the Athenian vase from Eleusis are much more 'painterly' than that on the Argive piece, but the compositions are a vase-decorator's conception while the other imitates the creation of a wall-painter.

The pictorial freedom of the Argive work is hardly parallelled for centuries. The painter, or his model, starting from Egyptian conventions, strikes out boldly towards a spatial development that was only properly compassed in the classical age. Other archaic remains—fragments of free painting and the vase-paintings that seem nearest to it—cling more closely to tradition. Early works of this kind are a series of little vases made in Corinth about the same time as the Athenian and Argive pieces we have been looking at, or not much later.

Corinthian Geometric was of exceptionally fine technique, equal to Athenian, but practised for the most part on small vessels with a very limited decorative repertory and normally avoiding human figures and even animals apart from birds. From this beginning Corinthian potters during the seventh century (while Athenian were experimenting rather wildly to keep their craft level with the new great arts) developed the finest and most successful vase-painting of the time. Here, on small vases of fine make, was evolved and perfected the so-called 'black-figure' technique—black silhouette with engraved details and discreetly added colours—which was to become the accepted norm for vase-painting throughout the archaic period and of which there will be much more to say in the next chapter. This is essentially a form of pottery decoration, and its adoption sets vase-painting further from painting in other fields; but alongside it certain Corinthian workshops produced around the middle of the century very exquisite little pots with pictures in a miniature style whose compositions and colouring seem to connect them with wall-painting.

The latest, largest and finest of these is a small jug (the pictures are a couple of inches high) of which excerpts are shown on pp. 48-49. Details are engraved in the manner of black-figure, and the black as well as the subordinate red and white of vase-painting are used, but men's skin is painted in yellow-brown (the few women's are in outline) and the massing and varied spacing of the figures are very different from normal vase-painting where, though much overlapping of course occurs, there is a general tendency to an even distribution of separate figures over the surface. The unusual character of the compositions is most marked in a damaged picture on the shoulder which shows a battle: overlapping ranks of soldiers with round shields advancing against one another. A front rank of five men and a rear of six are shown of the army on the right; on the left a front of four, behind them an unarmed piper playing encouragement, and a rear rank of nine, two stragglers behind. There is no diminution: the figures all have feet on the ground-line and heads more or less level near the top; but the overlapping ranks and varied dispositions defy that care for the pot-surface which is the primary concern of most Greek vase-painters. Such a design cannot have been conceived for this use, but for a flat surface and, one would say, a large scale: a wall-painting.

Most battle-scenes on vases fall into individual combats, often illustrating the exploits of particular heroes. Here the meeting of ranked armies suggests rather a contemporary than a mythological scene; the tactics and equipment are those of warfare in historical Greece, and seem to have been introduced about this time. Similar scenes occur on little scent-bottles in the same technique and style as this jug; and on a famous inlaid chest dedicated at Olympia about this time or a little later, by Cypselus tyrant of Corinth or his sons, was represented (among dozens of mythological scenes) a battle of 'armies' whose interpretation was not clear to later observers. One would guess that such battle-scenes were a preoccupation of great painting at Corinth in this age.

The only certainly mythological scene on this jug was tucked away under the handle at the back of the principal frieze: a Judgement of Paris, now very fragmentary. The scenes in this frieze, though not framed off from one another, are yet several independent pictures, not a unity—a common arrangement in vase-painting. The longest is a procession: a four-horse chariot with a man leading the horses, followed by four riders each leading a spare horse (p. 48), backing on to the Judgement. In front of the chariot, which occupies the central position opposite the handle, comes a double sphinx, two seated lions' bodies in profile conjoined in a single woman's head facing us; between this and the Judgement a lion-hunt (p. 49). The procession of chariots and horses is a Geometric theme newly treated. The lion-hunt, popular in the Orient and especially in Assyria, occurs only rarely in Greek art even at the time of strongest eastern influence. This is perhaps the part of the design that comes nearest to the large spaciousness of the Argive Polyphemus. Corinthian vases have often a narrow border-frieze of hounds chasing a hare; this is enlarged here, below the main frieze, with hunters and indications of setting (bushes).

Closely related to these vase-paintings, but probably from further into the second half of the century, are remains of painted terracotta plaques which adorned temples

CORINTHIAN JUG, DETAIL, FROM FORMELLO, NEAR VEII (ETRURIA). MID 7th CENTURY B.C. HORSEMEN, CHARIOT; BELOW, HUNT. (H. OF MAIN PICTURE 4.5 CM.) "CHIGI VASE", MUSEO NAZIONALE DI VILLA GIULIA, ROME. (OVER NATURAL SIZE)

at Thermon and Calydon in Aetolia. They are much ruined, and are also somewhat provincial in style, inferior to the little vase-pictures we have been looking at. They are, however, the only remains we have of seventh-century Greek painting other than on vases; they are on a comparatively large scale (complete figures stood about two feet high); and their character confirms the idea that wall-painting is reflected in the Corinthian and Argive vases.

This is the time when the Doric temple was created, traditionally at Corinth. It was at first a timber construction, and above the beams which rested on the column-capitals appeared the ends of cross-beams with squarish gaps between them. When the style was (almost at once) translated into stone, the beam-ends became the triglyphs, the gap-covers the metopes, often carved in relief. These painted terracotta slabs from

48

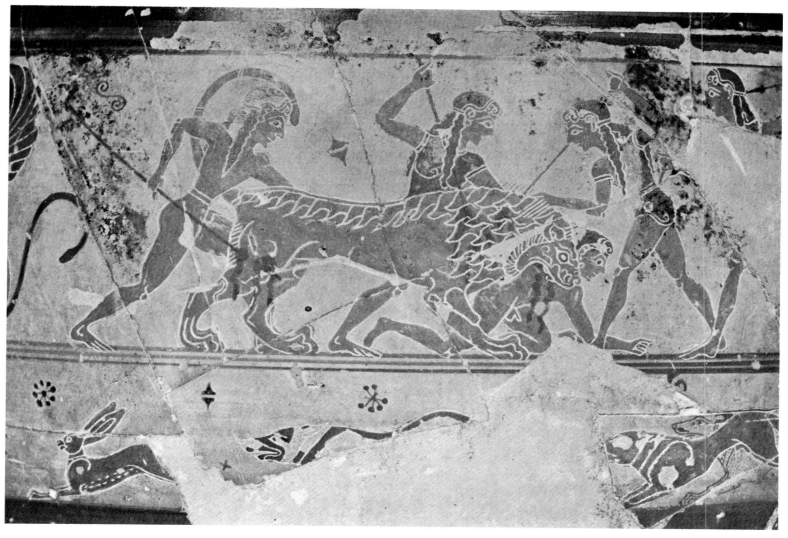

CORINTHIAN JUG, DETAIL, FROM FORMELLO, NEAR VEII (ETRURIA). MID 7th CENTURY B.C. LION HUNT; BELOW, HARE HUNT. (H. OF MAIN PICTURE 4.5 CM.) "CHIGI VASE," MUSEO NAZIONALE DI VILLA GIULIA, ROME. (OVER NATURAL SIZE)

early timber temples are likewise metopes, set between the wooden beam-ends. Their compositions, with one, two or three figures, are much simpler than those of the little vase-pictures; but one, much damaged and partly repainted at a later date, shows three seated goddesses in profile overlapping each other—just the same principle as the battle on the jug. The skin of male figures is brown outlined in black, like that of the Polyphemus fragment, and the colouring in general is just that of the Corinthian vases. The fragment on p. 50 shows a woman's head, painted in white within a red outline. This convention reappears in the only surviving painted wooden panels from Greece, of the middle of the next century or rather later. It occurs occasionally in Corinthian and Athenian vase-painting of the intervening period, and was no doubt the regular usage in free painting. Also in red is the inscription *Chelidwon,* written from right to left beside

the woman's head. The composition showed two women facing each other across a table on which lay a child. The story is best known to us in a version where the women are Athenian princesses, Procne and Philomela, but in that illustrated here they are Aedon and Chelidon. Aedon's husband ravished her sister Chelidon or Chelidonis and cut out her tongue that she might not tell. She conveyed the story to her sister and together they killed Aedon's child Itylos (Itys in the other version) and served him to his father to eat. He, when he discovered, would have killed the women, but the gods changed them all into the birds whose names they bear: Aedon the mourning nightingale, tongue-cut Chelidon the twittering swallow, the husband a hoopoe. Greek myth has many such dark stories.

Writing appears on vases already occasionally in the eighth century, and names are commonly written by figures from about the middle of the seventh: they are so in the Judgement of Paris on the Corinthian jug, and on Athenian vases related to the big one from Eleusis. They are written in either direction and in alphabets which vary from place to place and sometimes include letters which later drop out, as the W (digamma, written like F) in Chelidwon. The practice continues in vase-painting throughout its history, and in wall-painting is found sometimes through the classical age of Greece into Hellenistic and Roman times and so into the Middle Ages.

FRAGMENT OF ATHENIAN BOWL, FROM GRAVE AT ATHENS. SECOND HALF OF 7th CENTURY B.C.
SPHINX. (H. OF PICTURE 21 CM.) 801, KERAMEIKOS MUSEUM, ATHENS.

ARCHAIC PAINTING

THE 'black-figure' technique has been mentioned more than once: figures in black silhouette, details drawn on it with a graver, a little addition of extra colours. It was one of the techniques with which vase-painters experimented during the seventh century. We have seen it used irregularly, in subordination to other methods, on the big Athenian jar from Eleusis; and elements of it, especially the use of engraved detail, on the little Corinthian jug. This jug and the smaller vases that go with it are a special class. The great majority of Corinthian vases from quite early in the seventh century are in more or less pure black-figure. It was there that the technique was perfected and a style evolved to suit it; but before the end of the century Athenian potter-painters had abandoned their experimentalism and adopted black-figure, and it remained the norm in vase-painting throughout most of the archaic period.

It is clear that this is essentially a vase-painter's technique, and during the period of its dominion we never come so close to the lost painting on wall and panel as we do before and after. The reason for its triumph must be that it was felt more suitable as vase-decoration than other techniques: outline drawing and the use of a more natural colour for men's skin. Certainly the broad areas of black do tell on the curved surface of the pot, and emphasize it, in a way that other treatments do not. The aim is thus analogous to that of the overall decoration of Geometric, though the means are very different, and its general acceptance can be regarded as a reimposition of the discipline so marked in Geometric and very much loosened in the intervening period. Its adoption by Athenian vase-painters is perhaps a sign of admission that their art is not in all respects on a par with painting on wall and panel; but there is by no means a full retreat from their earlier position.

Corinthian vases of the time when they were perfecting black-figure are all comparatively small. Athenian craftsmen of the later part of the century take the technique, and elements of the style, evolved in Corinth, and apply them to pots on the grand scale we have become used to in their work. The fragmentary vase shown on p. 52 is an example. The shape is derived from a type of small cup developed at Corinth, enlarged probably as a mixing-bowl. The idea of a return to Geometric discipline is confirmed by the very geometrical character of the ornament in the subordinate friezes and panels; but the fullness of the forms and the powerful curves are a world away from that tradition. White is normally used in black-figure for female skin, generally laid over black.

The use of white and red on the wing here is unusually rich, and on later vases the sowing of the background with little ornaments is discontinued; otherwise this is a typical black-figure vase.

Corinthian clay is pale, often with a greenish tinge. Attic is naturally buff, but from this time potters tend to mix ruddle with it, which produces an orange colour, ranging from golden towards red. Their technique also became wonderfully refined during the sixth century, so that many vases, with their satiny orange surface and brilliant black glaze picked out with white and cherry-red or purple, look almost as if they were new; though often the surface is damaged and especially the white, the most fugitive colour of the four, flaked or darkened.

The sphinx on p. 52 was confronted by another, whose foot appears overlapping this one's. Sphinxes, male as well as female, are very ancient creatures in Egypt and elsewhere in the East, whence they come into Mycenaean art and again into Greek art of the late eighth and seventh centuries. A lone female sphinx has a place in Greek mythology: the scourge of Thebes, outriddled by Oedipus; but that story is seldom told in art and never early. When at this time the creature has more than a purely decorative significance it is a symbol of death. It is possible that it is so here, since this pot comes from a grave; and a sphinx regularly crowns the earliest marble tombstones of Athens, which about the turn of the seventh and sixth centuries drive out the big tomb-vases.

One of the last monumental Athenian pots is shown on pp. 55 and 56. It is not quite so large as the jar at Eleusis, but similar in form and in disposition of the decoration, and partly in the subject-matter of the pictures, whose figures have a sculptural power one might think in conscious rivalry to the new type of monument. The proportions of the shape are different, compacter and less swelling. The subordinate picture on the shoulder has been suppressed, animals appearing on the handles and on the enlarged and more architectural rim instead. The surface is not so well preserved as that of the vase with the sphinx, and white and red are largely perished. On the body Medusa falls, and her sisters fly off in pursuit; but their fuller forms, wings and enormous heads, all now of the canonical type for Gorgons, fill up more space, and the hero and his protectress are omitted. This kneeling posture becomes for some time the accepted symbol of running, especially for airborne runners. Dolphins below indicate that the pursuit is over the sea. After the experiments of the past century archaic art is settling into a system of accepted techniques and symbols; but in neither field does the system ever become static, and the struggle between current formulae and new ideas is one of the things which makes the peculiar character and appeal of Greek work throughout this period.

On the neck is another favourite scene from legend: Herakles attacking the Centaur Nessos, who had offered to carry the hero's wife Deianira across a river and assaulted her on the way. The woman is often shown, but here the artist has pared the theme down to its simplest terms: hero kills monster; and the drawing has a corresponding simplicity and largeness. The way the figures overlap the frame increases the sculptural effect. Again the names are written beside each: Nessos in Attic dialect is Nettos, and a single letter does duty for the double, a regular convention at this time.

In the later part of the seventh century Corinthian pottery tends to decline into conventionality, though good figured work is still produced there until about the middle of the sixth. About the end of the seventh Athens suffered a severe economic and political crisis. The monumental pottery we have been looking at belonged to a world that then went under, and disappears with it. Athens had taken little or no part in the overseas trade and colonization of the later eighth and seventh centuries. Attic Geometric pottery had been exported to other Greek cities, but that of the seventh century is scarcely found outside Attica; while the rich markets of the West in that period are dominated by Corinthian. The crisis at Athens was resolved by the political and economic measures of Solon, statesman, philosopher and poet. His political reforms soon came to little, though they were held the basis of fifth-century Athenian democracy,

ATHENIAN JAR, FROM GRAVE AT ATHENS. END OF 7th CENTURY B.C. HERAKLES AND NESSOS; GORGONS RUNNING OVER SEA (DOLPHINS); ON LIP AND HANDLES, BIRDS. (H. 122 CM.) 1002, NATIONAL MUSEUM, ATHENS.

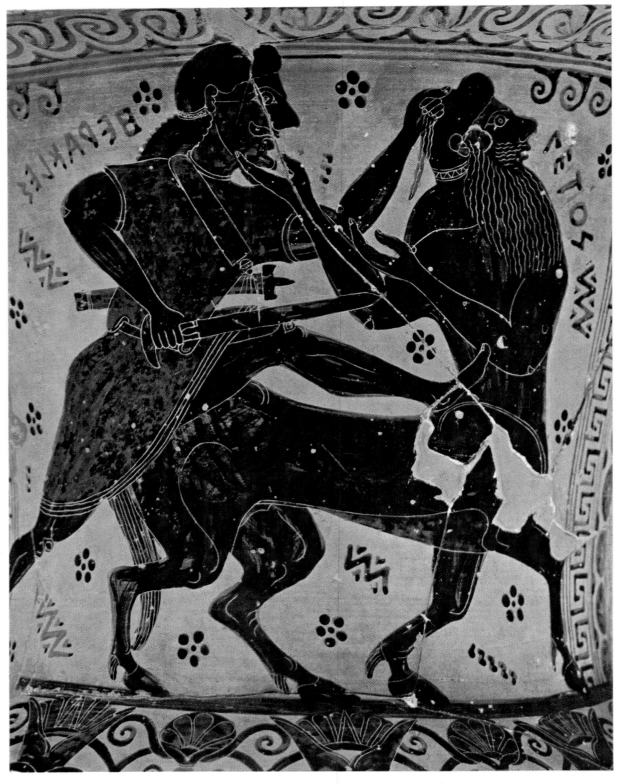

ATHENIAN JAR, DETAIL, FROM GRAVE AT ATHENS. END OF 7th CENTURY B.C.
HERAKLES KILLING THE CENTAUR NESSOS. (H. OF PICTURE C. 27 CM.) 1002, NATIONAL MUSEUM, ATHENS.

but his economic devices put the city on the road back to prosperity. They included encouragement of craftsmanship and trade, partly by making it worth the while of good foreign practitioners to settle in Athens. During the early sixth century Athenian and Corinthian pottery come particularly close to one another, and there can be little doubt that Corinthian potters came to Athens and helped their new home to win the markets from their old; for by the middle of the sixth century Athenian pottery has flooded the West (and is exported also over all other parts of the ancient world) and Corinth has ceased to produce fine figured wares.

The battle for the markets seems to have been fought rather on mass-production than on quality; at least there is no Athenian pottery of the first quarter or so of the sixth century to compare with the best of what went before or what comes after. Biggish vessels were still produced, but from now on a height or breadth of about two feet is the limit; and during this phase even such large vases are usually decorated with friezes of quite small figures and animals in the same often mechanical and not very careful style as is used on smaller pots.

A piece of average quality (there is better drawing on others) but unusually bold in theme is shown on p. 58. It is a fragment from a large round mixing-bowl. Friezes of animals and floral ornaments, of the kind popular since the first impact of eastern influence, adorn the rim and the lower part, but they are conventionally drawn and the painter's interest is concentrated in the broad band on the shoulder: a race of four-horse chariots, which probably went all round the vase, interrupted only at one point by the spectators on the grand-stand. One of them is named: Achilles; and on the other side of the grand-stand are two inscriptions of a kind we have not met before: "Sophilos painted me. Patroclus' funeral games." Potters' signatures occur earlier, though not in Athens, and the potter may in those cases have been also the decorator of the vase; but Sophilos is one of the first Greek vase-painters whose name we know for certain. Timonidas of Corinth was about his contemporary. His writing is untidy and his spelling shaky, but he evidently liked the written word, for it is extremely rare to find a vase-picture given a title. He may have been influenced by the practice in wall or panel painting—we know of one great fifth-century wall-painting that had its title written on or under it in a verse—and his painting too seems to show such influence. In black-figure, women's skin is generally painted white over a black undercoat. Sophilos on other vases lays the white straight on the clay within a red outline, a practice of free painting, as we saw, both earlier and later. The white horse is so treated here, and the inscriptions too are in red. The bold idea of showing the grand-stand with the spectators might also be borrowed from a large composition; but work of this quality and character can give us no impression of what such painting was like.

Dating of works of art at this time is still somewhat schematic, but we are now in a historical period (though one on which our information is sketchy and unreliable), and the range of doubt is less than in earlier ages. During the second quarter, probably, of the century a wonderful revival takes place in Athenian pottery. It goes with a general flowering of art in Athens which seems to have reached its acme under the rule

FRAGMENT OF ATHENIAN BOWL, FROM PHARSALUS (THESSALY). FIRST QUARTER OF 6th CENTURY B.C. SIGNED BY
PAINTER SOPHILOS. FUNERAL GAMES OF PATROCLUS; ANIMALS. (H. OF MAIN PICTURE 8 CM.)
15.499, NATIONAL MUSEUM, ATHENS.

FRAGMENT OF ATHENIAN DRINKING-VESSEL (KANTHAROS) DEDICATED ON THE ACROPOLIS. SECOND QUARTER OF 6th CENTURY B.C. SIGNED BY POTTER-PAINTER NEARCHOS. ACHILLES PREPARING FOR BATTLE. (H. 15 CM.) ACR. 611, NATIONAL MUSEUM, ATHENS.

ATHENIAN JAR, DETAIL, FROM VULCI (ETRURIA). THIRD QUARTER OF 6th CENTURY B.C. SIGNED BY POTTER-PAINTER EXEKIAS. THE DIOSCURI AT HOME. POLYDEUCES AND LEDA. (H. OF PICTURE 26 CM.) 344, MUSEO ETRUSCO GREGORIANO, VATICAN.

of Peisistratos. This aristocrat made himself 'tyrant' at the end of the sixties, and though his rule was not unbroken he and his sons controlled Athens for most of the rest of the century. During the seventh and sixth centuries many Greek states went through such a political phase, one member of the ruling class seizing power to himself and often bequeathing it to his sons. Under Peisistratos the Acropolis was adorned with architectural and sculptural monuments by Athenian and other artists—signatures of sculptors from eastern Greece and the Peloponnese have been found there. Painters no doubt worked there too, and it is possible that potters and vase-painters from east of the Aegean settled in the city at this time, as Corinthians earlier, but the development of Attic vase-painting is essentially within its own tradition.

The beginnings of the revival are particularly associated with the names of Ergotimos and Kleitias, potter and painter of the famous 'François vase', who have left their names together also on small pieces. Their work, however, is essentially miniaturist; even the big mixing-bowl in Florence is decorated with dozens of small figures in many friezes. The miniature style has a future, but it is not the main line of Athenian vase-painting. A much more monumental tradition runs beside it which, though it is in black-figure and is essentially a vase-painter's style with no direct relation to major painting, yet in character approximates to that. The fragment shown on p. 59 is by a contemporary of Kleitias and Ergotimos, Nearchos, who sometimes like them worked in miniature, and whose sons, like a son and grandson of Ergotimos, continue the miniature tradition. On this, however, and on another fragmentary vase, he combines with their exquisite detail a simple bigness of form that recalls the Nessos vase of a couple of generations before, and a subtlety of feeling that is wholly new.

The big straight-walled drinking-vessel from which the fragment comes was dedicated, like many other superlative pieces, on the Acropolis. The upper border (and another below) were exceptionally painted white, with black and red adornments, but the colours have flaked badly. The white freely used in the picture has suffered much too, but the quality outsoars that and the ugly fragmentation. As in the Nessos picture the sculptural figures overlap the border. A chariot is being harnessed. Three horses are already in, and the master stands at their head, making much of one, while an old man brings up the fourth. It is a favourite *genre* scene later in the century, but is marked here as heroic by the armour (the Greeks of historical times did not use chariots in war) and by the name written beside the warrior: once more Achilles. He wears only corselet and greaves, both originally white, but parts of a helmet, spears and a white sword-hilt can be seen behind him. A joining fragment shows that these and a big shield of heroic form were carried by a woman. This, then, is the moment in the Iliad when the hero's mother Thetis and her sister sea-nymphs come to him with the armour made by the smith-god Hephaestus. Achilles, after a bitter quarrel with King Agamemnon, had retired to his tent; but when, the Greeks hard pressed, his bosom friend Patroclus had begged to be allowed to fight, he let him go and lent him his own armour. Apollo, who loved the Trojans, had torn the protection from Patroclus, and Hector had killed him and taken the armour. Now Achilles is preparing to go out to avenge his friend. He killed

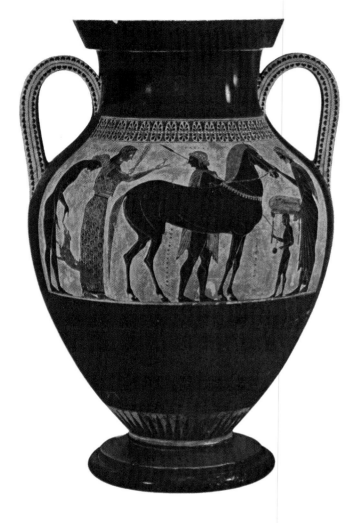

ATHENIAN JAR, FROM VULCI (ETRURIA). THIRD QUARTER OF 6th CENTURY
B.C. SIGNED BY POTTER-PAINTER EXEKIAS. THE DIOSCURI AT HOME.
(H. 65 CM.) 344, MUSEO ETRUSCO GREGORIANO, VATICAN.

Hector, and afterwards buried Patroclus and held over his grave the games illustrated
by Sophilos. The old man is almost certainly meant for his tutor and friend, Phoenix.

For all the minute detail of the engraving there is not only a monumental simplicity
in the forms but a gravity which convinces one that great and tragic events are in hand;
an anticipation of classical feeling rather rare in archaic art and expressed also in the
choice of moment: a quiet action between crises. This subtlety, as well as the sure hand-
ling, contrasts fascinatingly with still very primitive elements in the rendering of
observation: the hands, for instance, and the way the bottom of the cuirass is shown
in full front view above the profile legs, while the relation of shoulders and breast is
gallantly but awkwardly tackled. Unusual care is shown not only in the engraving but

throughout execution and plan. White is laid, as normally, over black, but on the fourth horse (and on the woman on the other fragment) a black outline is carefully left. There are also traces of elaborate preliminary sketching, not only for the pictures but for the inscriptions too.

The horses' names are written as well as those of the human or divine participants. Only two survive, and they are not those given in the Iliad. Homer knew of only two horses for a chariot, the sixth-century vase-painter of four, and it is possible that the other two had the Homeric names. The firm letters, very different from Sophilos' scrawl, are in black. In front of Achilles is the inscription: "Nearchos painted me and..."; it breaks off, but no doubt ended "made me", for he signs other vases as a potter.

ATHENIAN JAR, FROM VULCI (ETRURIA). THIRD QUARTER OF 6th CENTURY B.C. SIGNED BY POTTER AMASIS. DIONYSOS AND MAENADS; ON SHOULDER, BATTLE. (H. 33 CM.) 222, CABINET DES MÉDAILLES, PARIS.

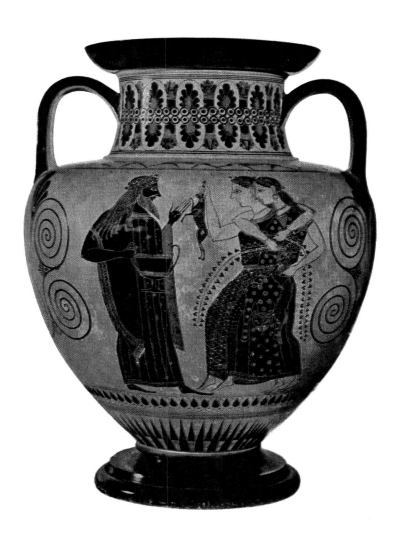

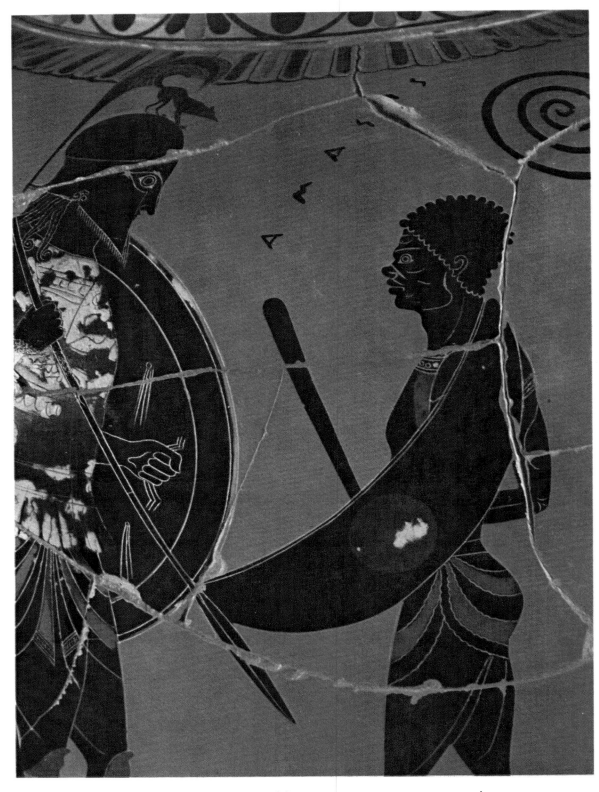

ATHENIAN JAR, DETAIL. THIRD QUARTER OF 6th CENTURY B.C. ONE OF MEMNON'S NEGRO SQUIRES. (H. OF DETAIL C. 18 CM.) B 209, BRITISH MUSEUM, LONDON. (JUST OVER NATURAL SIZE)

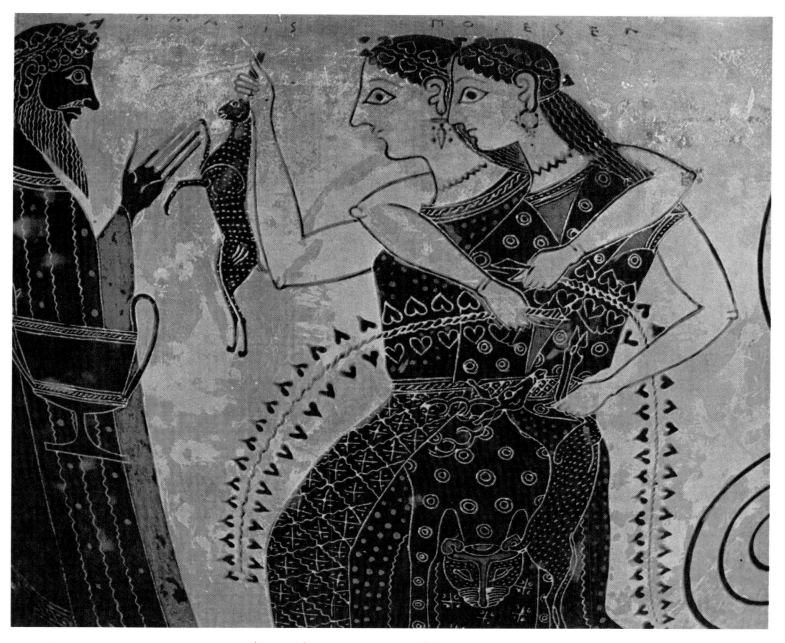

ATHENIAN JAR, DETAIL, FROM VULCI (ETRURIA). THIRD QUARTER OF 6th CENTURY B.C. SIGNED BY POTTER AMASIS. DIONYSOS AND MAENADS. (H. OF DETAIL C. 13 CM.) 222, CABINET DES MÉDAILLES, PARIS. (OVER NATURAL SIZE)

Another artist who signs in both forms is one who carries on the style of Nearchos, his pupil one would say, the only other black-figure painter to achieve the same kind of gravity and the one whose style seems to bring the technique to its most perfect realization; the greatest, perhaps, of Greek vase-painters: Exekias. His picture on the big jar shown on pp. 60 and 62 has much in common with that by Nearchos we have just looked at. Here too a scene of ordinary life is raised to heroic level not only by the inscribed names but by a grave nobility in the figures and in the whole composition,

ATHENIAN CUP FROM VULCI (ETRURIA). THIRD QUARTER OF 6th CENTURY B.C.
SIGNED BY POTTER TLESON, SON OF NEARCHOS. HUNTER. (D. OF PICTURE
WITH BORDER 7.5 CM.) B 421, BRITISH MUSEUM, LONDON. (OVER NATURAL SIZE)

which does not obscure a charming observation of natural action. There is no hint of tragedy here, though elsewhere the artist shows that he can compass that too. This is a family scene: the Dioscuri, Castor and Polydeuces (Pollux), with their mortal parents Leda and Tyndareus. They were (it is the meaning of the name Dioscuri) children of Zeus, who took their mother as a swan; but the seedlings of the gods are always in Greek mythology regarded as being also an integral part of their mortal family, belonging to the father as much as to the mother. Castor was a great horseman, and he stands beside his steed, named Kyllaros, in a cloak, spear on shoulder. He turns to his mother who carries twigs in one hand and stretches out a flower to him in the other. The father strokes the nose of the beautiful beast. Behind Leda Polydeuces stands naked, playing with a dog which jumps up. A little slave-boy has oil-bottle, garment and stool ready for him. The dog's action, and the little boy with clean things, suggest that Polydeuces has just arrived home. Castor, one would rather say, was setting out, his parents bidding him farewell, but one cannot be certain. The child is drawn under the horse's nose, but his burden is painted across Tyndareus' arm, so he is thought of as nearer us. The four principals wear berried wreaths. The men's long hair is looped up behind; Leda wears

66

hers loose, like Achilles in Nearchos' picture. The white of Leda's skin, the dog and the stool has darkened, and the surface of the clay has suffered, but again the quality of the work is triumphant over time. As with Nearchos, the exquisite refinement of detail does not obscure the large and simple design and the subtle feeling.

Exekias' lettering is as firm and clear as his master's but smaller and neater. The signature is on the mouth of the vase. Between the horse's hind-leg and Castor runs an inscription of another kind: "Onetorides is beautiful". Such praises are common from this time on, sometimes of popular favourites, sometimes of the personal loves of the vase-painters (boys more often than girls), sometimes in a generalized form: "The boy (much more rarely 'the girl') is beautiful"; a suitable motto for a present. The practice was not confined to vase-painting: a century later Pheidias was said to have cut the praise of a beloved boy on the ivory thumb of his colossal Zeus at Olympia; and Aristophanes speaks of such words on walls.

The form of this vessel is new. The big jars we have met so far (pp. 34, 42, 55) are of the kind we call 'neck-amphora', with the neck set sharply off from the body. Here neck and body form a continuous double curve between offset lip and foot. This type, generally called simply 'amphora', comes into Athenian pottery about the beginning of the sixth century, reaches its greatest popularity during the second half, and declines during the first half of the fifth. Most of the vase not occupied by the actual pictures is painted black, while the neck-amphora, which continues popular though reshaped, is covered with bands of pattern.

Exekias made and painted neck-amphorae, and the detail on p. 64 is from one, not signed but certainly his work. The negro soldier is one of two in attendance on a tall hero: Memnon, mortal son of the goddess Eos, the Dawn, who came to Troy and was killed by Achilles. Their combat, the immortal mothers in anxious attendance, is often shown. Memnon, of unsurpassed beauty, was king of Ethiopia. The Greeks did not admire negroid features, so the hero is generally given a classical visage and a negro companion: so here, and in the next century in Polygnotos' great wall-painting of the Underworld, as we know from a description. The figure here is labelled Amasis, a foreign name, but borne by the other leading potter of this generation. Exekias gives it once again, or a variant of it, to a negro, and it may be a joke against his rival. The neck-amphora illustrated on pp. 63 and 65 is inscribed "Amasis made me". The name appears on many vases all decorated by one man, who may have been the potter himself (so Nearchos, Exekias) or his regular partner, as Kleitias was of Ergotimos. Exekias and Amasis worked at the same time, probably mainly after the middle of the century, and Exekias' neck-amphorae resemble this in general proportion and in the decorative scheme: light ground with zones of pattern—the Geometric tradition; but they are rounder, with heavier lip and simpler foot, the shoulder less flat. The separate little picture on the shoulder is sometimes found in Exekias' work, but seems more in harmony with this painter's approach. He loves elaboration for its own sake, and has less feeling for the simple underlying form and no concern with a deeper content. His work is always decorative, sometimes a little dull, at his best enchantingly gay. Dionysus and his crew

become a favourite theme of vase-painting from the early sixth century—suitably, since so many vases were for storing or mixing wine or to drink it from. No rendering of the theme is more pleasing than this, where two maenads, ivy-branches and animals in their hands, dance up to the wine-god with their arms about each other's necks.

This painter often preferred outline drawing to the usual white for women's skin, and time has proved him wise. We saw that black-figure prevailed from a feeling that silhouette was more suitable than outline for vase-decoration, but outline never dies out. In Athens during the sixth century it is comparatively rare, but was later revived to magnificent effect, as we shall see in later chapters. At this time it is more freely used in other centres. An example which compares amusingly with the Athenian is that on p. 70, the inside of the wide, shallow bowl of a stemmed drinking vessel *(kylix)*. This was made in Sparta, about the same time as the other in Athens, and shows the sons of the North Wind chasing off the Harpies from robbing and fouling the table of the blind king Phineus—an adventure on the voyage of the Argo. A break in the centre has carried away the forward legs of the wind-gods, who overlap each other so closely that at first glance they appear only one figure. The defeated fiends, drawn in outline, are more clearly differentiated. The sphinx below is perhaps, so far as subject goes, a separate picture. By all accounts that we have, the Harpies were immortal and escaped; but I am not sure that this vase-painter thought so, and the sphinx for him may have been a symbol of their doom.

Spartan pottery was always rather provincial, looking in the seventh century to Corinth, in the sixth to Athens, till it peters out. Even the soundest work—this is as good as any—lacks the strength and the subtlety, as well as the finesse, of the best Athenian, but it has a character of its own. The clay is normally covered with a white slip, and the favourite shape is the kylix, the picture covering the whole interior within a narrow border, often as here of stylized pomegranates. On Athenian cups the picture is more often confined to a small tondo in the centre, framed with alternate black and red 'tongues' (a leaf or petal-pattern in origin) between fine concentric circles. The pretty picture on p. 66, from a very small cup, shows a successful hunter, hare and fox slung behind him, his dog on a lead. The cup is signed "Tleson son of Nearchos made", and many such cups bear the same signature, mostly seeming decorated by the same painter, whether Tleson himself or another. They belong to a large class of exquisitely shaped cups, signed by many different potters and decorated in a style that is miniature in feeling as well as scale. It would take more than an inscription to make this into a heroic hunter, Orion or Actaeon. They are a side-line in the history of Greek painting, but a very charming one.

Two other cups of this period in which virtually the entire interior of the bowl is covered with a picture are shown on pp. 69 and 71. The first was made somewhere east of the Aegean, perhaps Samos or Rhodes, and is painted in a version of black-figure current there, in which engraved lines are avoided and details left in the background colour when the silhouette is painted in: a simplified, blobby effect. East Greek vase-painting in general is less sophisticated, more simply decorative than most, less concerned

EASTERN GREEK CUP, FROM ETRURIA. MID 6th CENTURY B.C. MAN AND TREES.
(D. 23.5 CM.) F 68, MUSÉE DU LOUVRE, PARIS.

LACONIAN (SPARTAN) CUP, FROM CERVETERI (ETRURIA). MID 6th CENTURY B.C.
BOREADS PURSUING HARPIES; SPHINX. (D. 18.5 CM.) MUSEO NAZIONALE DI VILLA GIULIA, ROME.

ATHENIAN CUP, FROM VULCI (ETRURIA). THIRD QUARTER OF 6th CENTURY B.C. SIGNED BY POTTER EXEKIAS.
DIONYSUS ON A SHIP. (D. 33 CM.) 2044, STAATLICHE ANTIKENSAMMLUNGEN, MUNICH.

with fine drawing; more, perhaps, what we expect pottery decoration to be. This, however, is an altogether exceptional design. Greek art now and for long after is insensitive to nature; never reflects it with the intense interest of Minoan or Egyptian. It is not so reflected here; but to fill the circle with the leafy branches of two trees is unparalleled. On one stands a bird, and a second flies with an insect in its mouth to a full nest in the fork of the other, which is also approached by a snake. On another branch is a grasshopper or cicada. Between the trees is a man, grasping a branch of each, but the arrangement is so schematic that the action is not clear. The feet of the flying bird point the opposite way to those of the man, and the trunks rise in opposite directions at right-angles to this axis, so that the picture may be legitimately looked at from all four cardinal points. In later and more sophisticated cup-tondos there is often a deliberate slight ambiguity about the exact position of top and bottom—the circular vessel is meant to be turned in the hand; but this is different.

With the kylix on p. 71 we return to Athens and to Exekias. The ground here is a bright sealing-wax red, achieved by a special firing of the same substance in which the picture is painted and fired black; a complicated process used occasionally for special pieces from this time on. Again the figure is small, the setting exceptionally important, but the effect is totally different. This is a far more conscious work of art; but in neither picture, though both painters are unusually concerned with setting and both have abandoned the usual convention of a ground-line, is there the faintest attempt to render the actual organization of objects in space. Trees grow from earth, are seen against sky, but you would not guess that from the plain background against which the separate elements are so decoratively set in the East Greek cup. The elements in the other are more cunningly integrated and related to a constant vertical and horizontal, but there is no horizon and the shiny red ground does duty alike for the sky and the sea across which the wine-god sails in his little ship, a laden vine wreathing the mast, dolphins leaping about it. A story is told in a hymn to Dionysus, how he was seized by pirates but suddenly revealed himself: the ship ran with wine, vine and ivy sprouted from the mast, a bear appeared and the god himself turned into a lion and seized the captain; the terrified crew dived into the sea and were turned to dolphins, except the helmsman who had recognized the godhead and tried to turn his comrades from their blasphemy; him the god saved. There may be allusion to this story here, or it may be rather a symbolic picture of the god's journey across the world. Other ships in black-figure ride a conventional, wavy-topped black sea. The confounding here of sea and sky helps to give this picture its magical quality, unlike anything else in Greek art and hardly dimmed by the flaking of the white from the sail and the damage to the god's face.

Most of the finest vase-painting in the sixth century is Athenian, but the great majority of craftsmen even in Athens were naturally not of the calibre of Nearchos or Exekias, or even of the painter who decorated the vessels made by Amasis. There is much mere bad hack-work; much that is pretty but slight, like Tleson's cup (p. 66); much also that lacks finesse but has often good decorative quality. Such is the vase shown on p. 73, painted in the circle of Exekias, with a labour of Herakles: his destruction

of the predatory birds of Lake Stymphalos. The hero with his sling is a large, simple figure; and the birds, their plumage gaily splashed, sailing the water or rising about him with a clangour (one feels) of wings and cries, make one hesitate to repeat that Greek painters had no feeling for nature, though it is nature curiously transformed.

Outside Athens, Corinthian vase-painting virtually ceases before the middle of the sixth century; and during the second half all other rivals gradually go out of production. We have glanced at cups from Sparta and East Greece. To the second half of the century

ATHENIAN JAR, DETAIL, FROM VULCI (ETRURIA). MID 6th CENTURY B.C. HERAKLES AND THE STYMPHALIAN BIRDS. (H. OF PICTURE 18.5 CM.) B 163, BRITISH MUSEUM, LONDON.

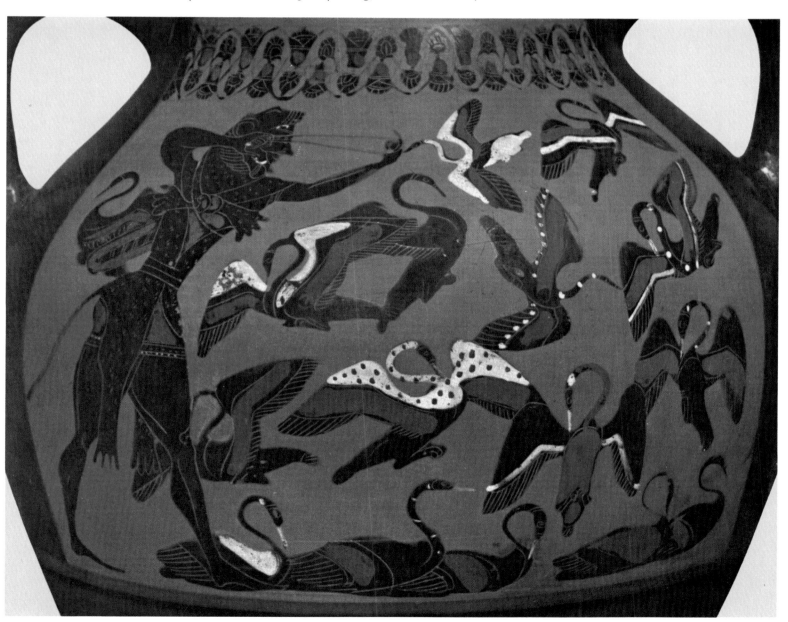

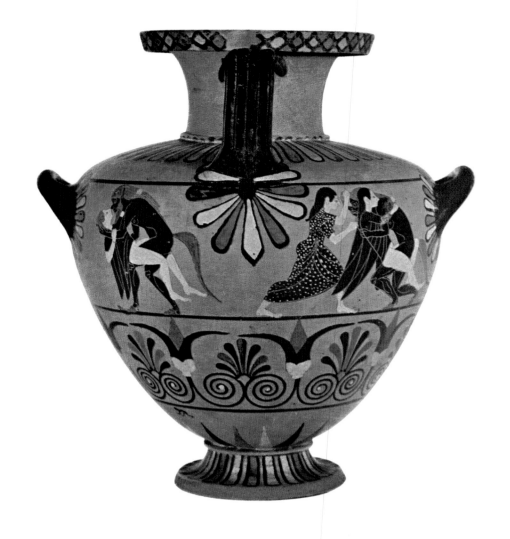

CAERETAN HYDRIA (WATER-POT), FROM CERVETERI (CAERE, IN ETRURIA). SECOND HALF OF 6th CENTURY B.C. BACK: SATYRS AND MAENADS. (H. 41.5 CM.) 3577, KUNSTHISTORISCHES MUSEUM, VIENNA.

belong several short-lived groups of black-figure, whose origin is uncertain but which include fine work. All seem rooted in earlier styles of eastern Greece, but are influenced by Corinthian and especially by Attic. It is likely that some or all were made in Greek colonies in the West or by Greek settlers in Etruria. During this time Cyrus was extending the Persian empire over Asia Minor as well as far and wide in the East. In 546 B.C. Croesus of Lydia fell to him, and after that the Greek cities of the coast and later the islands of the eastern Aegean. The peoples of Phocaea and Teos abandoned their cities in a body, to found new ones elsewhere, and many individuals must have emigrated at the same period; the influence of East Greek artistic ideas is prevalent all over Greece and in Etruria during the late archaic period.

The vases illustrated on pp. 74-77 belong to the latest and finest of these groups, known as the 'Caeretan hydriai'. Some thirty vessels of the class are known, all of one shape, a particular form of *hydria* (three-handled water-pot). All whose place of finding is known are from Etruria, most from Caere, the modern Cerveteri. A high proportion of all Greek vases that survive complete come from Etruscan tombs, but the total lack of even fragments of this type from elsewhere suggests that they may have been made in Caere, which had a Greek quarter, Agylla. One bears Greek inscriptions, and they are certainly Greek and not Etruscan work, products of one workshop and most likely painted by one man.

As with contemporary Athenian neck-amphorae, none of the vase here is painted black. The floral chain in the subsidiary frieze, however, is very unlike Attic work: bigger, bolder and more colourful; and red and white are in general more freely used on these vases both in the pattern-work and the pictures. In what is perhaps the master-piece of the class (p. 76) red and yellow are used for men's skin, suggesting influence from free painting; and this picture is in fact a parody of a wall-painting or relief, not Greek or Etruscan but Egyptian.

On one of his journeys Herakles came to Egypt where, the Greek story said, the king Busiris used to sacrifice strangers to Zeus. The worthy Greek was led to the altar before he realized what was happening, but then he turned on his captors. In this picture the king in his snake-crown lies fallen on his face by the altar. Six of his white-robed minions, yellow and black, are caught at once by the full-blooded hero: one in each hand, one in the crook of each elbow, one under each foot. Another flees to the altar, on which two more have taken refuge while a tenth crouches behind it. The scene is unquestionably a well-informed skit on Egyptian representations of Pharaoh subduing his enemies. There were at this time Greek settlements in the Nile delta, where it is likely though not certain that Greek pottery was produced. This painter must, one would say, have visited Egypt.

The vigorous, expressive drawing carries out the amusing idea perfectly. Humorous subjects and light-hearted treatment prevail on these pots. That on pp. 74 and 77 (which is in fresher condition) takes up a favourite theme: the return of Hephaestus to Olympus. The god was born lame, and his mother Hera, disgusted, flung him out of heaven. He fell into the sea and was nurtured by the nymph Thetis, who was to marry a mortal and become the mother of Achilles. He grew up to become the most skilful of craftsmen, and it was in gratitude that he made Thetis the suit of armour she was bringing to her son in the picture by Nearchos. One day he made a beautiful throne, and sent it as a present to his mother in heaven. She sat down on it, and found she could not rise. No one could release her, though Zeus offered the hand of Aphrodite to anyone who should. At last Dionysus contrived to make Hephaestus drunk, and brought him back to Olympus where he freed Hera, married Aphrodite and settled down. The subject is popular from early in the sixth century: the tipsy smith-god on a mule, Dionysus and his crew accompanying him on foot. Generally Hephaestus is already a bearded man; here a barecheeked boy still. His skin is painted white like a woman's; but so is that

of the bearded Dionysus, and it is probably only a decorative variation, as on the Athenian vase of more than a century before (p. 45) and occasionally on work of the intervening period both from eastern Greece and from Corinth. Hephaestus' lameness is carefully shown in a club foot, which is unusual. More of Dionysus' followers appear on the back of the vase (p. 74), too busy to join in the procession: on one side of the handle a satyr with a maenad or nymph; on the other the same, a second girl intervening. Satyrs and silens, ribald creatures with snub noses, bushy beards and the ears and tails of horses, come into Greek art in the wine-god's train at about the beginning of the sixth century. They remain a favourite theme till, with the goatish Pan who comes in rather later and the Centaurs who had been there since Geometric times, they are degraded into devils by Christianity. Here they have horses' hooves, an East Greek tradition; Athenian satyrs have generally human feet.

The indulgence in colour, which distinguishes these vases from contemporary Athenian work, relates them to the last phase of figure-painting on Corinthian pots; which, however, seems to come to an end before these begin. On them the Corinthian potters cover their naturally pale clay with an orange slip, to simulate the effect of Attic, but the style remains their own. A detail from one such vessel is shown on p. 80. A woman in bed sits up naked from her wraps and raises eye and hand pleadingly to a man who

CAERETAN HYDRIA (WATER-POT), DETAIL, FROM CERVETERI (CAERE, IN ETRURIA). SECOND HALF OF 6th CENTURY B.C. HERAKLES IN EGYPT. (H. OF PICTURE 15.5 CM.) 3576, KUNSTHISTORISCHES MUSEUM, VIENNA.

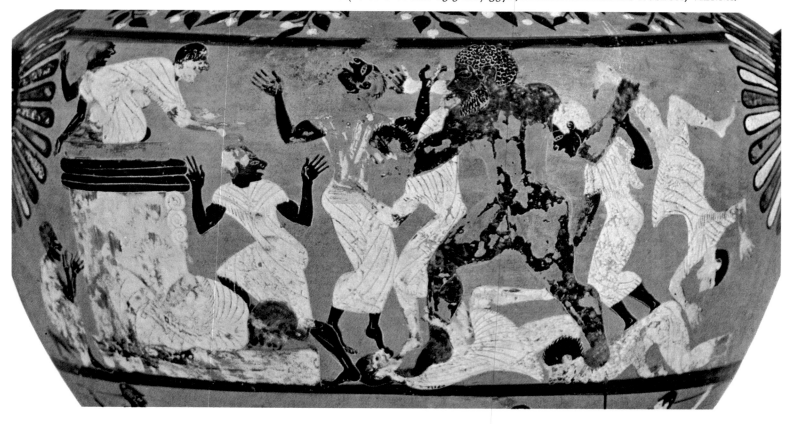

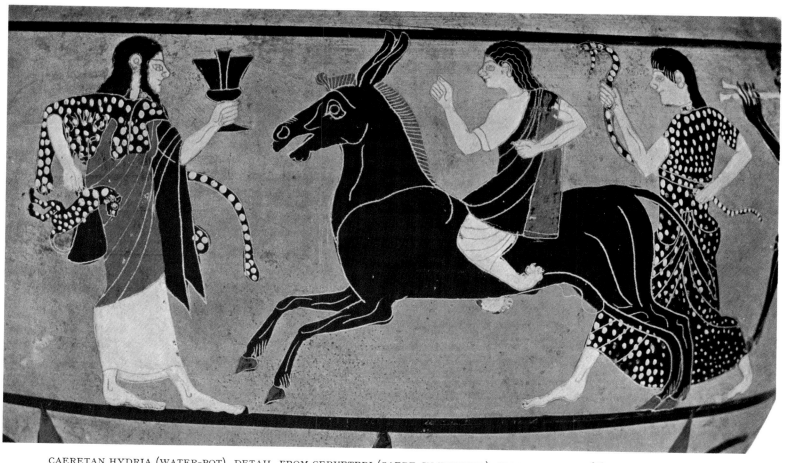

CAERETAN HYDRIA (WATER-POT), DETAIL, FROM CERVETERI (CAERE, IN ETRURIA). SECOND HALF OF 6th CENTURY B.C. FRONT: DIONYSUS AND HEPHAESTUS. (H. OF PICTURE 15.5 CM.) 3577, KUNSTHISTORISCHES MUSEUM, VIENNA.

advances against her with drawn sword. Their names are written beside them, from right to left in the Corinthian alphabet: *Hysmena* and *Tydeus*. Behind Tydeus a man, Periklymenos, naked and unarmed, flees away, looking behind him. He is painted white. Corinthian artists of this time, like the later Caeretan, use white sometimes as a purely decorative variation; but Periklymenos here is playing a sorry part, and the colour may indicate his lack of manhood. A black horseman beyond Periklymenos, and a white dog under the bed which makes no move against the intruder, are hardly part of the story. Corinthian vase-painters of this time are very free with horsemen and dogs. The first will be here a separate picture, put in because the main scene did not quite fill the space available; while the dog adorns the empty rectangle, like the creatures under the bier in the Geometric wake of two hundred years before. Such devices are found at times throughout archaic art. They are particularly common in late Corinthian vase-painting, where decoration and narrative are less integrated than in Athenian.

A poet, Mimnermus, of probably rather earlier date than the vase-painter, is said to have written how Tydeus killed Ismene at Athena's behest, but nothing is recorded of the cause or circumstances. Tydeus was a famous fighter, but no Paladin. In another

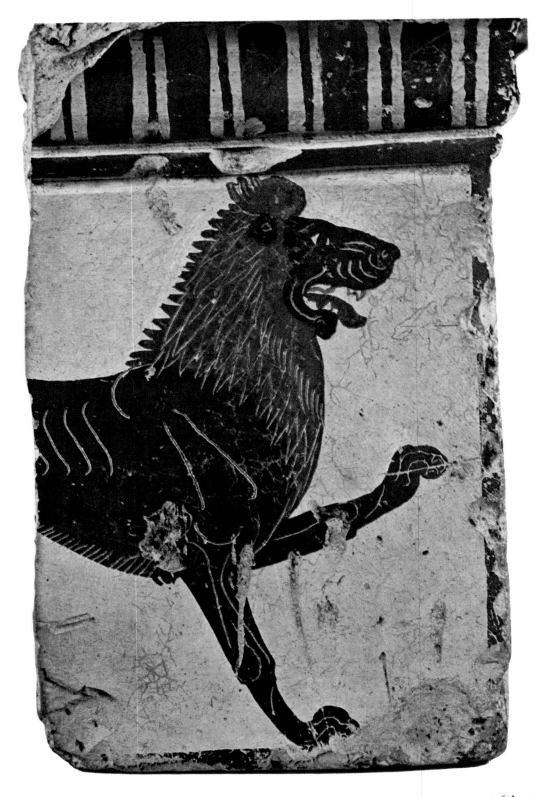

FRAGMENT OF CORINTHIAN PORTABLE ALTAR IN CLAY, FROM CORINTH. SECOND HALF OF 6th CENTURY B.C. LION. (H. OF PICTURE 8.8 CM.) MUSEUM, CORINTH. (OVER NATURAL SIZE)

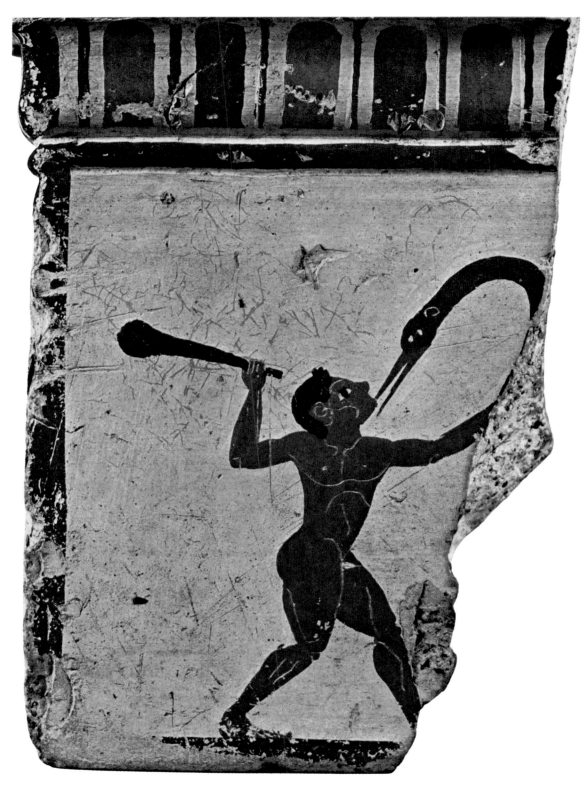

FRAGMENT OF CORINTHIAN PORTABLE ALTAR IN CLAY, FROM CORINTH. SECOND HALF OF 6th CENTURY B.C. PYGMY FIGHTING CRANE. (H. OF PICTURE 8.8 CM.) MUSEUM, CORINTH. (OVER NATURAL SIZE)

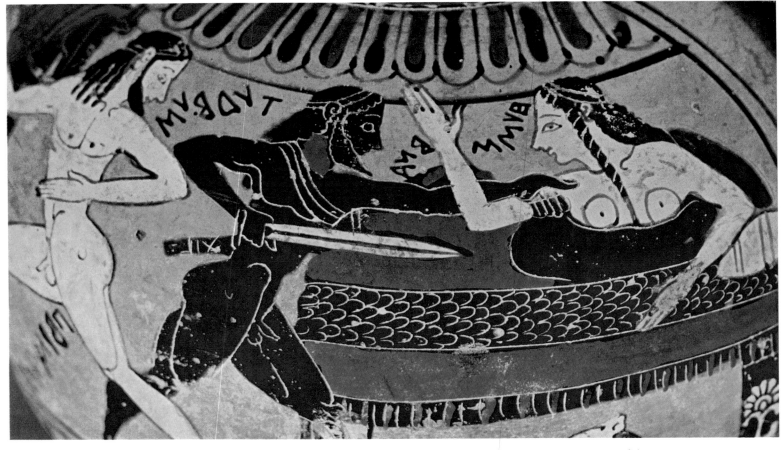

CORINTHIAN JAR, DETAIL, FROM CERVETERI (CAERE, IN ETRURIA). SECOND QUARTER OF 6th CENTURY B.C.
ISMENE KILLED BY TYDEUS. (H. OF DETAIL C. 12 CM.) E 640, MUSÉE DU LOUVRE, PARIS.

story Athena was moved by his extreme prowess to bring him immortality as he lay
dying on the field before Thebes, but he forfeited the gift by an act of disgusting brutality.
The killing here, though ordered by the goddess, seems in character. Hysmena must be
Ismene, and this the tale Mimnermus told; and it affords an interesting commentary
on the development of Greek mythology. We know Ismene well from Athenian tragedies
of the fifth century, especially Sophocles' *Antigone*. She is the daughter of Oedipus and
Jocasta, Antigone's gentle sister, loving and grieving, neither heroine nor accursed,
involved in the fall of her house but the least doomdriven of that unhappy brood. The
battle in which, by all accounts, Tydeus perished was that in which also the sons of
Oedipus destroyed one another, and which precedes the action of the *Antigone*. Whatever
story it was that culminated in the ferocious scene here pictured, was dropped, with
all its implications, allowing the tragedians to recreate the character of Ismene in the
spirit of their time and for their own dramatic ends. This is probably typical of their
use of traditional material, and fifth-century artists showed sometimes a like freedom.
One might guess that in the old story Ismene was a priestess of Athena, who offended
the virgin goddess by betraying her vows with Periklymenos; but it is only a guess.

Figure-work on Corinthian vases stops towards the middle of the sixth century, but tradition suggests that the area remained an important centre of painting. The only painted wooden panels that survive from Greece belong to the second half of the century and were found in a cave near the neighbouring town of Sicyon. They are awaiting publication. Two show parts of large figures, the clothes decorated with exceedingly fine detail; one, pairs of women, seemingly in conversation, most delicately and sensitively drawn; the most complete (rather over a foot long), a family at a sacrifice, with a long inscription recording a dedication to the Nymphs. (They are also named on one of the other fragments; no doubt the cave was sacred to them.) The long inscription on the sacrifice scene is fragmentary. It ends, after a gap, with the words 'the Corinthian', which probably describe the dedicator though it is not inconceivable that it is part of a signature. The essential character of drawing and composition is not different from that of contemporary vase-painting: all figures ranged in simple elevations along the surface plane. No serious change of approach has taken place since the early style of painting that we found echoes of in the last chapter. The quality, too, is not superior to that of the best vase-painting, but the effect is very different. On a white ground a light, bright blue and red predominate. Yellow and black are used discreetly, and a pinkish colour for male skin, outlined in black. Woman's skin is drawn on the white ground in red outline, as on the Thermon metopes and in the work of Sophilos, but the inscriptions are here in black.

Though no figure-decorated vases were produced in Corinth at this time, there is a class of little clay altars with painted decoration, of which the best preserved and most pleasing is illustrated on pp. 78 and 79. We have a fragment, one corner: on one side a lion with the fine heraldic character developed by Greek artists under eastern influence in the seventh century and maintained in the best decorative animal-drawing throughout the archaic period; on the other a pygmy fighting a crane. This seems never to have been a very popular theme, but occurs occasionally in Greek literature and art from the Iliad on. The drawing is not so strong as on the Caeretan hydriai, but the spirit is similar and there is a fine easy freedom in the placing of the figure.

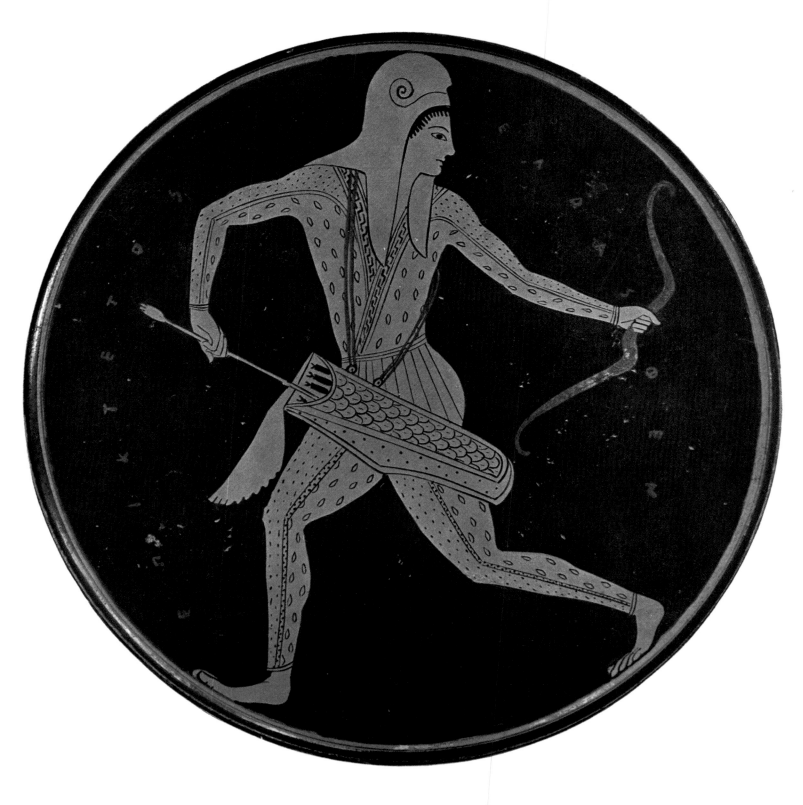

ATHENIAN PLATE, FROM VULCI (ETRURIA). LAST QUARTER OF 6th CENTURY B.C. SIGNED BY PAINTER EPIKTETOS. ARCHER IN EASTERN DRESS. (D. OF PICTURE 13 CM.) E 135, BRITISH MUSEUM, LONDON. (OVER NATURAL SIZE)

LATE ARCHAIC PAINTING

EXEKIAS is an outstanding artist among vase-painters of any time; but the work of that generation in general seems to show black-figure at its acme. At the risk of confusion it must be called a 'classical' moment, when archaic artists have achieved perfect mastery of techniques which perfectly express their intentions and spirit. The spirit of late archaic art is different. The old forms there are shaken and twisted by new feelings, struggling to find expression which they only fully achieve in the classical revolution; and in the process old techniques are found unsatisfying and new ones are developed to replace them.

In vase-painting the change of spirit hardly begins to be noticeable in the first generation after Exekias. His pupils, and those of his contemporaries, continue very much in the manner of their predecessors, only none of them is of equal calibre with the best of those, and one senses the oppression that sometimes follows an age of great masters. Some of them, especially it seems a nameless pupil of Exekias who sometimes worked with a potter Andokides, turned to technical experiment and lighted on a new formula, the technique conventionally known as 'red-figure'.

This method is in principle a reversal of the old technique: the figures are left in the colour of the clay, and the background painted over with shiny black. It is to begin with simply a decorative variation, with certain advantages over black-figure and certain disadvantages. The great advantage is that while keeping the principle of silhouette, which we have seen was so precious to Greek vase-decorators, it allowed a freedom of handling analogous to that of outline drawing. The fact that all detail on the figures in the old technique is engraved makes for an essential formality, which goes with the remoteness from nature of the shiny black surface and is entirely in keeping with the archaic spirit. When the black becomes the background and the figures are left in the light orange of the clay, they are not only immediately nearer to nature in colour, but detail also is put in with a brush or a pen-like instrument in the fluid black: the ordinary process of drawing, which lends itself, and indeed leads, to a suppler line than the graver makes. This line, moreover, can be thinned or thickened, and the black diluted to a brown or golden yellow. All these possibilities are an invitation to the vase-painter to move away from the extreme formalism of black-figure towards a comparative (though still very formal) naturalism, already approached in other painting, as the wooden panels from near Sicyon show. On the other hand the black background isolates the figures in a new

way; but the divorce between vase-painting and painting in other media imposed by the adoption by vase-painters of the black-figure technique begins now to be healed.

The disadvantage of the technique for the ordinary craftsman lies in its difficulty and the more elaborate planning which its execution entails. The whole design has to be outlined, and the painter must determine every detail before he begins the outline; for this broad line (often detectable in the finished picture) must not at any point cross a part which is to be left in the colour of the clay. A preliminary sketch, lightly incised in the surface of the clay, is often found in black-figure; in red-figure it is indispensable. In fact there is no rush from the old technique to the new. In the first generation only a few artists practise it regularly; to the second and third black-figure holds its own. Alongside fine work cheap mass-production of red-figure begins before the end of the sixth century (the invention seems to belong to the third quarter) but black-figure is employed equally for this purpose down to about the middle of the fifth; and in certain specialized uses the old technique survives the new, dying only in the advanced Hellenistic age.

In the work of the early experimenters in red-figure the enfranchisement of style is gradual. By training and spirit these were black-figure artists; stylistically their red-figure is simply black-figure reversed: black lines as sharp and little modulated as engraved ones; a liking for surface pattern; considerable use of added purple-red and white. Some of these characteristics are still present in the charming plate shown on p. 82. There is much surface pattern, not much variation in the black line and no use of thinned glaze; and the bow is drawn over the black in added purple-red. There is, however, a suppleness and freedom, a natural ease, which is wholly foreign to the black-figure tradition and is expressed not only in the inner drawing but in the lively and harmonious contour. Epiktetos, who signs this and many other vases as painter, is one of the first artists evidently brought up to use the new technique. He worked also in black-figure, but with less assurance and only early in his career; he seems really at home in red-figure. This, too, is early; later he discards the old-fashioned elements we noticed here. Bowmen like this in eastern garb are common in Athenian vase-painting from a little before this. Whether they represent mercenaries employed by the tyrants (at a later date the police of Athens were Scythian archers) or are more or less fanciful pictures of outlandish types it is hard to say. Certainly vase-painters often give the same costume to the legendary Amazons.

The plate, not very common in Greek ceramics, is a favourite shape with this painter. A contemporary, who also worked in both techniques, but seems more at home in the older, adorns plates like this, with a single figure as sole decoration, but in black-figure; and the effect is curiously unsatisfying. Comparing the two one realizes that the shiny black, when it is transferred from the figures to the background, becomes in itself a decorative element which makes pattern-work superfluous. There is much beautiful red-figure ornament, but alongside richly patterned vases one finds others on which the whole adornment is the marshalling of the figures against the black. This, which is part of the beauty of red-figure, is however something which keeps it further away from painting on wall and panel. Those, like black-figure, were on a light ground.

At this period, when all painting is strictly surface-bound and artists are not interested in exploring the third dimension, the distinction, though real, is not of great importance; it becomes so later.

If the perfection of black-figure and the classical moment of archaic art come in the Athens of Peisistratos, the new movement in art is paralleled by a political upheaval in which his son was expelled from the city. This occurred in 510 B.C., and was achieved with military help from Sparta by exiled aristocrats. After a few years of civil disturbance and renewed Spartan intervention one of these aristocrats, Cleisthenes, drew up and succeeded in establishing the democratic constitution which, little modified, fostered the classical flowering of Greek civilization in the coming century. In 499 B.C. the Ionian cities of Asia Minor revolted against Persian rule. Of the cities west of the Aegean only Athens and one other (Eretria in Euboea) sent help. The revolt was put down, and in 490 the Persian king Darius sent a punitive expedition which, subduing the Cycladic islands on its way, burned Eretria and landed in Attica. The Athenians, however, defeated the Persians at Marathon, a victory which made an enormous impression at home and abroad. Ten years later Darius' son Xerxes invaded Greece with the intention of adding the whole country to the Persian empire. After the betrayal of the pass at Thermopylae and the chosen destruction of the Spartan force there, all of Greece north of the Isthmus of Corinth was subdued by the Persians or abandoned to them. The majority of Athenians evacuated their city, which was twice sacked, in 480 and 479 B.C. The Persians were defeated in those years by sea and land, the Athenian fleet playing the principal part at Salamis, the Spartan army at Plataea. When Athens was re-occupied, the débris of the Persian sack, architectural members, sculpture, painted pottery, was thrust into new walls and the foundations of new buildings. These fragments give us much of our knowledge of archaic art and a fixed point of dating. It is roughly to the thirty years between the expulsion of Hippias and the evacuation of Athens before Xerxes that the works discussed in this chapter belong; on a background of the difficult establishment of the democracy, justified by the glory of Marathon (where Hippias was with the Persian fleet), and the looming threat of absorption in the Persian empire. To make a close connection between political events (or even social circumstances) and artistic developments is rarely convincing, but to deny any is arbitrary. It is hardly chance that this disturbed period, culminating in victory, saw in art the questioning of archaic formulae and the beginnings of the classical revolution, one of the most significant movements in the history of European art.

Good artists still practised black-figure in the earlier part of this time, the last decade or so of the sixth century, and the vase illustrated on pp. 86 and 89 shows how different is their approach from that of Exekias and his contemporaries. The shape is the hydria, the three-handled water-pot we met earlier in the Caeretan vases, but a different form of it. Round-bodied vessels vaguely like those had been current earlier in Athens, but the normal form in black-figure of the second half of the century is this angular type. Often these water-pots are decorated with scenes at the fountain, illustrating their use. Water was not laid on to Greek houses, and the fountain-house was

one of the centres of life. In this picture three of the vessels in use are of the angular form, two of a new round form in which the neck curves unbrokenly into the body, shown one in profile, one from the front. This round form is known also in many actual vessels from this period and later, but decorated almost exclusively by red-figure painters, who also use the other for a time but it goes out. By now the two traditions are diverging, and potters and painters who prefer red-figure often use new shapes or modifications of old ones. The earliest red-figure tends to be on amphorae and other vases which were normally already covered largely with black. The neck-amphora, which in black-figure is a light-ground vase with pattern bands, is only taken regularly into red-figure towards the end of the century, and then in a drastically modified form. *Hydria*, unlike 'amphora', is a word which we know was actually used by the Greeks for vessels of this type.

Scenes at the fountain-house are particularly well suited to hydriai of the angular form, not only because of the use of the vessel but because the straight edge of the sharp shoulder at the top of the main picture is satisfactorily emphasized by the architectural entablature supported on columns and walls which frame and divide the scene. Such scenes seem first to be so used in the generation that saw the invention of red-figure. A pretty example is shown on pp. 87 and 88, showing the fountain-house in another of its uses, as public baths. The men have hung their clothes and oil-flasks on the trees outside, and those who have finished washing are standing under them to oil themselves, as Greek men did after bathing. Another vase shows women washing; yet another, women drawing water, but above the spout under which one pitcher stands is hanging an oil-bottle left behind by a careless man.

In the bathing scene the figures are disposed, as one would expect an archaic artist to set them, between the columns. In the picture we show of women at the fountain, on the contrary, columns and figures overlap in varying degrees, alternate columns in

front of and behind the girls, who are all forward of the blocks on which their pots are set under the spouts. There is no coherent organization of space. Feet, columns, blocks, rest equally on the ground-line, not because the picture is conceived from a low view-point—there is no view-point; this is simply the traditional disposition. The action of the women, too, shows that they are all thought of as within the building, whether they are shown behind or in front of the columns which form its façade. Nevertheless the interweaving of girls and columns is a deliberate insistence on the existence of a third dimension, such as pure archaic art is careful to avoid. This is perhaps the first picture we have looked at that reminds us at all of those on the Bronze-Age sarcophagus from Agia Triada. Here there is no suggestion of diminution with distance, but the implication of the complicated overlapping is carried on in another way by the lion's-head spouts (no doubt of bronze) set on the side-walls in profile, at right-angles to the back wall where another is shown full-face, flanked by two of a different form, a circular orifice topped by a sharply foreshortened half-figure of a horse with a rider.

Spouts and wall are adorned with sprays, and two of the girls are hanging up wreaths; for a fountain-house, like almost any Greek building or place of a particular activity, has its own holy spirits, the Nymphs of the water. The branches wander about the field, as do the letters of the names scrawled by three of the four girls (whose is the fifth pot?): Kleo, Rhodopis and Iope—'white Iope'; and really the picture is not unlike a poem by Campion.

Not all earlier work is careful; but one can there say in general: the better the painter, the more careful his work. Care in the black-figure technique implies precision of line and delicacy of detail; for a bolder, freer effect care must be sacrificed. In general, however, Greek artists preferred a fine finish even for the boldest work; and that is probably one reason why red-figure, whose suppler line could be lively

ATHENIAN HYDRIA (WATER-POT), FROM VULCI (ETRURIA). LAST QUARTER OF 6th CENTURY B.C. MEN WASHING AT FOUNTAIN; BELOW, HUNT; ON SHOULDER, CHARIOT. (H. 46 CM.)
XV e 28, RIJKSMUSEUM VAN OUDHEDEN, LEIDEN.

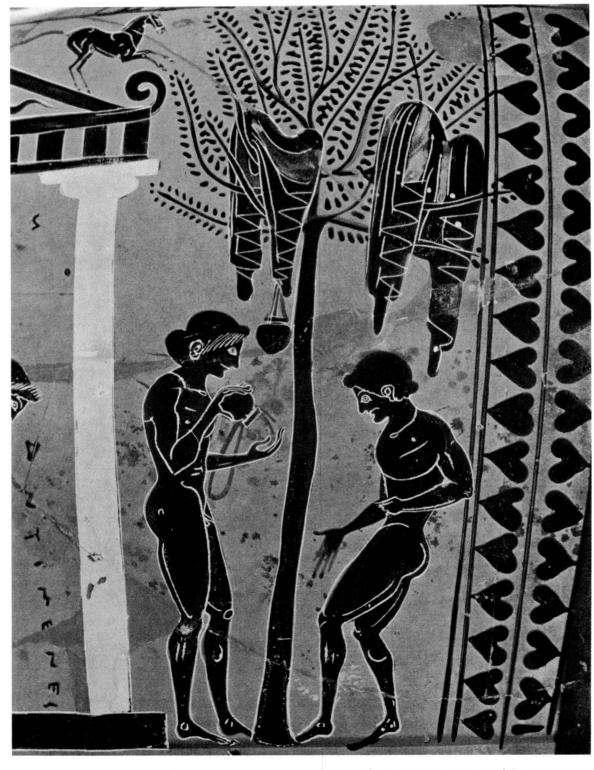

ATHENIAN HYDRIA (WATER-POT), DETAIL, FROM VULCI (ETRURIA). LAST QUARTER OF 6th CENTURY B.C.
MEN WASHING AT FOUNTAIN. (H. OF PICTURE 15.8 CM.) XV e 28, RIJKSMUSEUM VAN OUDHEDEN, LEIDEN.
(OVER NATURAL SIZE)

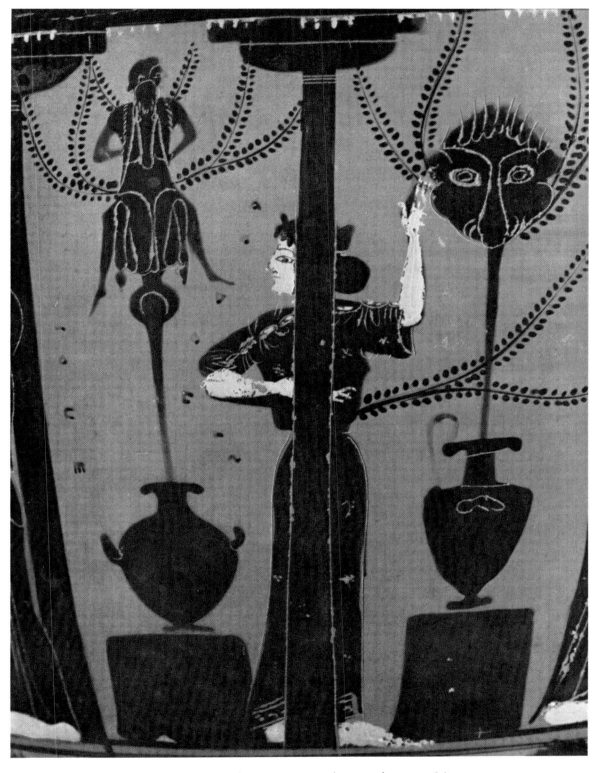

ATHENIAN HYDRIA (WATER-POT), FROM VULCI (ETRURIA). LATE 6th CENTURY B.C.
WOMAN AT FOUNTAIN. (H. OF PICTURE C. 19 CM.) B 329, BRITISH MUSEUM, LONDON.
(JUST OVER NATURAL SIZE)

without sacrificing refinement, now draws ahead of the old technique. There are still fine black-figure painters, but the finest prefer red-figure, and the future is there and in a third technique which develops from it and to which we shall shortly come. The rudimentary interest in space implied in the black-figure picture, and in others with similar subjects or with wheeling chariots seen in three-quarter view, is not found in contemporary red-figure work. The positive character of the shiny black ground rules out the vague suggestion of space which the black-figure painter can hint at without working it out. The red-figure artists, too, are preoccupied with the problem of the third dimension; but, in the central tradition of Greek artistic development, they struggle slowly for real mastery of it in the field of the simple human figure before they turn to any wider application. Very similar preoccupations are found in contemporary sculpture.

Typical of the finest work of this time is the vase shown on pp. 91 and 92. It is an amphora of the same type as that on p. 62, and shows no fundamental change of form; it is only rather slenderer. Exekias' picture had a pattern-band at the top alone. This has bands at bottom and sides which, like the ivy on the handles, are in the old technique; the band at the top is in red-figure like the picture. With its pattern-bands the picture occupies more of the vase-surface than the older one; the actual figure-scene about the same amount, but owing to the slighter form of the vessel it is higher in proportion to its breadth. The whole field is occupied by three great figures of an altogether different cast from any we have looked at so far. It is not only their massiveness, though that is new, but the care with which their complex postures and movements are studied. The painter is passionately interested in the structure and articulation of man's body. In earlier work bodies are shown either frontal or in profile, or frontal above the waist and in profile below, the transition ignored or slurred. Here a conscious and careful attempt is made to render the twist. The anatomical drawing is in some degree schematic, certain important lines plotted in black, the rest in golden brown, all used with a strong sense of pattern. Nevertheless these lines really correspond to something in nature, and one feels the bodies built of bone clothed in muscle which swells and pulls as they move and turn. The shoulders and breast of the man on the left (p. 92), the transition from near-profile buttocks to near-full back view of the shoulders in the central figure, are the fruit of excited observation. These renderings strongly imply a sense of volume; but the relation of the three figures, isolated each from each by the black ground, is still purely in the decorative surface plane.

The subject, a party, is taken, like that of the fountain-scene and an increasing number of vase-pictures from this time, from everyday life. On the other side of the vase the artist put a youth arming between mother and father. He named them from legend: Hector, Hecuba, Priam; but he used the youth's figure on another pot with a contemporary name, Thorykion. So long as a subject gives him interesting problems of drawing he does not much mind to what world it belongs. He likes to write on his pictures: names (old or new), signature, praise, boast or nonsense. He signed the picture on the other side of this vase: "Euthymides son of Polias painted"; and he uses the same formula elsewhere. It is not very common for a potter or vase-painter to name his father,

and when one does the name is several times known to us as that of a practitioner in the craft: so the sons of Nearchos and Ergotimos give their fathers' names. We do not know of a potter or painter Polias, but signatures of a sculptor Polias or Pollias, of about this time, have been found on the Acropolis, and it is not difficult to believe that the painter of these massy figures had a sculptor for a father.

We have no explicit evidence on the position of vase-painters in Athens or on how their work was regarded in relation to that of other painters and of sculptors. One of the largest and finest marble statues on the Acropolis was dedicated out of his earnings by one Nearchos, who perhaps described himself as a potter and may well have been the one we know in his old age or a younger member of his family; and another dedication, certainly by a potter, is a fine marble relief which shows the dedicator (his name is lost)

ATHENIAN JAR, FROM VULCI (ETRURIA). LATE 6th CENTURY B.C. SIGNED BY PAINTER EUTHYMIDES. REVELLERS. (H. 60 CM.) 2307, STAATLICHE ANTIKENSAMMLUNGEN, MUNICH.

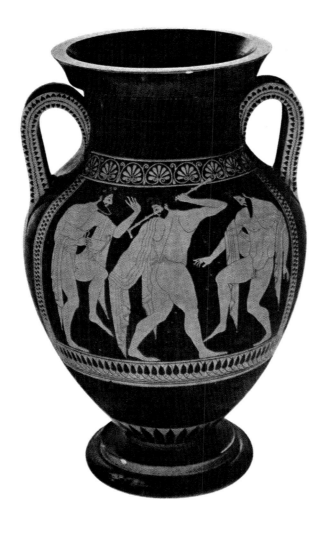

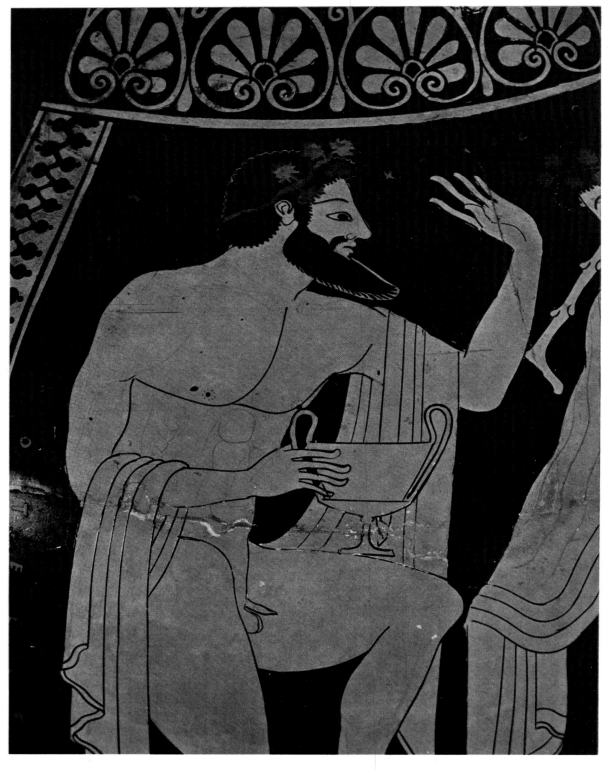

ATHENIAN JAR, DETAIL, FROM VULCI (ETRURIA). LATE 6th CENTURY B.C. SIGNED BY PAINTER EUTHYMIDES. REVELLER. (H. OF DETAIL 20 CM.) 2307, STAATLICHE ANTIKENSAMMLUNGEN, MUNICH. (JUST OVER NATURAL SIZE)

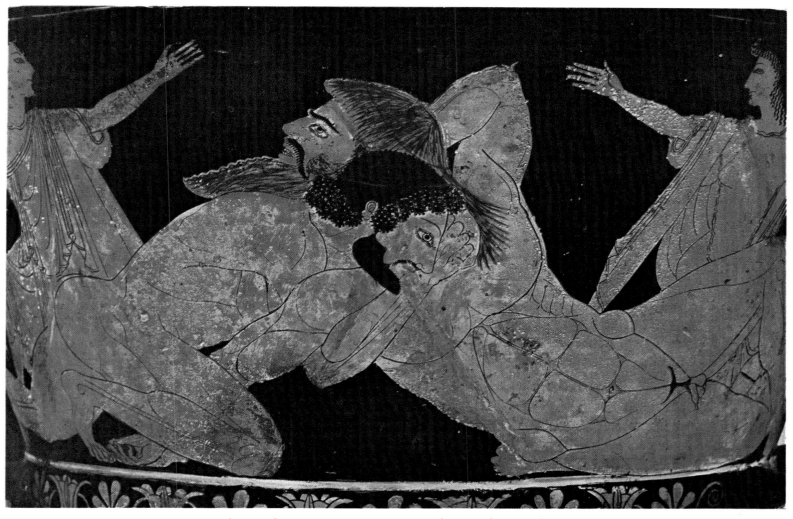

ATHENIAN MIXING-BOWL (KRATER), DETAIL, FROM CERVETERI (ETRURIA). LATE 6th CENTURY B.C. SIGNED BY PAINTER EUPHRONIOS. HERAKLES WRESTLING WITH ANTAIOS. (H. OF DETAIL C. 20 CM.) G 103, MUSÉE DU LOUVRE, PARIS.

sitting holding two cups. A statue-base carved in low relief with athletic and other scenes found in the walls hastily thrown up round Athens after the return from Salamis, is so like in style to the vase-paintings of Euthymides and his companions that one would have no difficulty in supposing that one artist practised the two crafts. Another base found with it bears the signature of a famous Athenian sculptor Endoios, yet it is not carved but painted; and the reliefs of part of the frieze of the Siphnian Treasury at Delphi, put up a generation before this, are completed in paint in a way which implies that sculpture and painting went hand in hand. That late archaic Athens was already an important centre of painting other than on vases is indicated by the tradition that Kimon of Cleonae, the accounts of whose work suggest that he was a leading figure in this phase of the art's evolution, 'developed the discoveries' not of any painter of Sicyon or Corinth, in whose neighbourhood Cleonae lies, but of an Athenian, Eumaros.

ATHENIAN PLAQUE, FROM THE ACROPOLIS. LATE 6th CENTURY B.C.
WARRIOR. (H. 65.5 CM.) 1037, ACROPOLIS MUSEUM, ATHENS.

We have one piece of independent painting from Athens of the time of Euthymides,
which has an important place in this discussion: a plaque from the Acropolis, illustrated
on p. 94. Votive plaques, thin slabs of clay with holes to hang them up by, were often

dedicated and are commonly painted by vase-decorators in vase-technique. This is different, not only larger but a thick slab designed probably for some architectural use; and colouring and character of the decoration are mainly foreign to vase-painting, linking it rather to the panels from the Sicyonian cave and the metopes from Thermon. It was originally inscribed with the praise of Megakles, who is also lauded on a vase painted by Euthymides; but the name recurs in the famous family of the Alcmeonidae, who were largely responsible for the expulsion of Hippias, so he was probably a public rather than a private favourite, and the erasure of his name and the substitution of another, Glaukytes, no doubt echoes political trouble. The incision on the black wrap round the warrior's loins is a link with vase-technique, and the treatment of the helmet-crest is paralleled in a fragment of a votive plaque of normal type but exceptionally large and painted with a figure of Athena in a modification of black-figure (white skin outlined in black; detail mostly painted on instead of incised). The style of the warrior-plaque is so like that of Euthymides in his red-figure vases that it has often been ascribed to him. The Athena plaque, from its fragmentary condition, is hard to compare; it could be his, however; and it is inscribed with a dedication by Polias.

It does look as though in this period at Athens sculptors, painters and vase-painters all felt themselves pioneers together. That the leading vase-painters at least did not feel mere imitators of the discoveries of others is specifically suggested by a further inscription on Euthymides' vase-picture on p. 92. Down the left-hand edge he has written: "As never Euphronios"; and works signed by Euphronios show him as the only other vase-painter of this time of the same calibre as Euthymides. On p. 93 is shown a detail from one of his masterpieces: Herakles wrestling with Antaios. The vase is an earlier form of that shown on pp. 124 and 125, much lower and broader; and the huge figures stretch horizontally across the long, low field. The careful observation of the locked, muscular limbs is carried on here in the strain and pain of the faces, especially that of the shaggy giant who has met his match.

All vase-pictures signed by or attributable to Euphronios or Euthymides seem to belong to quite a short period, probably mainly the last decade of the sixth century. Of Euthymides we hear no more; but Euphronios seems, rather oddly perhaps to our ideas, to have given up painting in favour of potting. From about the time that his painted work stops, begins a series of fine large cups which bear his signature as potter but are decorated by other painters, the latest of them perhaps produced after the return from Salamis in 479. Euphronios himself, as a painter, decorated big pots as well as cups, and there are fragments of at least one cup by Euthymides as well as the jars he usually preferred. In the following generation there is a certain tendency for painters to specialize in one or the other, and while the greatest pot-painters were pupils of Euthymides, the main line of cup-painters issues from the school of Euphronios, among them those who decorated the earlier of the cups he signed as maker.

Such was the painter of the Triton, merman, shown on p. 97, but this is not in red-figure. It is a fragment of a cup dedicated at Eleusis, the outside plain black, the whole interior of the bowl white-slipped and filled with this splendid figure drawn in

outline and washes of thinned glaze. We saw that outline drawing, common on vases in the seventh century, was practised intermittently throughout the sixth. This cup, however, is an early example of a new and distinct departure: closely related to red-figure (practised largely, indeed, as a side-line by red-figure painters) but the drawing always done not on the orange clay but on a white slip. This gives the method its conventional name: 'white-ground'; the third important technique in Greek vase-painting.

A white slip was normally used by the potters of many centres during the seventh and sixth centuries. An example is the cup illustrated on p. 70. In Athenian black-figure of the later part of the sixth century there is a certain fashion for it; and the artist who seems to have been the inventor of red-figure experimented once at least with the 'red-figure' technique over a white slip: 'white-figure'. This vase he adorned with entirely feminine subjects, evidently with the idea of bringing red-figure into line with the black-figure tradition of painting women's skin white; but the idea did not take on. One of the great differences between black-figure and red-figure is that in the latter the orange clay is felt equally suitable for the appearance of man and woman. After the earliest stage white is rarely used and the purple-red very discreetly (regularly for wreaths and other slight adornments and for the inscriptions in the field). Red-figure is essentially a two-colour manner; while in the practice of outline drawing on a white ground some play is made from the start with washes of colour: thinned glaze, as here; purple-red; and (as we shall see later) other reds, browns and yellows.

The cup with the Triton is a baked clay vase, and the colours are clay-based potters' colours, limited in range and differing from those used in free painting as we know them on the panels from near Sicyon, but the general balance and relation of colours here, and especially on the more elaborate white-ground vases of slightly later date, is much the same as on the panels. We know, too, that throughout antiquity many wall and panel painters limited themselves deliberately to four colours (of which two are not colours in the strict sense); red, yellow, black and white and their mixtures, eschewing blue and the greens and violets that can be made with it.

The white-ground technique involves the abandonment of the cherished vase-decorator's principle of silhouette. Perhaps for that reason it was long practised most often on the interior of cups, whose almost flat surface invited imitation of panel-painting; and while most black-figure and red-figure cup-tondos occupy only an area in the centre, the white-ground picture is often extended over the greater part of the bowl. So it was here. Part of a dolphin survives above the figure, and there were probably others about him; and the lower part of the picture will have been filled by the curves of his scaly fish-body and tail. The wreath, too, is not like the wreaths of landsmen but waves and trails like a weed in water. The minute drawing of the eyelashes is commonly found in elaborate work of these two generations, the pioneers of the new style and their immediate followers. In general, however, the younger artists are noticeably less preoccupied than Euthymides and Euphronios with problems of representation: volume, torsion, muscularity. The strenuous achievements of their predecessors are accepted as a basis for beautiful stylization.

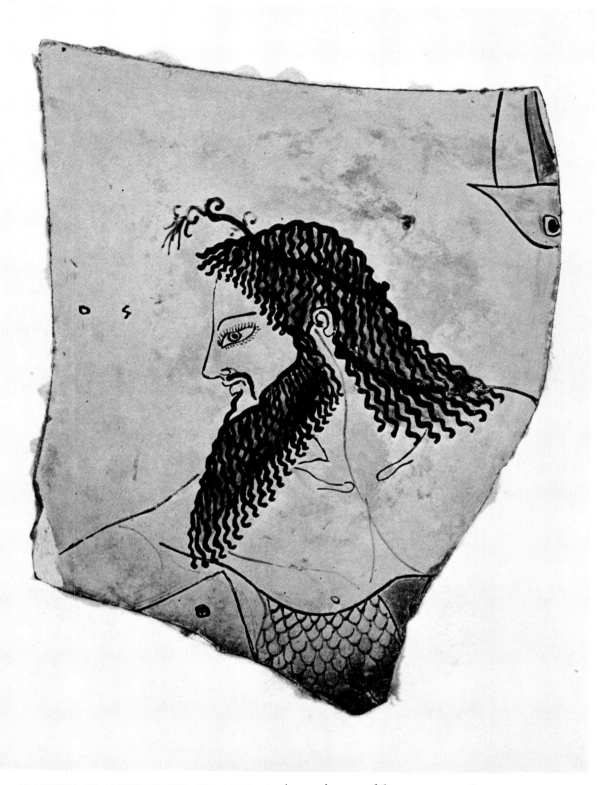

FRAGMENT OF ATHENIAN CUP, FROM ELEUSIS (ATTICA). LATE 6th OR EARLY 5th CENTURY B.C.
TRITON. (H. OF DETAIL C. II CM.) MUSEUM, ELEUSIS. (OVER NATURAL SIZE)

The first two decades of the fifth century saw in sculpture the definitive formal break with archaic convention. The *kouros*—the ideal youth of archaic sculpture: completely frontal, weight disposed equally between the forward left and backward right foot, no hint of bend, turn or twist in the upright body, neck and head—had been the accepted form of statue for Greek artists since they had borrowed it from Egypt upwards of a century before. In relief-sculpture, in the figures carved in the round for

ATHENIAN MIXING-BOWL (KRATER). EARLY 5th CENTURY B.C. GANYMEDE (H. 33 CM.) G 175, MUSÉE DU LOUVRE, PARIS.

the gables of temples, and occasionally for free-standing groups of figures in action, the exploration of torsion which we have observed in painting had been admitted already; but to recognize that the traditional form of substantive statue, so long accepted, could be discarded as having served its turn took a tremendous effort of the imagination, and it was at this time that the effort was made. The earliest surviving Greek athlete-statues relaxed from the formality of the *kouros*—weight on one leg, the other knee bent, hips and shoulders out of line, head turned and bent; all very slightly, but deliberately and clearly—come from the débris of the Persian sack of the Acropolis. This might be called the birth of European art after the gestation of the archaic age.

The corresponding formal change in painting, of equally profound importance when it came, did not take place for another generation; and the vase-painting of these years, infused in varying degrees with the new feeling whose growth accompanied the formal change and helped to determine its moment, belongs essentially to the archaic world; its last and among its loveliest flowers. The Triton is a masterpiece; but such creatures have by their nature something about them of a formal, heraldic character. A truer comparison with the revellers of Euthymides is offered by the boy—a drawing of equally splendid quality—on the red-figure vase of p. 98, by a pupil of Euthymides whose name we do not know. He is called, not very happily, the Berlin Painter, from the location of his most elaborate work. The one we illustrate is a form of mixing-bowl, known as 'bell-krater', new at this time in fine Greek pottery. There are earlier pictures of such vessels, probably of rough kitchen-ware; but it seems to have been this painter or the potter with whom he worked (if they were not one) who first adapted it. Slightly later a more elegant version is developed, and an ugly variant with high foot, splayed rim and handles instead of lugs became very popular in the later fifth and fourth centuries.

The boy stands on a strip of pattern, as does the single figure on the other side of the vase. There is no other extraneous ornament whatever; and on a few vases by this painter there are only the figures, one on each side of an otherwise completely black pot, without even a line beneath the feet. The spread figure isolated on the black ground with a minimum of pattern-work—the decoration pared to the balance of light figure and dark ground—reminds one of Epiktetos' plate. The two artists have much in common, but the work of Euphronios and Euthymides stands between them. The boy here is far more strongly modelled and surely articulated. The relation of the legs—one in profile, one three-quartered—to the torso with its gradual twist from three-quartered hips to frontal shoulders, presupposes the experiments of the last generation; but the effects are taken for granted: not explored for their own sake but used to express the beauty of youth through the beauty of imposed design. A fine feeling for contour is common to all the best vase-painters, but none perhaps has it so pure and full as this; and the detailed muscula-ture, though it closely resembles that of Euthymides' figures, is more carefully patterned to echo and enrich the rhythm of the figure against the black. Such simplification is widespread in vase-painting at this time, but one cannot point to another artist who, by the disposition of a single figure without any extraneous aids, so triumphantly achieves the decoration of a broad surface like that presented by this shape.

ATHENIAN JAR, DETAIL, FROM VULCI (ETRURIA). EARLY 5th CENTURY B.C. ECSTATIC MAENAD. (H. OF DETAIL C. 12 CM.) 2344, STAATLICHE ANTIKENSAMMLUNGEN, MUNICH. (OVER NATURAL SIZE)

The long hair loose (in thinned glaze for gold) and the hoop show that the boy has not yet passed from being a child; the cock (a favourite gift from Greek men to their loves) that he has reached a time to be wooed. The giver is shown on the other side of the pot: a bearded figure of kingly aspect, and indeed he carries a sceptre. They are not named, but their identity is not in doubt: Zeus, the king of the gods, and Ganymede, the patron saints of all such lovers. They are often pictured at this period, but never so nobly as here.

ATHENIAN JAR, DETAIL, FROM VULCI (ETRURIA). EARLY 5th CENTURY B.C. RAPT MAENAD.
(H. OF DETAIL C. 10 CM.) 2344, STAATLICHE ANTIKENSAMMLUNGEN, MUNICH. (OVER NATURAL SIZE)

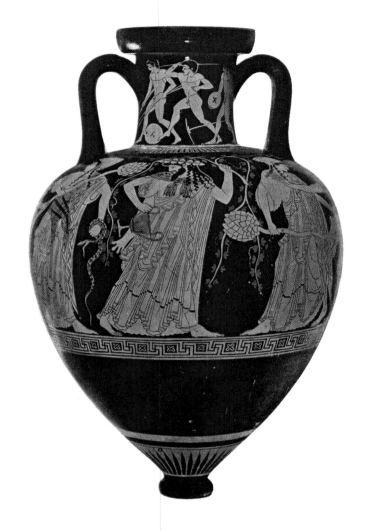

ATHENIAN JAR, FROM VULCI (ETRURIA). EARLY 5th CENTURY B.C. DIONYSUS, MAENADS AND SATYRS;
ON NECK, ATHLETES. (H. 56 CM.) 2344, STAATLICHE ANTIKENSAMMLUNGEN, MUNICH.

The Berlin Painter is a purely archaic spirit, though this figure expresses to perfection the ideal of beautiful youth that was the Greeks' at all times. His chief rival among the painters of big pots, the other great pupil of Euthymides, has more of the character of the coming age. His name was almost certainly Epiktetos, like the earlier vase-painter's; one of his latest and slightest works bears that signature, and it may possibly have occurred also on a vase that may be one of his very early efforts; but he is better known as the Kleophrades Painter, after a potter with whom he once at least worked. On that occasion it was an exceptionally large and splendid cup that he decorated, and he painted others, but he is primarily at home on large pots. The vessel illustrated on p. 102, a 'pointed amphora', is another shape proper to rough ware (wine was carried in such) but occasionally adapted, especially at this time, to fine painted pottery. This is a

crowded vase, showing an opposite tendency to the Berlin Painter's extreme restraint (practised also by this artist on other vases, though on the whole less effectively). Here too, however, there is little pattern and the decoration is almost entirely in the figures. On the neck are small pictures of naked athletes at their exercise, with discus, javelin and pick for loosening the soil on the wrestling ground; a favourite theme of fifth-century art. The painter, however, is not at his best on a small scale, and these figures are summary. It happens to be the only picture we illustrate of scenes in the *palaestra*, the athletes' ground for training and exercise (though the mythological contest on p. 93 is rendered as a formal wrestling-bout); but there is no painter of this period who does not treat the subject. From about this time it became the regular custom for athletes victorious in the games at Olympia to dedicate in the sanctuary of Zeus there bronze statues of naked youths (allegedly themselves; but this is an idealized art, far removed from our idea of portraiture). These statues play an important part in the development of Greek sculpture, and the athletic ideal left its impress on Greek painting too, visible in such naked youths as those of pp. 98, 124 and 132 no less than in pictures of the *palaestra* itself. The main picture has the enduring theme of the wine-god with his train of satyrs and maenads. On the front is Dionysus, flanked by two maenads each of whom is attacked by a satyr under the handle; on the back a piping satyr, his face towards us, stands between two maenads who move away. The figures have the breadth and weight of Euthymides', but the last two, at least, have also something new. The satyrs, especially the piper, show all the late archaic delight in physical action. The rest, in particular the two maenads on the back (pp. 100 and 101), have an inner life, aflame or still, that perhaps is faintly foreshadowed long before in the work of Nearchos and Exekias; but much rather they seem

<div align="center">standing apart
Upon the forehead of the age to come.</div>

One, dark, clutches her thyrsus (the Dionysiac wand: a fennel-stalk tipped with ivy-leaves) and flings up her head, her mouth open in a cry; her golden sister, the thyrsus across one shoulder, a snake about the other arm, moves in silence with rapt upturned look, unaware.

The varied washes of thinned glaze for hair, mottled hides, the snakes, the god's cup, give at moments an effect of light and shade. This is an early work of the artist. On some later works he definitely attempts shading, and experiments also with three-quarter faces, which the pioneers of the previous generation had avoided. Similar experiments are found also in the work of other vase-painters; and one poor vase-picture which shows it in an unusual degree looks copied from a wall-painting. No doubt among painters in other fields too there were two trends now, some resting in the last warmth of the archaic tradition, other pressing on towards the revolution of the next generation. The cup is a *kantharos*, like that carried by Euthymides' reveller (p. 92). It is especially associated with Dionysus. Nearchos' fragments (p. 59) come from such a vessel.

One of the cups signed by Euphronios as potter bears also the name of its painter, Onesimos. A splendid series of red-figure works, the earliest very close to the white-

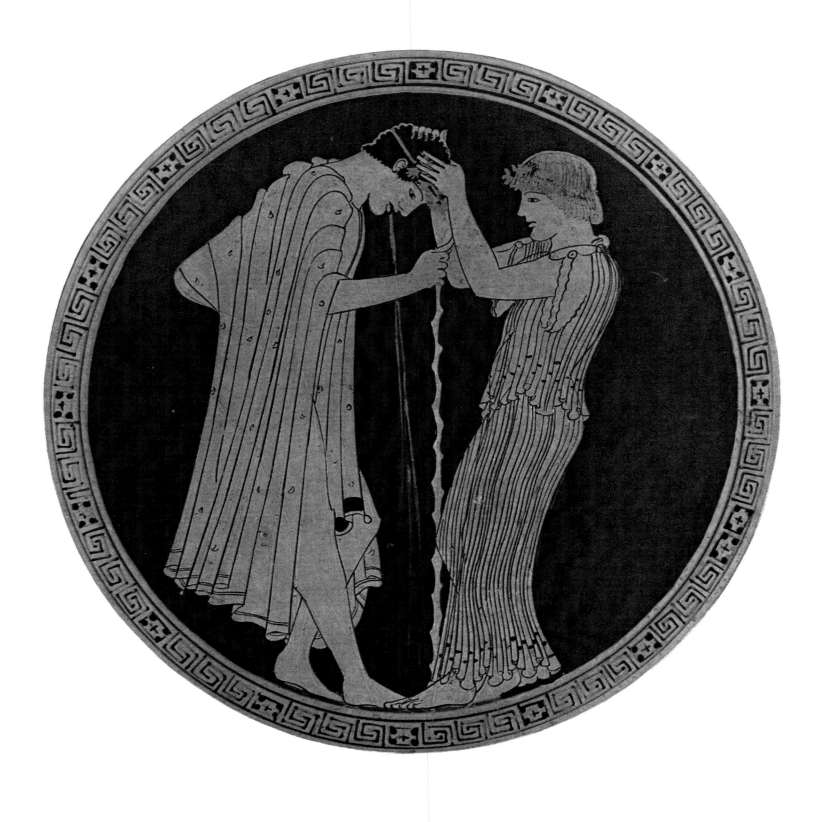

ATHENIAN CUP, FROM VULCI (ETRURIA). EARLY 5th CENTURY B.C. SIGNED BY POTTER BRYGOS. AFTER THE PARTY. (D. OF PICTURE 15.5 CM.) 479, MARTIN VON WAGNER MUSEUM, WÜRZBURG. (OVER NATURAL SIZE)

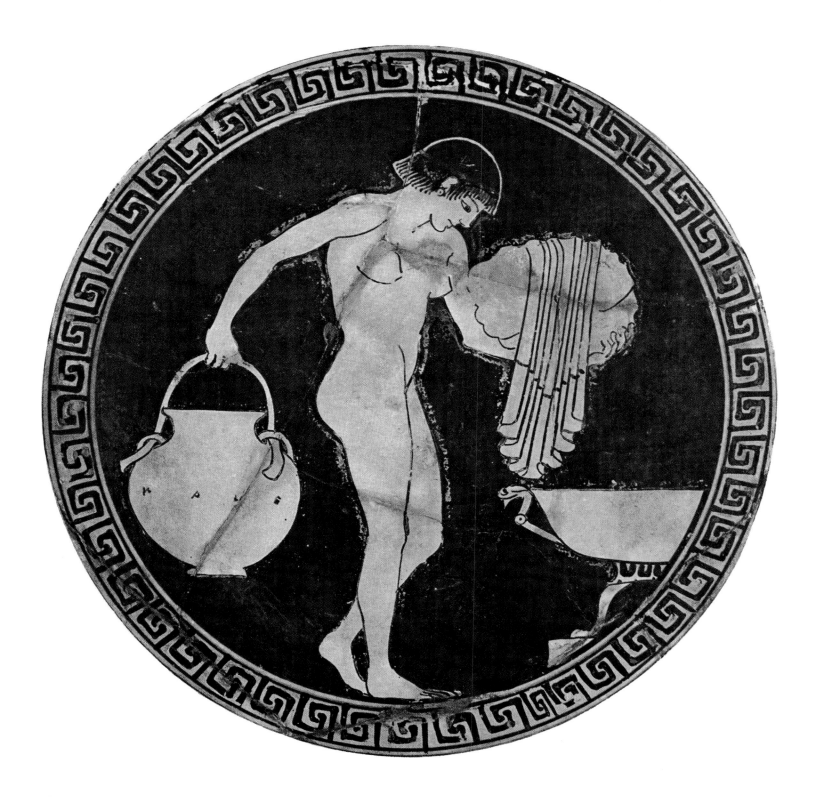

ATHENIAN CUP, FROM CHIUSI (ETRURIA). EARLY 5th CENTURY B.C. GIRL GOING TO WASH.
(D. OF PICTURE 15 CM.) A 889, MUSÉES ROYAUX DU CINQUANTENAIRE, BRUSSELS. (OVER NATURAL SIZE)

ground cup with the Triton, including most of the cups with the potter-signature of Euphronios, is by one man, known (after a youth whose praise he often writes) as the Panaitios Painter. He was perhaps Onesimos' master, perhaps the young Onesimos himself. Certainly by Onesimos is the exquisite little cup-tondo on p. 105. The naked girl (her short hair shows her a slave), clothes piled on one arm, a jar of water in the other hand, is approaching a basin with a snake-head handle on a lion-footed stand, both like the pail of metal. Whether she is going to wash herself or the clothes one cannot be sure. Beside her the artist has written (and who will quarrel with him?) *The girl is beautiful*, in the usual purple-red letters on the black background. The word for 'girl' is the same as that for 'boy'. He put the article in the feminine, but when he came to 'beautiful' carelessly wrote it in the more familiar masculine form; then noticed his mistake, and wrote 'beautiful' again, but in the feminine form, in black letters on the vessel the girl is carrying. At least I suppose that is what happened. There is no marking of musculature here in lines of thinned glaze; and this is a regular distinction in red-figure drawing between the bodies of women and those of men.

We know the names of two other leading cup-painters of this time, Douris and Makron, but of perhaps the greatest only that he worked regularly with a potter Brygos. Potter and painter may have been one; but Makron, whose signature appears on two surviving vases only, worked habitually with a potter Hieron whose name is on more than thirty, while Douris signs an even larger number as painter, most of them by one potter whose name, Python, is found only three times. There was evidently no accepted practice; and some cups signed by the potter Brygos were decorated by other artists than 'the Brygos Painter', as not all of Hieron's and Python's are by Makron or Douris.

The Brygos Painter's tondo on p. 104 is slightly larger than that by Onesimos which fronts it. That forms the whole decoration of a small cup, the outside black. The Brygos Painter's cup is a large one with pictures on the outside also. This painter is perhaps the most perfect master of composition on the difficult field of the cup-exterior; but the form of the vessel makes these pictures impossible to illustrate satisfactorily. The tondos shown in the last chapter are from other forms of cup, all with the bowl set off sharply from the stem, but the many in this and the next chapter are all from varieties of this type with the continuous double curve: the *kylix* which is perhaps what we first think of at the words 'Greek vase'. The shape of the cup-exterior demands a design of many figures; and in general the most successful compositions for this field show figures in violent action or swift motion, leaning up from the narrow ground-line into the widening space, often with draperies spreading to blot out the background. The outside of the cup whose interior is shown on p. 104 has a party, bearded men like those in Euthymides' picture, accompanied by youths and girls, some making music on lyre and pipe. The tondo shows the aftermath. The young man throwing his wine and the slave-girl (her fair hair is cropped) who holds his head lean slightly apart from one another, and there is a faint ambiguity about the setting of the picture—there is no absolute vertical. This, often in a much more marked degree, is common in these cup-interiors; they are not pictures to hang on a wall but vessels to turn in the hand.

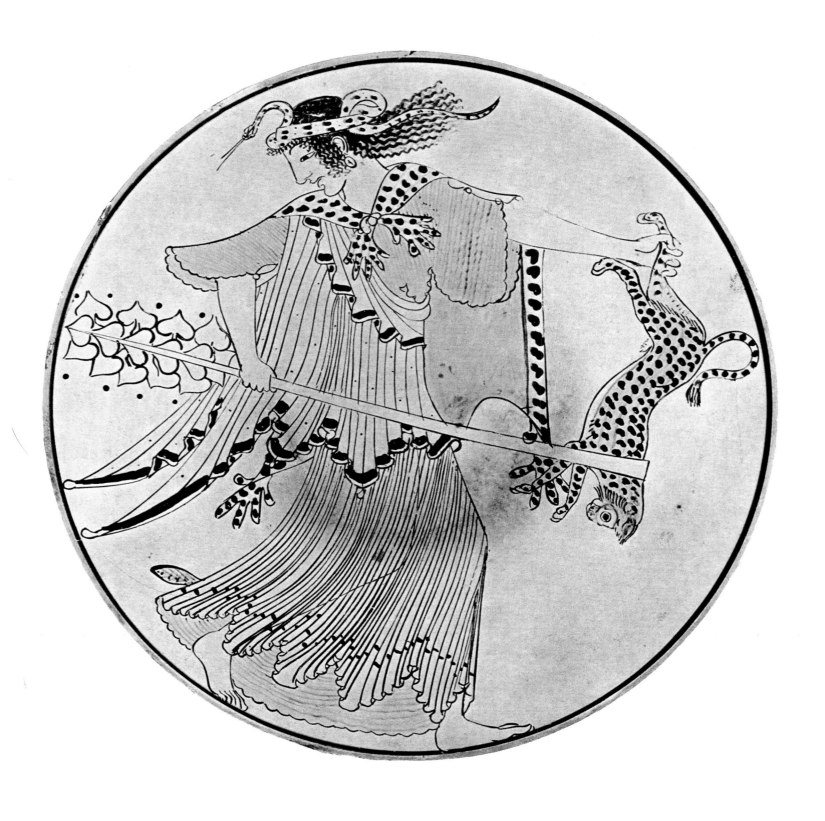

ATHENIAN CUP, FROM VULCI (ETRURIA). EARLY 5th CENTURY B.C. MAENAD.
(D. OF PICTURE 13.5 CM.) 2645, STAATLICHE ANTIKENSAMMLUNGEN, MUNICH. (OVER NATURAL SIZE)

In Balzac's *Illusions Perdues* Lucien, similarly overcome, is helped by Coralie. There passion is involved: she puts away her stained dress as a memorial of the night. One need not read any such emotion into this picture; yet here too an artist has transformed a squalid occurrence into a moment of beauty, not only through the purely decorative design but by a tenderness in the girl's action, expressed (as feeling is often expressed in Greek art) not so much in the face as in the whole figure: gesture, movement, the angle of the head. Such a tenderness comes more often into this artist's work than into most of his time. In the picture on the outside there seems likewise a touch of feeling in the way some of the revellers are making up to the flute-girls; and this contrasts with the treatment of a similar scene on the outside of a cup by the Panaitios Painter. There roistering men revel unaccompanied, and the marvellously strong and sensitive drawing of the naked bodies seems unconcerned with anything the eye cannot see. There is a difference, too, in the composition, built up in both cases of a rout of leaning figures swaying round the vessel. In the Panaitios Painter's work each figure (though limbs touch and overlap) is largely isolated against the black background, on the Brygos Painter's hanging cloaks cover much of the ground and unite the figures into a more even whole. This tendency is carried even further in some works of Makron; but he, like Douris, is a less sensitive draughtsman.

Both this and Onesimos' picture are circled by varieties of the maeander pattern, an etiolated Geometric heritage which forms the basis for most borders at this period and reminds one of the strength of tradition in Greek art. The simplest form is seen on the Berlin Painter's vase on p. 98, a more complex on the Kleophrades Painter's which follows it. After its overwhelming popularity, in full and elaborate forms, on Geometric pottery, it suffered a decline in the seventh and early sixth centuries, though thin linear versions of it can be found at all times (for instance on the vase illustrated on pp. 55 and 56). In the later part of the sixth these forms increase in popularity, and it is found on a very high proportion of red-figure vases.

The Brygos Painter also worked in outline on a white ground, as the cup illustrated on p. 107 shows. The Triton cup is plain black outside; this has red-figure decoration there. White-ground decoration for cup-exteriors, though not unknown, is very rare. An early cup by the Pistoxenos Painter, whom we shall meet in the next chapter, has white-ground pictures on the outside as well as inside; and a generation before the young Douris had decorated one in the same way. To the same time as that belongs a cup unusually adorned with red-figure inside and white-ground out, but in general it seems to have been felt that this technique suited only the interior; perhaps, as already suggested, because the almost flat surface recalled the fields at the disposition of panel-painters and did not seem to the vase-decorator to demand silhouette with same insistence as the rounded vessel-wall. The red-figure pictures on the outside of this show Dionysus with satyrs and maenads, and inside is a maenad also. Most white-ground pictures cover almost the whole interior of the bowl; so the Triton, and several we shall meet in the next chapter. Here there is a plain white circle within the rim, then black, and the picture is confined to a comparatively small central circle in the red-figure manner. The drawing too is exceed-

ingly close to red-figure. In the picture of the Triton the free use of thinned glaze washes, with or without black lines across them, showed the artist's sensitivity to the new technique and its possibilities; and in the next generation we shall find the possibilities much more fully explored. The Brygos Painter thinks in red-figure as he thinks in archaic terms. This rushing figure, snake-wreathed, carrying a leopard and cloaked with another's pelt, has excitement, but none of the inner excitement of her fellows by the Kleophrades Painter. She is all of the old age, recalling in spirit the Dionysiac scenes on the Caeretan hydria of some generations before (pp. 74 and 77), where the god, similarly clad, similarly holds an unresisting leopard by the leg. She is more sophisticated and more finely drawn, but she seems to miss the quality of the artist's best work in red-figure. We just glimpse here, perhaps, something that shows more strongly in certain sculptures of the next generation: the sterile conventionality into which Greek art might have lapsed if great spirits had not dared to break with archaic tradition.

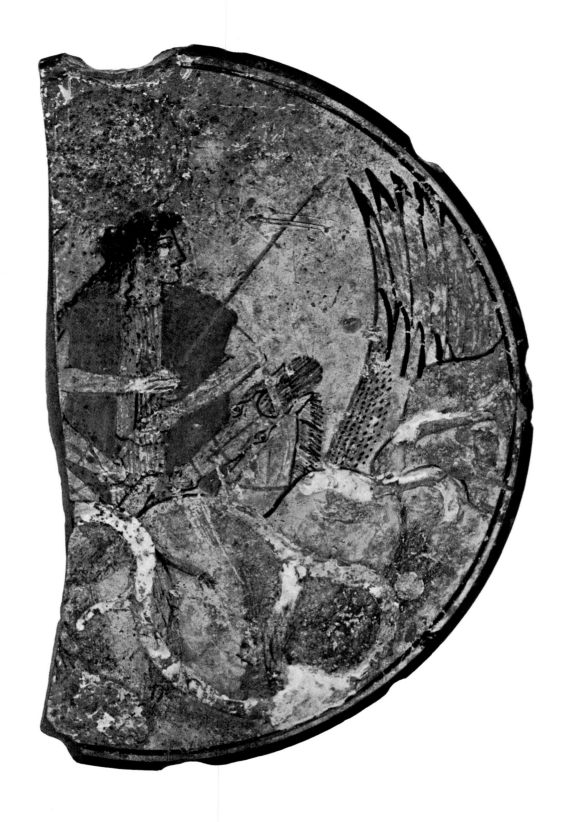

FRAGMENTARY ATHENIAN "BOBBIN", FROM ATHENS. FIRST QUARTER OF 5th CENTURY B.C.
HELIOS RISING OVER THE WAVES. (D. 11.5 CM.) AGORA MUSEUM, ATHENS. (OVER NATURAL SIZE)

THE CLASSICAL REVOLUTION

I N a beautiful red-figure tondo the Brygos Painter showed Selene, the Moon, driving towards us in a two-horse chariot. She stands in the car, the small moon-disc on her head cutting the upper border, the lower half of the picture—indeed a little more—occupied by the foreparts of the winged beasts. They are drawn as though facing each other, though the near horse has its head turned frontally to us. Their muzzles cross and their forefeet interlock, and the patterned wings fill the sides. The black ground fitly displays the night, and a formal pattern of flecks symbolizes stars on either side of the goddess; while a series of little arcs along the lower border shows the waves over which she is rising. These are lightly washed with thinned glaze, which is used also on the chariot and perhaps faintly on the disc; as well as in flecks on the wings, on which too one range of feathers is emphasized by a thick black outline. The painter, for all his archaic character, is one of those who make some play with tentative shading. The outer picture on this cup shows more than usual of that, and more complex foreshortenings than he commonly attempts. One feels throughout that he has been looking at wall-painting; but the work has still the flat linear beauty of archaic red-figure.

The painter of the white-ground tondo shown on p. 110 gives us the twin subject: the Moon's brother, Helios, the Sun. The elements of the composition are the same, too, but by his treatment he seems to have added a dimension. Selene's disc is about the size of her head and overlaps the border; the Sun's is twice as big and does not touch it, so that the figure is set much lower in the picture. Both hold their hands in front of the body above the horses' heads, but while the centre of the Brygos Painter's circle is covered by the crossing muzzles, here it falls between the god's hands. The horses' heads are smaller in proportion to the deity; both are frontal to us (one is largely lost but enough remains to be certain of this); and they do not overlap. Part of a high-lifted foreleg appears between the muzzles, but all the rest of the beasts below the neck is hidden by a mass of waves, which covers a full third of the diameter in the centre and rises to the sides, topped by up-curving wings. The wings on the other cup, cut by the encircling frame, reach hardly as high as Selene's shoulders; the tips here top her brother's head. Heavy black outline is used for the tips as well as for the inner range of quills and for the top of the wave-barrier. Black also is the speckling of the wing-covert, the god's hair and the outline and detail of his face. Thinned glaze is used for the other outlines, for the close folds of the tunic, on the feathers and the horses' coats, and in close hatching

over a wash for their manes; also to mottle the waves. The cloak is purple-red. The smooth white bands which serpent over the foreground mass bear traces of a pinkish matter sometimes used as a base for gilding, and so no doubt it was here: the sea touched by the rising sun—the disc too was most likely overlaid with gold. The application of gold leaf to details of fine vase-painting is not uncommon in Athens in the late archaic and early classical periods; we shall meet other examples in this chapter.

This is not a cup-tondo but an object of uncertain use: a shallow reel; two flat clay discs (the second is here missing) joined back to back by a short central stem. There are a number, mostly from the early classical period, decorated with red-figure or white-ground pictures. They are called bobbins, or supposed to be a child's toy (like our yo-yo); a Sunday toy, one would think.

I have described the composition as though it were complete; and though nearly half is missing it can be safely assumed that it was approximately symmetrical. There is here no intellectual attempt to master the rendering of space. The treatment of the waves is highly schematic; they could as well be clouds, only that we have other representations, on poor black-figure vessels of this period, where the horizon over which the chariot mounts is clearly defined as sea. Yet the extent and prominence given to them here, so much of the equipage concealed behind them, with the low setting of the figure against the sky, the big sun-disc above his head; these, and the modulation of colours, do adumbrate a new world.

A point of detail in which this differs from anything we have so far seen is the drawing of the eye: open at the inner corner; a profile eye, that is, instead of the full-face eye in a profile face that was the rule up till now. It is still very long and narrow, giving an archaic look to the head, emphasized by the hard black line; one would guess this to belong early in the new age, or at least that the painter's style was formed in the old. The transition takes place about the time of the Persian invasion. It would be absurd to suggest that all such works as we looked at in the last chapter were made before the evacuation of 480 B.C., all in this after the return the next year; but that violent interruption does not only serve us for a convenient dating point; it will for the Athenians too have helped to crystallize a change of spirit which was gradually taking place.

No other works have been associated with the painter of the Helios. The lovely cup-tondo on p. 113 is the masterpiece of one of the first vase-painters whom we can see as a personality of the new age, a purely classical spirit. He is known as the Pistoxenos Painter, after a potter whose signature appears on one vessel that he painted early in his career. The name occurs elsewhere, once with that of Epiktetos as painter on a rather late work by the artist of the plate illustrated on p. 82. Another of the Pistoxenos Painter's earliest vases (a white cup) is the latest surviving work with a signature of Euphronios as potter, and two other of his early white cups, now fragmentary, had potters' signatures, perhaps the same. One is shown on the title-page. The eyes there are still drawn in approximately the archaic manner. In the artist's mature work, as the cup on p. 113, the eye is in profile. These links of potter and painter remind us how the living generations overlap our schematic organization in periods.

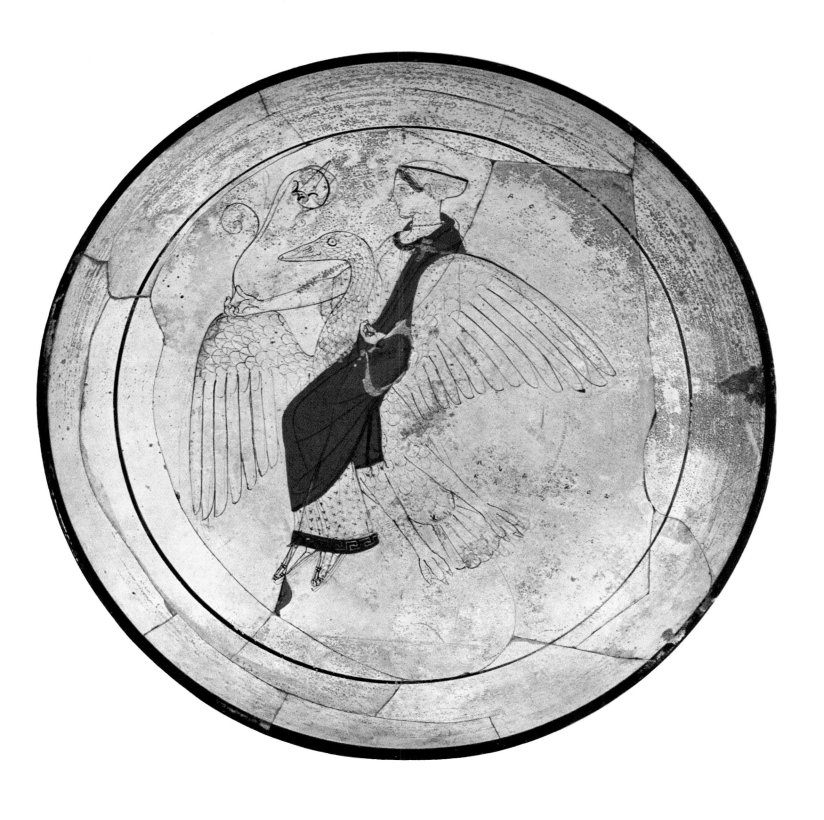

ATHENIAN CUP, FROM CAMIRUS (RHODES). FIRST TO SECOND QUARTER OF 5th CENTURY B.C.
APHRODITE ON A GOOSE. (D. 24 CM.) D 2, BRITISH MUSEUM, LONDON.

The complete cup, plain black outside, has for the subject of its white tondo again a deity borne on wings: Aphrodite riding a bird, goose probably rather than swan. It is in any case a schematized, heraldic creature, and the flowering tendril which the goddess carries in her hand comes from no terrene plant. The group is set free in the empty white, like Dionysus in his boat on the empty red field of the earlier cup; but here the whiteness stands for sky alone, not sky and sea; and though the artist is not concerned to particularize the idea of space, one feels the figures ethereally afloat. With its sweet calm—the goddess of Love in her kindest mood—this picture is the most perfect embodiment of early classical quietude at its gentlest. In other hands it conveys a brooding melancholy, or the threat or aftermath of storm; here it is pure peace embodied in beauty.

All outlines and details here are in thinned glaze of varying strength; in the hair dark lines are drawn over a thinner wash. The cloak over the patterned dress is purple-red, as is the dress-hem with its white maeander pattern. The shadowy lines visible round the flower, on the wing and elsewhere are part of the first sketch, indented lightly in the white slip while it was soft. Beside the goddess is written her name in the genitive: "(image of) Aphrodite". The other names we have seen written beside figures are in the nominative, but this form is not uncommon. Another inscription praises the beauty of Glaukon, often recorded by this painter and others of the time, sometimes with his father's name, Leagros. Leagros himself is praised on vases painted by Euphronios and his contemporaries and on early works of the generation after them. It occurs on the vase illustrated on p. 93; and the fragmentary inscription beside the Triton on p. 97 may well have recorded it too, since the same painter places it on other vases.

Glaukon was surely praised again, though only the ends of the words survive, under the maenad's right arm on a splendid cup by the Pistoxenos Painter, part of whose fragments are shown on the title-page. Above is part of a potter's signature, perhaps that of Euphronios. The third inscription, BYB... is the beginning of the satyr's name, perhaps Bybax. In subject as well as in drawing this picture stands closer to archaic tradition than does the Aphrodite. Dionysus is among those deities particularly concerned with growth and breeding, the enjoyment and the renewal of life; and his companions often act in that spirit. Satyrs are making up to the maenads who flank the god on the Kleophrades Painter's jar (p. 102); and we saw them also on the Caeretan hydria (p. 74). Here the character of the assault, though not in doubt, is less emphatically expressed than on the archaic examples. The artist has amused himself with the contrast between the classical beauty of the girl's profile and her lover's bald brow and snub nose, thick lips and round eye; but the drawing has throughout the same smooth line as the picture of Aphrodite, and the atmosphere is smooth too. The maenad has swung her snake-twined thyrsus behind her head, and perhaps she is going to bring it down on the satyr, as perhaps with her other arm round his head and shoulder she is trying to pull him from her, but one does not feel that she is angry or afraid—rather,

She bid me take love easy, as the leaves grow on the tree.

ATHENIAN CUP, DETAIL, FROM VULCI. SECOND QUARTER OF 5th CENTURY B.C.
DEATH OF PENTHESILEA. (H. OF DETAIL C. 32 CM.) 2688, STAATLICHE ANTIKENSAMMLUNGEN, MUNICH.

ATHENIAN CUP, FROM VULCI. SECOND QUARTER OF 5th CENTURY B.C. BATTLE OF GREEKS AND AMAZONS.
(D. 46 CM.) 2688, STAATLICHE ANTIKENSAMMLUNGEN, MUNICH.

The correct angle of the picture is not easily determined. It should perhaps be tilted a little more to the right than in our illustration, bringing the girl's figure nearly vertical, the inscriptions to left and right of the group approximately horizontal; but we have seen that these compositions are often not meant to have a rigid setting. Again the thinned glaze is used with sensitive variation, laid in dark lines over a light wash on the hair, and for most delicate detail throughout: finger-nails and knuckles on the satyr's elegant hand; his musculature, and lines of hair dotted in on his body; wrinkles on his brow and a crease in the girl's eyelid; markings on the snake's skin and the fennel-stalk; and for very lightly hatched shading along the satyr's arm. The thick fillet round his brow, his bracelet, the girl's bracelet in the form of a snake, the pendants on her necklace, her earring and a band in her hair, are all added in clay which must once have been gilded. Two matt colour-washes are used: the usual purple-red for the girl's dress, and something darker with seemingly a trace of blue in it for the animal-skin (dappled in white) which the satyr wears.

Own sister to this votary of the wine-god is the stricken warrior-queen of the great cup shown on pp. 115 and 116. In this, one of the largest vessels of the form to survive, the entire bowl is filled with a picture, in red-figure but modified towards the character of white-ground by the free use of added colour and of added clay once gilt. On the outside of the cup are lively, sketchy pictures of boys and horses, certainly by the same hand as the picture within but much smaller in scale and slighter in feeling. Round these it has been possible to group a large number of vases decorated in red-figure and white-ground by this painter (and many more by his assistants and companions) of varied scale and quality but none so ambitious or so fine as this. His style is so closely linked to that of the Pistoxenos Painter that some have supposed that these works are actually the later productions of that artist; but others seem to me right in feeling a different personality. He is known as the Penthesilea Painter, from the identification of this fight as the death of that queen, who brought her Amazons to Priam's aid before Troy and was slain by Achilles. Later, at least, it was told that as the Greek dealt the fatal blow he was seized with love for the dying Amazon. It is hard not to believe that this painter knew that story; or another like it, for Greek met Amazon on more than one field, and a tragic love is recorded between Theseus, king of Athens, and the Amazon Antiope, though the story does not generally take this form. We may, however, be reading more into the picture than is warranted. Youth mortally stricken in battle is tragedy enough, without a love-theme, for the passionately emotive effect which the picture undoubtedly makes.

The surface is in bad condition, but it is evident that several added colours were used: purple-red for the cloak of the subordinate Greek, with white patterns; another for that of Achilles and for the interior of his shield; and apparently a third for Penthesilea's tunic, though that is almost entirely perished. Traces of gilding remain on the freely added clay for ornaments and weapons. Much of the detail, and in particular the drawing of the queen's head, is very like the Pistoxenos Painter's style, and the grappling figures present a compositional problem analogous to that of the last cup;

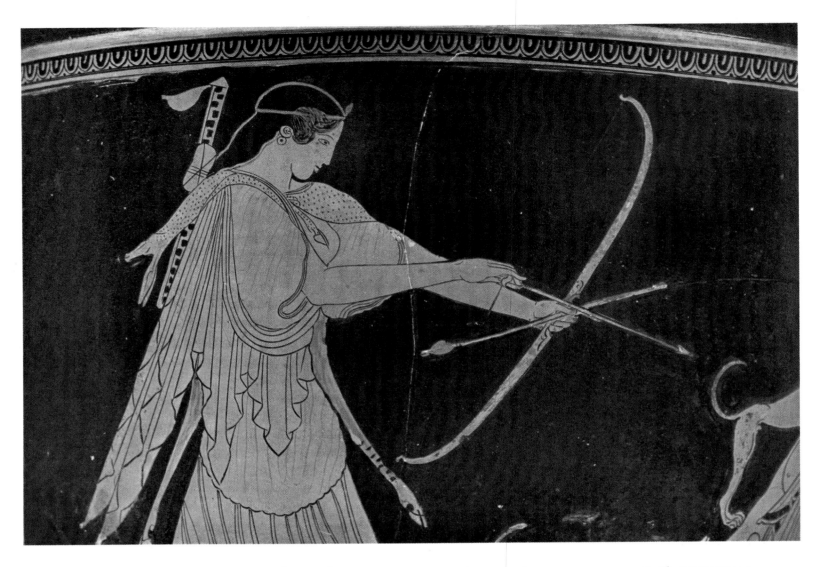

ATHENIAN MIXING-BOWL (KRATER), DETAIL, FROM CUMAE (CAMPANIA). SECOND QUARTER OF 5th CENTURY B.C. ARTEMIS. (H. OF DETAIL C. 12 CM.) 10.185, MUSEUM OF FINE ARTS, BOSTON.

but in the organization of the figures and in the feeling the picture is a world away from that. There is no taking love or life easy here; and the drawing has a nervous, staccato quality that expresses the different spirit. Compare the Greek's body with the satyr's, or with those (like in many ways) of Euphronios' wrestlers (p. 93). There the straining muscles are contained in clear, continuous lines; here, though the continuity of line is much more marked still than in most modern drawing, it is beginning to break up. We noticed that vase-painters of the generation after Euphronios and Euthymides seemed content to use their masters' discoveries and to press no farther. In the rendering here of the Greek's contorted posture—the twisting of the left arm, with the shield behind the shoulder; the subtle foreshortening of the left leg and foot—we see experiment awaking again.

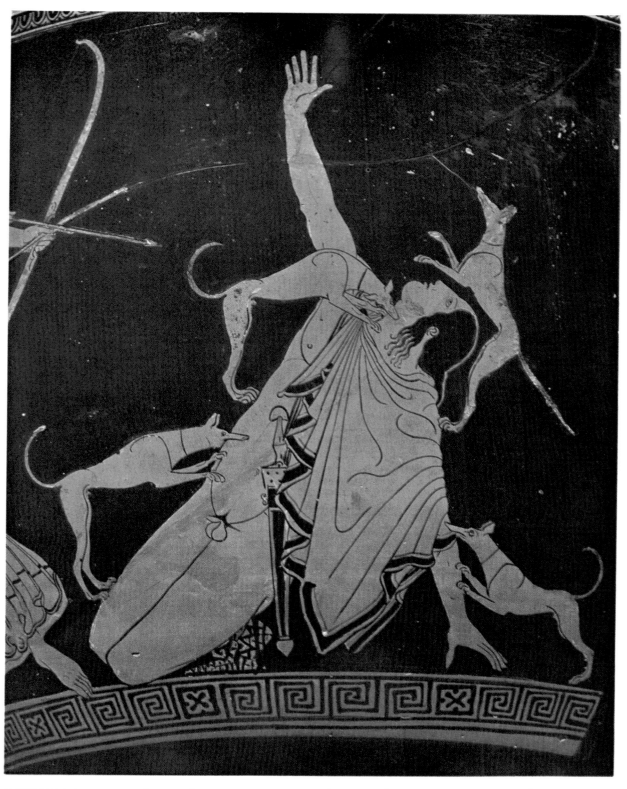

ATHENIAN MIXING-BOWL (KRATER), DETAIL, FROM CUMAE (CAMPANIA). SECOND QUARTER OF 5th CENTURY B.C. ACTAEON. (H. OF DETAIL C. 22 CM.) 10.185, MUSEUM OF FINE ARTS, BOSTON.

With the two subordinate figures, a Greek storming by, a dead Amazon twisted along the rim, the painter has brought before us the whole battlefield. He has done it as a vase-painter, bending his composition to the cup-circle (here again there is no absolute vertical and horizontal), and using the shiny black ground, though it is reduced to a small area by the massing of the figures. We need not doubt, however, that what makes this so different from most vase-paintings is a profound influence exerted on the artist by a great new movement in wall-painting which we know to have taken place at this time, completing the classical revolution begun by sculptors a generation before. We shall have much more to say of this revolution and shall look at vases which reflect more immediately the specific spatial innovations of the wall-painters, but nothing gives us so well as this the feeling that we glimpse something of the spirit which must have animated those lost works.

The dead Amazon wears a sleeved and trousered combination like that of Epiktetos' archer (p. 82), and over it a belted tunic of Greek fashion. The queen wears two such tunics in different stuffs. Both have only bands about their heads. The second Greek wears helmet, corselet with flaps and a kilt beneath, and a cloak round one arm. The other has only helmet, cloak, greaves and shield. The choice is arbitrary in that the artist is not concerned with actual practice either in his own day or in the supposed time of the heroic scene. To enrich his design he rings the changes on Greek and foreign costume, and on man's naked body which the Greek artist is always ready to introduce anywhere. Frontal faces are occasionally drawn on vases from the early sixth century; three-quartered ones from the time of the Kleophrades Painter. Often they are used in contexts (the death-agony here) which justify distortion and ugliness; but from now on they appear increasingly in scenes with no such implications.

Before we turn to the great wall-painters and their imitators on pottery we may look at a work of a different kind. We noticed that the vessel shown on p. 98 was of a form taken from coarse ware. The details on pp. 118 and 119 are from a pot of that basic shape, consciously refined and made more elegant; and the drawing of the picture stands in just the same relation to archaic drawing. The Pan Painter (so called after a charming and ribald picture, on the other side of this vase, Pan pursuing a shepherd) is that rare thing a backward-looking genius. This, his masterpiece, shows like the Penthesilea cup, a man, a woman and death; but the woman is a goddess and it is the man that is dying. Actaeon, the Theban hunter, offended his patron Artemis, and she so bewitched him and his hounds that they took him for a stag and tore him in pieces. The transformation is implied in some representations of this time, but not the story that his offence was to see her naked. That only appears later; in other tales he assaulted her, or boasted that he was the better hunter—equal grounds for destruction in the eyes of a Greek deity. This, like the death of Ismene (p. 80), is punishment: the victim has no chance. Achilles and Penthesilea are as honourably matched as Tancred and Clorinda.

The union of the figures in a surface design that has nothing to do with space, the formulae of the patterned folds, are archaic; yet not quite, and certain things—the drawing of the eyes, the hunter's cloak—set the artist unmistakably in this period.

Moreover there is something in his whole manner that says the same; this is the archaic style worn with a difference. The figures, for all their elegance, have not only a power (much archaic work has that) but an overtone of feeling that is not archaic. In their renderings of death and of the relation of the slayer and the slain this and the picture of Achilles and Penthesilea have something in common.

The movement of Artemis, hastening one way, look and gesture turned back the other, is the same as that of the second Greek on the Penthesilea cup, and is a favourite in classical art; especially in the form of two such figures crossing each other, where it symbolizes strife. Athena and Poseidon were so set in the centre of the West Pediment of the Parthenon, disputing the land of Attica; and a splendid earlier example is a metope from the Temple of Zeus at Olympia on which Herakles fights the Cretan bull. On these vases the victor drawing away from the falling or fallen victim is a variant on the theme.

There are other backward-looking vase-painters at this time, but all are negligible, most miserable. The Pan Painter is perhaps the best vase-painter of his generation; certainly he produced the most beautiful red-figure work of the time. Red-figure is, indeed, a technique essentially suited to archaic art. Figures clearly isolated within a firm continuous contour against an emphatic, unmodulated background, cannot fully express the interests of the new age. The Penthesilea Painter miraculously achieves such an expression, but in his masterpiece the technique is substantially modified. We shall see others attempt it with less success; but from now on we illustrate little red-figure. It flourished for two centuries more, and there is good work now and later, but it is a craft living more and more on its past.

It was sculptors who made the first definitive formal break with archaic conventions in the years of the Persian threat, the first two decades of the fifth century B.C.; and fifty years later, in the high classical moment of Periclean Athens, it was a sculptor, Pheidias, who stood out for posterity as the leading figure, the embodiment of the art of his time. The intervening period saw the revolution in painting; and the artistic figure who in the literary record occupies a position analogous to that of Pheidias was a painter, Polygnotos of Thasos. His father Aglaophon, his brother Aristophon, and a younger Aglaophon, probably his son or nephew, were also celebrated painters; but the only contemporary who rivalled him in fame was an Athenian, Mikon. The two worked together in Athens, and are connected with the circle of Cimon, son of Miltiades the victor of Marathon, who was the leader of the Athenian democracy from the exile in 472 B.C. of Themistocles, the victor of Salamis, until his own in 461. Three buildings in Athens decorated with wall-paintings of this time survived in late antiquity and are mentioned in the guide-book written by Pausanias in the second century A.D.: the old sanctuaries of Theseus and of the Dioscuri, both of which seem to have lain to the north of the Acropolis, above the Agora (market-place); and on the other side of the Agora a *stoa* (portico), built at this time and known as the Stoa Poikile (Coloured Colonnade). This was where later the philosopher Zeno walked and talked, giving us the word stoic.

The paintings in the sanctuary of Theseus were no doubt connected with the bringing to Athens of bones supposed to be those of the hero, discovered by Cimon in the island

of Skyros when he was rooting out a pirates' nest there in 474/473 B.C. These, then, are likely to belong early in the period of Cimon's dominance. Pausanias mentions four pictures, ascribing one to Mikon and almost certainly implying that all were his work. He names both Mikon and Polygnotos as working in the other sanctuary and in the Stoa, where the first painted a *Battle of Greeks and Amazons* (there was another in the sanctuary of Theseus) and the second a *Troy Taken*. In this Polygnotos was said to have given to Laodice (the fairest of Priam's daughters, as Homer tells us) the features of Cimon's sister Elpinice, among whose numerous lovers the artist was counted. There were also in the Stoa two further battle-scenes, one a very famous *Battle of Marathon* of doubtful or disputed authorship; possibly begun by Mikon and finished later by Pheidias' brother or nephew Panainos. There is evidence that these works were painted on panelling secured to the walls; and it looks as though this, rather than painting on plaster, was the normal practice among painters of murals in classical Greece.

Polygnotos' most famous works were not at Athens but at Delphi, in a *lesche* (club-house) dedicated in the sanctuary by the people of Cnidus on the coast of Asia Minor. The date of this is not known, but it may well have been put up in thanks for the city's liberation from the Persian yoke, which took place, with that of the other cities of the area, as a result of Cimon's campaigns in the sixties. The foundations of this building survive, on its own little terrace near the top of the steeply sloping sanctuary, and show it to have been a long room with a roof supported by wooden pillars set round a central area, which was used, we are told, for athletic exercises. In the surrounding space (a kind of closed colonnade) entered through a door in the middle of the long south wall, one could walk or sit below the two great pictures, which met in the centre of the north wall and occupied also the short walls; perhaps, too, the south wall up to the door, but there may have been windows there, unless it was lit by a clerestory —the centre will hardly have been open to the sky. The pictures were *Troy Taken*— a much larger and fuller version than that at Athens—and *The Underworld*. These are described in detail by Pausanias. It is of course quite impossible to form any notion of them as works of art from the description, but this does tell us things of very great interest about the problems that preoccupied the painter and his way of tackling them.

Most striking is the way Pausanias moves about the picture, not describing the figures from one end to the other but going back and using such phrases as 'above these', 'higher up again', 'looking back to the lower part', 'further in'. Such expressions could not be used about any archaic painting, and they imply that a step of momentous importance has been taken. This is the beginning of the idea of pictorial space, of the picture as not only decoration of a surface (which it still primarily is and ever remains) but also a window opening on a feigned world.

About the nature of the first hesitant steps taken into this new world we may learn something by turning from Pausanias' description to certain vase-paintings of Polygnotos' time. The Penthesilea Painter must have looked at Mikon's Amazon-battles, but he adapted their grandeur to the traditional composition of a cup-tondo. The painter of the big mixing-bowl on p. 124 gives a more literal transcription of some

elements in his great models. His figures, instead of being set down on the base-line of the picture, are scattered up and down it, resting on thin wavy lines, drawn in white over the black glaze, which seem to represent the recession of steeply rising broken ground. It would be perverse to doubt that this was how Polygnotos and Mikon set their figures, but one great difference is immediately evident. The silhouetting of figures against a shiny black background is purely a vase-painters' technique, cherished by them because it emphasized the curving surface of the vessel; and for that very reason it is in flat contradiction to the new spatial concepts of the wall-painters. Euphronios and Euthymides could feel themselves fighters in the forefront of the revolution of their time. Red-figure vase-painters of the Polygnotan generation must abandon the attempt to keep abreast of great painting, or else must compromise with its achievements. By using the white-ground technique vase-painters could, as we shall see, absorb far more of the new ideas without distorting them or sacrificing the character of their own craft; and the best vase-painting from now on is of this kind. The decorative principle, however, of silhouette it seems was rooted too deeply in Greek vase-painting tradition to be abandoned; and the white-ground technique never becomes more, in practice, than a side-line of red-figure. The revolution of Polygnotos and Mikon marks the beginning of the end of vase-painting as a serious art.

If we transfer in the mind's eye to the composition of the vase-picture on p. 124 the technique of that illustrated opposite and on the following pages (a smaller and slightly later vessel of the same form) we shall perhaps not be very far from an idea of the appearance of the lost wall-paintings: the unmodulated white sky, the mottled rocks with their creeping plants, the washes of colour on the clothes. The colouring of the wall-paintings, however, will have been more elaborate than here, or at least the gradations and transitions

ATHENIAN MIXING-BOWL, FROM NUMANA
(PICENUM). SECOND QUARTER OF 5th CENTURY B.C.
BATTLE OF GREEKS AND AMAZONS;
ON NECK, BATTLE OF GREEKS AND CENTAURS.
(H. TO TOP OF HANDLES 63.5 CM.) 07.286.84,
METROPOLITAN MUSEUM OF ART, NEW YORK.

ATHENIAN MIXING-BOWL (KRATER), FROM ORVIETO (ETRURIA). SECOND QUARTER OF 5TH CENTURY B.C.
UNCERTAIN SUBJECT (THE ARGONAUTS?). (H. 53 CM.) G 341, MUSÉE DU LOUVRE, PARIS.

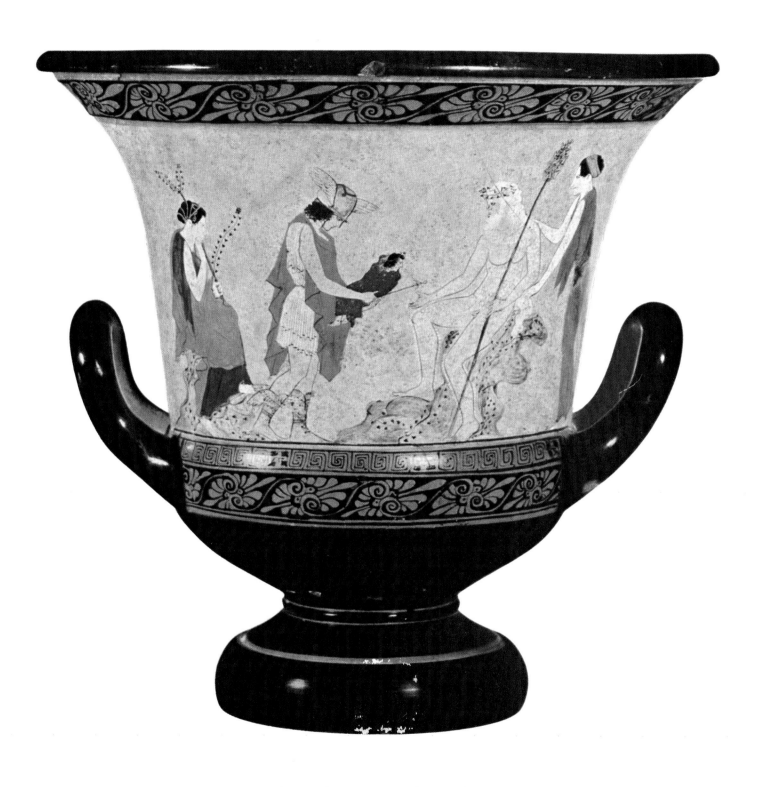

ATHENIAN MIXING-BOWL (KRATER), FROM VULCI (ETRURIA). MID 5th CENTURY B.C.
THE CHILDHOOD OF DIONYSUS. (H. 35 CM.) 559, MUSEO ETRUSCO GREGORIANO, VATICAN.

ATHENIAN MIXING-BOWL (KRATER), DETAIL, FROM VULCI (ETRURIA). MID 5th CENTURY B.C.
MUSE (FROM BACK OF VASE). (H. OF DETAIL C. 17 CM.) 559, MUSEO ETRUSCO GREGORIANO, VATICAN.
(OVER NATURAL SIZE)

will have been more subtle and delicate, especially in the treatment of the human skin. On this vase the women's is painted in a dead white over the creamy white of the ground, on which the men's is drawn in outline. This recalls the black and white sex-distinction of black-figure. It is less crude than there, but still rather

ATHENIAN MIXING-BOWL (KRATER), DETAIL, FROM VULCI (ETRURIA). MID 5th CENTURY B.C.
HERMES AND THE CHILD DIONYSUS. (H. OF DETAIL C. 17 CM.) 559, MUSEO ETRUSCO GREGORIANO, VATICAN.

crude; and the distinction will have been subtler in wall-painting, though present, as it is not in red-figure, or (under red-figure influence) in much white-ground work. We shall meet evidence for a sharp distinction in painting of the end of the fifth century; and some of those Roman paintings which seem most clearly to echo Greek works of the fourth show a purposeful contrast between bronzed man and pale woman. The distinction is based on a difference of ideal, and no doubt to some degree of actuality: the sun-burned frequenter of market-place and sports ground, field, sea and campaign; and the shadow-bred woman whose place is in the house. In early classical wall-painting one must imagine that man's skin was basically the brown of archaic art (as seen on pp. 44 and 94 above) and women's white; that these basic hues were modified to a more natural tone is implied in a reference by the late writer Lucian to the colour in Cassandra's cheeks in the picture at Delphi.

The subject of the white vessel is the child Dionysus, after his miraculous second birth from Zeus his father's thigh (whither he had been snatched from his mortal mother's body when she had been blasted by the sight of her lover in his full godhead), brought by Hermes to be nurtured by the Nymphs of Nysa and old Silenus, white too in his different way. The subject of the red-figure picture has never been satisfactorily explained: Athena, Herakles, and a group of heroes; possibly the Argonauts (pictured at this time by Mikon in the sanctuary of the Dioscuri, who took part in that adventure). Many vase-pictures of this period are difficult of interpretation; and it is clear from descriptions that if Polygnotos' figures had not had their names written beside them his subjects too would often have been exceedingly obscure.

In each of the two paintings in the Lesche at Delphi there were some seventy figures, probably not much under life-size, and they rose in many more tiers than this; which will have made more marked a problem discernible here. 'The recession of steeply rising broken ground'; how much is recession and how much rising? For the vase-picture there is no answer; the two ideas are ambiguously combined. The warrior between Athena and Herakles (posed with a new complexity, like the Achilles of the Penthesilea cup) is certainly, one would say, one of the figures 'furthest in' the picture, conceived as at the greatest distance from us behind the surface plane; yet his spear is drawn over the ornament of the crowning cornice, while those of Athena and the man holding his helmet, who seem to stand nearer to us, disappear behind it. One might ascribe this contradiction to the vase-painter's incomplete grasp of the new idea; but I think it more likely to reflect a deliberate ambiguity in the work of the wall-painters. Artists of the Italian Renaissance, with full command of spatial organization through a perspective system, employ similar ambiguities; and the Greeks, venturing for the first time into a third dimension, were no doubt extremely anxious to preserve and emphasize the surface design. It is relevant that names continued now and later to be written beside figures on the background (that is, on the surface) of wall-paintings no less than on that of vases.

One cannot even be certain that Polygnotos and Mikon were led to their breach with the old conventions in the first instance by an interest in space for its own sake.

We noticed that the change in spirit between archaic and classical art is in part a change from interest in doing to interest in being. A liking for stillness is marked in much early classical art, and is most noticeable in the descriptions of Polygnotos' paintings. Groups of inactive figures, like those on this vase, constantly recur there: Hector seated, clasping his knee, with an air of desolation, and Memnon sitting beside him on a rock (a negro boy in attendance), one hand on the shoulder of Sarpedon whose face is buried in his hands; Protesilaus seated, looking at Achilles, who is also seated, with Patroclus standing beside him; and so on. Episodes in a scene of action, however disparate on analysis, can be organized into an effective whole in a purely surface composition; but to knit the figures and groups of a still gathering like this into an interesting unity the artist needs the help of the third dimension. The steeply rising terrain, limiting the space with its comforting ambiguities, reflects also a landscape at hand for any Greek to see. The site of Delphi itself is a perfect example.

ATHENIAN CUP, FROM ATHENS. SECOND QUARTER OF 5th CENTURY B.C.
UNCERTAIN SUBJECT (DEATH OF OPHELTES?). (D. OF BOWL 13 CM.) D 7, BRITISH MUSEUM, LONDON.

These observations perhaps do something to justify the vase-painter in his compromise. Nevertheless, the break once made is the entry into a new world from which there is no going back; and pictures of action, reflecting the battle-pieces of the wall-painters, show that some interest in space for its own sake was already awake.

The figure just visible at the top left of the picture on p. 124 is half hidden behind a rise in the ground; a more emphatic way of emphasizing the existence of a third dimension. We know that Mikon practised this device: of a warrior named Butes in one of his works only the helmet and one eye appeared over the hill, and 'quicker than Butes' became a proverb. Most of the works ascribed to Polygnotos are clearly defined as quiet scenes; sometimes deliberate adaptations of earlier action-themes to the new ideal of passivity, as in the transformation of the *Sack of Troy* into *Troy Taken*. Mikon, as certainly, was often a painter of action, especially battles.

A battle of Greeks and Amazons (on their invasion of Attica a generation before Penthesilea came to Troy) circles the vase shown on p. 123. Some of the figures are set on uneven ground (indicated by white lines now only visible in certain lights) and under the handles are others concealed to waist, breast or neck in folds of the hill. Other vase-pictures of the same subject show similar treatment, and one cannot doubt that there is influence from the Amazon-battles recorded as Mikon's; but there is little repetition of detail from one vase to another, and no evidence that any vase-painter ever directly copied a wall-painting.

In one such vase-picture the eye is led in by very bold foreshortening of a horse, ridden almost straight out of the picture by an Amazon whose face also is turned towards us, and by complex overlapping in the mêlée around her. In the one we illustrate the

ATHENIAN CUP, DETAIL, FROM ATHENS. SECOND QUARTER OF 5th CENTURY B.C. APPARENTLY ONCE SIGNED BY POTTER SOTADES. POLYEIDOS AND GLAUKOS IN THE TOMB. (H. OF DETAIL C. 5.5 CM.) D 5, BRITISH MUSEUM, LONDON. (OVER NATURAL SIZE)

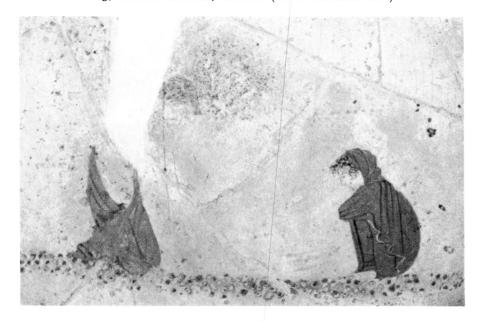

FRAGMENTARY ATHENIAN CUP, FROM ATHENS. SECOND QUARTER OF 5th CENTURY B.C. SIGNED BY POTTER SOTADES. GIRL PICKING APPLES. (H. OF DETAIL C. 8.5 CM.) D 6, BRITISH MUSEUM, LONDON. (OVER NATURAL SIZE)

painter has set his mounted Amazon more traditionally in profile; but the Greek crumpled under his shield between the horse's forelegs, and his fighting companion (Theseus perhaps) shown beyond him just higher up the vase-surface, give the setting (apart from the black ground) an unambiguous spatial reality. Plants grow on the ground lines among the feet, and others on other such lines higher up the picture are drawn smaller. In the narrow neck-picture (the fight of Greeks and Centaurs at Peirithous' wedding—an indoor scene) the figures are set down on the base-line. The violent foreshortenings, however, imply influence from wall-painting; and the central Greek (Theseus again) is closely paralleled in other vase-pictures and in the West gable of the Temple of Zeus at Olympia, where pictorial influence is pronounced; and this subject, too, was painted in the sanctuary of Theseus.

The Niobid Painter (as the artist of the 'Argonaut' picture is called, after the scene he set on the back of that vase, the slaughter of the children of Niobe) was no great draughtsman. His companion who painted the Amazon-battle was a very weak one.

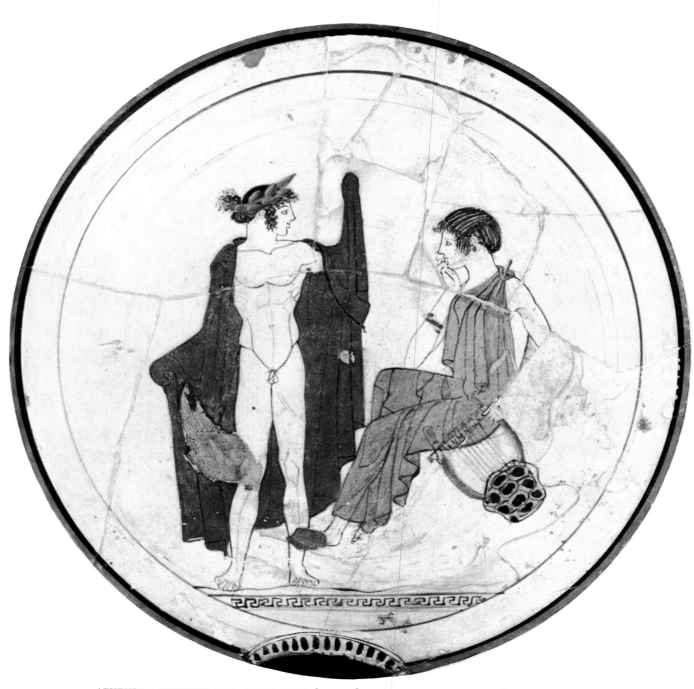

ATHENIAN COVERED CUP, FROM VARI (ATTICA). SECOND QUARTER OF 5th CENTURY B.C.
APOLLO AND A MUSE. (D. OF PICTURE 11 CM.) 00.356, MUSEUM OF FINE ARTS, BOSTON. (OVER NATURAL SIZE)

Yet we may be grateful to them for having ideas beyond their powers. Something of the crowded violence of a big battle-scene does get through here, though far less than in the genuinely recreated grandeur of the Penthesilea cup. If we can conceive a composition like this drawn with that power on a big wall in a technique reminiscent of white-ground vases, we may begin to approach Mikon.

A tiny, fragmentary white-ground cup may help us to this; and even if it does not, we are back with work of splendid intrinsic quality, though much is missing, as can be seen from the picture on p. 129. From a cluster of tall reeds, their tufted heads bent, rears a monstrous snake, breathing out a cloud of smoke which is modelled in a thick mass of the same white substance as makes the ground colour. Starting away from the creature is a rough-faced man with a skin cloak and cap, a hunter's throwing-stick in his left hand, a stone raised to hurl in his right. He stood well up in the centre of the circle. A piece from the lower part gives what are probably the toes of his right foot and part of a smaller female figure fallen kneeling against the rim. The subject has been interpreted as an episode from the story of the Seven against Thebes, the death of a child Opheltes; but the central figure should in that case be a hero, which his rustic garb and vividly individualized features seem to make impossible. In late archaic and early classical vase-painting there are many lively renderings of the old and the ugly, the alien and the poor, a concern rare in earlier times and again in the high classical age. The idea of individual portraiture, implied in the story of Elpinice as Laodice, is related to this, and there is some other evidence for its practice at this time.

This cup is a bowl on a low foot. It is of exceptionally delicate make; and of the same quality and character are two stemmed cups (like this very small), one at least of which is signed by a potter Sotades. The pictures on all three are by one man. The potter, here and elsewhere, shows himself an ingenious and sure-handed experimenter. The painter is of the same kind and calibre, and was most likely the same person, but can only be known as the Sotades Painter. On the certainly signed cup (an enlarged detail on p. 131) the figures rest on the border in the old tradition, but there is nothing old-fashioned about the drawing. In the centre grows a tree, with fruits applied in white like the dragon's breath. To our left of it was a crouching girl, no doubt picking up fallen fruit, but only part of her back remains and a name written above. On the other side a second girl, part of whose name also remains, stretches, face upturned, towards a fruit she cannot quite reach: the apple on the topmost bough, as Sappho had written a century before, which the harvesters forgot—no, not forgot; they could not reach it. With the other hand she pulls aside her thin, clinging gown. In late archaic vase-painting the body is often drawn through the clothes, but here there is a new sensitiveness in the realization of the stuff's soft nature and its relation to the firm limbs. Similar is the feeling for the hang of the scarfed hair. The drawing throughout these miniatures is of a wonderful strength and freedom.

Pliny, whose volumes on natural history compiled in the first century A.D. are the source of much of our information about Greek artists, writes that Polygnotos first painted women with translucent drapery and gave them headdresses of various colours, and first showed the mouth open, the teeth visible, the features varied from their ancient stiffness. Vase-paintings help us to detect the echo of a meaning in these arid and inaccurate observations.

The third of the Sotades Painter's cups (the figures in an enlarged detail p. 130) is more complete. Here again the two figures are labelled, showing that the story is a rare

one from mythology. Minos of Crete had a son Glaukos, who one day was lost. A seer Polyeidos, called in to search, found him drowned in a jar of honey. The father then put the body in a tomb, and with it the prophet, that if he wished to live himself he might find a way to revive the child. A snake crept into the tomb, and Polyeidos killed it. Its mate came, and finding it dead departed, and coming again with a herb revived it. Polyeidos took the herb and brought Glaukos too back to life.

In the picture a section of the tomb is shown, schematic shading within its domed roof beneath which the two figures crouch on a pebble floor. (The pebbled beach was shown along the foreground of one part of Polygnotos' *Troy Taken* at Delphi.) Near the top of the dome appears the end of the potter's name, with apparently no place for a verb. Outside, the tomb is crowned with a tripod. Opposite this, at the bottom of the circle, are the two snakes, one in the bold loop-pattern regularly used to show the creature in motion, the other in a twisted knot: evidently the living one approaching the dead. The figure of Polyeidos, however, illustrates a different moment: he is poised to strike and kill; while little Glaukos, in his dark cerements, sits up to watch. We have already considered ambiguities of space; here they are present again, with corresponding ambiguities of time, which were certainly also found in Polygnotos' *Troy Taken* and his *Underworld*. We must not expect always in this art the precision of setting and moment to which we are commonly accustomed. Analogous uncertainties are to be found in Attic tragedy, coming to its prime at just this period: Sophocles first won a prize in 468 B.C. and Aeschylus, born in 525, died in 455.

Action-scenes—the battles, the man with the dragon—are naturally without these ambiguities, and quiet pictures can be so too. Such is the idyll illustrated on p. 132, a small white-ground cup by another hand and of another form. The design is not laid in the bowl but on the slightly domed surface of a cover made in one with the cup, an orifice for drinking in the red-figure laurel-border; a rather rare shape. The base of the picture is here defined by a chord with a narrow band of pattern. The figures, however, are not set down on it but in 'Polygnotan' fashion on indications of broken ground: a wavy line beneath the feet of the standing figure; the other seated up on a rock. The youth, whose laurel wreath like many of the details was once gilded, is certainly Apollo. The girl's lyre perhaps shows her a Muse; but the god's gesture of revealing his body suggests a love-scene, where a Muse would not be in place. A Nymph, it may be; or one thinks of the story of Cassandra, who promised herself to Apollo and then refused; whereupon to the gift of prophecy with which he had endowed her he added the terrible rider that her true predictions should never be believed. The lyre would then be the symbol of her inspiration. This is probably to read too much into the picture; but it is a characteristic of work of this time that it seems to contain a weight of meaning beyond anything actually portrayed. From the descriptions, especially of the *Underworld*, it is clear that Polygnotos worked in this allusive manner; and this, one would say, is a very 'Polygnotan' work.

The hand to the chin, implying thought, often troubled thought, is of constant recurrence in this art. So also is the group of one figure standing by another seated on

a rock. The most splendid example we have is the metope, from the Temple of Zeus at Olympia, with Herakles bringing the bodies of the Stymphalian birds to Athena. How such a grouping might have been integrated into large compositions is suggested by the arrangement of the principal figures in the picture on p. 124, where the youth reclining at the bottom of the picture and the other above him clasping his knee are especially reminiscent of descriptions of Polygnotos' work.

In this chapter we have been trying to feel our way to some appreciation of a lost art. Some echo of it we have perhaps recovered; but it is more profitable at the last to remember the beauty of the cup-pictures in their own right.

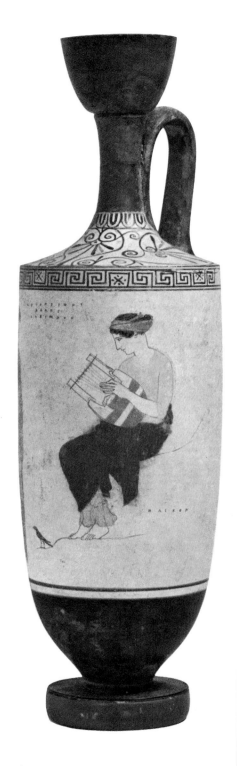

ATHENIAN OIL-FLASK (LEKYTHOS), FROM A GRAVE IN ATTICA. THIRD QUARTER OF 5th CENTURY B.C.
MUSES ON MOUNT HELICON. (H. 36.7 CM.) PRIVATE COLLECTION.

CLASSICAL PAINTING

THE picture on the vessel illustrated on pp. 136 to 139 is in composition very like that on the covered cup discussed at the end of the last chapter: 'Polygnotan' space, with two figures, one erect and fronting us but looking towards the other, seated in profile on a rock; as we saw, a favourite construction. In feeling, however, the later work (this is certainly well after the middle of the century, the other well before; perhaps twenty years or more between them), its wonderful serenity seeming lightly touched with melancholy, is surely closer to the earlier cup with Aphrodite on the goose. In another chapter we noticed a resemblance between the Berlin Painter's Ganymede and the archer by Epiktetos, across the profound changes wrought in the generation of Euphronios and Euthymides: changes absorbed and taken for granted by the younger artist. So it is here. We shall find evidence that the great painters of the late fifth and early fourth centuries were wrestling with new problems, breaking new ground. The best vase-painters of the intervening period, the high classical age of Periclean Athens, show an acceptance, a serene enjoyment, of fields already won, very much as did the latest archaic painters half a century before; and this probably echoes the situation in great painting; at least the references to the younger Aglaophon and to Panainos, the brother or nephew of Pheidias and his collaborator, do not suggest that their admired pictures were remarkable for any striking innovations or developments One may guess that some of the eight panels by Panainos, each with two figures, which adorned or fenced off the throne of the colossal Zeus in gold and ivory made by Pheidias for the temple of Zeus at Olympia, were not very different in effect from vase-pictures like this; the "Hellas and Salamis" for instance, perhaps the "Theseus and Peirithous"; certainly the "Two Hesperids carrying apples". Pictures on the walls of Roman houses, like that illustrated in *Roman Painting* p. 29, must be copied from Greek originals of this time; and their remarkable resemblance to the pictures on the vases confirms the close relation between the two arts. Others of the panels at Olympia showed scenes of action; one Pausanias tells us, "Penthesilea giving up the ghost, and Achilles supporting her", which perhaps confirms the romantic interpretation of the great red-figure cup.

The white cup goes out of fashion in Periclean Athens, and the favourite form of white-ground vessel is this, the *lekythos*; a word which we know the Greeks themselves used for this particular shape, though also for other related ones. It was an oil flask, different from the little round athlete's oil-bottle shown in the picture on p. 88, and

ATHENIAN OIL-FLASK (LEKYTHOS), DETAIL, FROM A GRAVE IN ATTICA. THIRD QUARTER OF 5th CENTURY B.C.
STANDING MUSE. (H. OF PICTURE 15.5 CM.) PRIVATE COLLECTION. (OVER NATURAL SIZE)

ATHENIAN OIL-FLASK (LEKYTHOS), DETAIL, FROM A GRAVE IN ATTICA. THIRD QUARTER OF 5th CENTURY B.C
MUSE SEATED WITH LYRE. (H. OF PICTURE 15.5 CM.) PRIVATE COLLECTION. (OVER NATURAL SIZE)

intended in the main for different purposes; at first probably domestic and later, the white ones at least, consecrated to a special religious use. The first vessels to show the tall, narrow form and distinctive mouth appear in Attic black-figure of the early sixth century. The angular shoulder comes in before the middle of the century, and towards the end the canonical form shown here is approximately reached. It is a favourite shape of the mass-producers of cheap black-figure active through the first half of the fifth century, who often use a white slip and occasionally vary their work with drawing in a black glaze outline. The earliest red-figure lekythoi belong to the sixth century, but the first great artist in that technique to make regular use of the form is the Berlin Painter. We have no white lekythoi by him, but an occasional one by a contemporary, Douris for instance; and they become commoner in the period covered by the last chapter. At that time a second white is used for women's skin, as on the mixing-bowl shown on pp. 125 to 127. This practice, foreign to the white cup, is followed in his early work by the first great artist to specialize in the white lekythos: the Achilles Painter, to whose mature style belong the vases shown on pp. 136 to 145. The effect of the second white (a clinging, perhaps, to the tradition of silhouette) is seldom very happy, and the painter only reaches his full stature when he gives it up.

The Achilles Painter started as a red-figure artist, and was a pupil of the late archaic Berlin Painter, whose last works, tired and mechanical, are, like his pupils' earliest, contemporary with the classical revolution. The younger man's name-piece is a big red-figure amphora (one of the latest vases of the form illustrated on pp. 62 and 91) decorated in his master's tradition with a single figure on either side: Achilles and a woman, perhaps Briseis, beautifully drawn. He even worked in black-figure too. The prize vases for the games at the great four-yearly Panathenaic festival (whose procession is illustrated on the frieze of the Parthenon), reorganized by Peisistratos in the mid-sixth century, were traditionally painted in the manner of that time, black-figure. We have examples by the Kleophrades Painter, the Berlin Painter towards the end of his career, and after him the Achilles Painter; and the practice outlasts white-ground vase-painting and red-figure too, dying only in the second century B.C.

What makes the Achilles Painter a great name, however, is his white-ground work. The lekythos had probably always been used, apart from its domestic employment, for anointing the dead; and the white lekythoi produced in Athens from before the middle of the fifth century into the beginning of the fourth are designed exclusively to be placed in or on graves. Where the find-spot is known it is almost always a grave, and generally a grave in Attica or in an Athenian settlement like that at Eretria in Euboea. They are found sometimes in other Greek cities, but never, like most Greek vases, in Etruria. The subjects of the pictures are limited in scope and often concerned with death; and in some such cases, where the tomb is shown, such vessels are standing on its steps.

It was perhaps partly because they were meant for this brief use that the technique was felt suitable. More, and more fugitive, colours are placed on these than on the earlier white cups, and have often flaked or faded: so, the transparent undergarment of the standing woman on p. 138; the seated figure's is better preserved. This vase was found

ATHENIAN OIL-FLASK (LEKYTHOS), DETAIL, FROM GELA (SICILY). THIRD QUARTER OF 5th CENTURY B.C.
MISTRESS AND MAID: THE MISTRESS. (H. OF PICTURE 19 CM.) 13 201, MUSEUM OF FINE ARTS, BOSTON.

in a girl's grave, but the subject has not, for us at least, any clear connection with death. We saw that the girl on the covered cup is perhaps a Muse. On the back of the white vessel on p. 126 a woman sits on a rock playing a more elaborate lyre, between two standing, one holding a lyre of the simpler kind, the other muffled and without instrument; probably Muses, for in a very similar composition on a poorer red-figure vase are names: Terpsichore sits on a rock, a simple lyre in her hand, between two standing figures without instruments: Clio, and their master Apollo. The figures on the lekythos are not named, but the seated one, with her *kithara*, the most complex form of lyre, is certainly a Muse, for the rock on which she sits is inscribed 'Helicon'. Such a local designation is as rare as the picture-title on Sophilos's fragment of a century and a half before. The standing figure, though she has no instrument, is probably a sister Muse, though one could imagine her a mortal poet, a Sappho or Corinna, awaiting the goddess's inspiration. Such a meeting of two worlds is, as we shall see, a feature of the pictures on these vessels which were made for the living to leave with the dead. Certainly the holy mountain ends sharply before her feet, in front of the little bird. The other way the lines fade off in a suggestion of rising ground. The rocks in the earlier pictures (pp. 125 and 132) are brought round and finished off rather unconvincingly. The impressionism of the treatment here looks forward to later developments, but there is nothing of it in the contours of the figures. There continuity and harmony are still the rule.

The inscription above praises the beauty of Axiopeithes son of Alkimachos, himself praised on works of a generation or so before. It is curious to find such inscriptions on vases of such a personal use as these lekythoi, but they are regular in the work of the early and middle years of the Achilles Painter (most often first one Diphilos, then one Hygiainon, then Axiopeithes), though afterwards he abandoned the practice and it is scarcely found in the work of later practitioners. The inscription is arranged, like careful ones on stone, with the letters aligned vertically as well as horizontally. Writing in purple-red on the black ground of red-figure vases is generally without much art; in white-ground pictures the better craftsmen exercise the same care as we saw displayed earlier in the inscriptions on good black-figure.

The feeling of the Helicon picture is rare and fine. The figure on p. 141, a detail from a lekythos with the same inscription, no doubt painted about the same time, is less remarkable in conception but at least as sensitive in drawing. Like a figure from the frieze of the Parthenon, she is the very image of classical calm. This was not the only kind of art at the time. The controlled power of the best figures that survive from the pediments of the same temple is something very different. Copies from the battle of Greeks and Amazons which Pheidias set on the shield of his great Athena Parthenos within the temple, and from the slaughter of the Niobids on the throne of the Zeus at Olympia, show that he himself could render physical and emotional strain as well as the sublime detachment for which his deities were renowned. The inside of the shield was painted with a battle of gods and giants, whether by Pheidias himself (he was said to have started as a painter) or by Panainos or another; and that will have been a different sort of painting from this or from the two-figure panels at Olympia. Red-figure

ATHENIAN OIL-FLASK (LEKYTHOS), DETAIL, FROM ERETRIA (EUBOEA). THIRD QUARTER OF 5th CENTURY B.C.
YOUNG MAN AT TOMB. (H. OF PICTURE 16.5 CM.) D 54, BRITISH MUSEUM, LONDON. (OVER NATURAL SIZE)

143

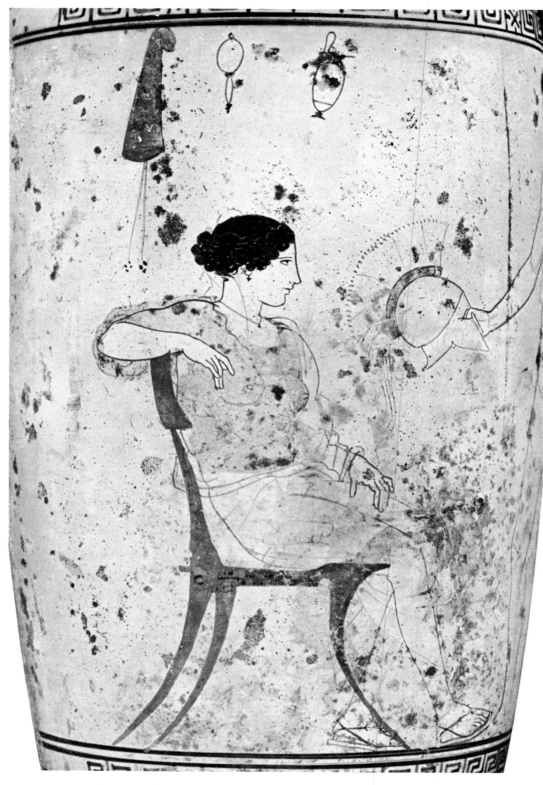

ATHENIAN OIL-FLASK (LEKYTHOS), DETAIL, FROM ERETRIA (EUBOEA). THIRD QUARTER OF 5th CENTURY B.C.
SEATED WOMAN (SOLDIER'S DEPARTURE). (H. OF PICTURE 21 CM.) 1818, NATIONAL MUSEUM, ATHENS.

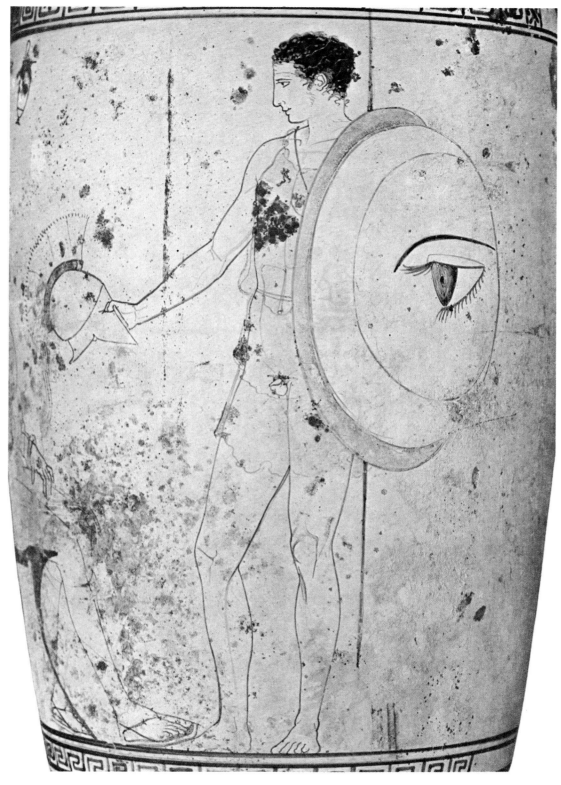

ATHENIAN OIL-FLASK (LEKYTHOS), DETAIL, FROM ERETRIA (EUBOEA). THIRD QUARTER OF 5th CENTURY B.C. DEPARTING SOLDIER. (H. OF PICTURE 21 CM.) 1818, NATIONAL MUSEUM, ATHENS.

vase-pictures from the end of the century perhaps echo it, and show giants in the foreground, many in back view, some *profil perdu*, resisting the gods who attack towards us from the top: a new step in the realization of space. About this trend in painting, however, we can only gather hints; the white lekythoi give us the actuality of the other.

The subject here is not concerned with death but with everyday life. The second figure is a little servant-girl bringing her mistress a box; probably, on other analogies, a jewel-box. The theme is common not only on lekythoi but on the carved tombstones of late fifth and fourth-century Athens; and there as here the figures have a gravity, if not a sadness, that allows one to remember that in the end the jewels will be used to deck their owner for the grave. If there be such an allusion, however, it is of the subtlest, faintest kind. In the next picture the reference to death is direct: a tomb stands in the centre, hung with fillets. Such are often tied round sacred objects, and the tomb is a holy place. The dead has become in some sense divine, and the gifts laid in or about the grave are in the nature of dedications. On one side a young man in a dark robe is holding out a bag, probably to lay it on the plinth of the tomb. It must contain some mortal gear that was precious to the dead in his life. On the other side stands another young man, half turned to us but looking towards the first. He wears a short cloak, light red, and slung behind his shoulder a wide-brimmed hat, a spear in his hand: a hunter's or traveller's garb. If we had this picture alone, we might perhaps think him too a visitor to the tomb; but there is a difference of character between the figures, and often in such groupings it is clear that, while one is a living mourner with offerings, the other, standing detached, unseen by the first, is the dead, not present in the same sense, the two divided and united by the pictured tomb. So it must be here; and the tiny wraith fluttering high beside the stone marks perhaps the living boy's awareness of the dead one's presence.

This, though delicate and beautiful, is a comparatively slight work. On the following pages we have another of the artist's masterpieces. This time we are in the house again, not at the tomb, but there is a clear hint of death. A jug, a mirror and a soft cap with tasselled strings which hang on the wall show that this is the women's quarters, and a young woman sits there in a chair; but the young man standing before her holds helmet, shield and spear. Again a quiet gravity (hardly amounting to sadness, controlled as it is by the harmony of the line) unites the pair in a timeless stillness. The woman's lovely relaxed pose, one elbow over the back of her chair, is found in relief and free sculpture of the second half of the fifth century as well as vase-painting, but looks perhaps like a painter's thought. Such acceptance of a satisfying creation into a common repertory of motives is typical of Greek art.

The eye, like the staring Gorgon-mask which we met much earlier, is an ancient symbol of defiance and protection; and as such, no doubt, it is used as a shield-device. Turned in profile, however, by the classical painter, and half hidden under the drooping lid, its character is changed and it harmonizes with the quiet scene.

The Achilles Painter has no equal among the contemporary or near-contemporary artists who took up the white lekythos under his influence, but some have left fine and attractive work. The author of the pictures shown on pp. 147 to 151 worked also in

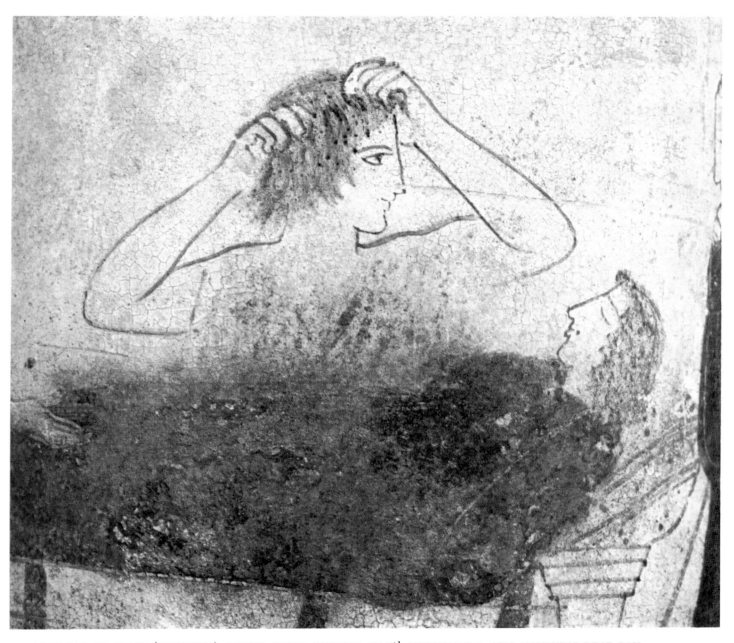

ATHENIAN OIL-FLASK (LEKYTHOS), DETAIL. THIRD QUARTER OF 5th CENTURY B.C. GIRL MOURNING DEAD BOY. (H. OF DETAIL C. 5.5 CM.) 07.286.40, METROPOLITAN MUSEUM OF ART, NEW YORK. (OVER NATURAL SIZE)

red-figure, especially as a cup-painter. Like the Achilles Painter he started in the time of the classical revolution, and the masterpiece of his youth is a white cup with a picture of Hera. Later he specialized in white lekythoi, working at first with the thinned glaze used for the lines on all those we have so far looked at, afterwards with matt colours, a red and a black or grey. The new medium was used also by the Achilles Painter, but only in a few of his latest works, whereas the greater number of the other's white lekythoi show it, though its possibilities were fully explored only by younger artists.

The charming detail on p. 147 is from one of his works in the old technique. The scene is found on a good many lekythoi, and we met it three or four hundred years earlier on the great geometric grave-vases (pp. 34 and 38): the *prothesis*, the laying out and mourning of the dead. Pictures of the rite are known from the interval: on plaques from tombs and on funerary vases of various forms. Here the dead is a child. A man and woman, the parents it must be, mourn at head and foot; and in the middle this girl, perhaps an elder sister. With her short fair hair she is a classical counterpart to the Brygos Painter's girl (p. 104), but the cropping does not here make her a slave; it is a sign of mourning. The painter's touch is unsure. He falls easily into conventionality; but in this head there is a freshness and charm that have perhaps a more immediate appeal than the greater artist's mastery.

The heads on the matt-painted vase (pp. 150-151) are not of this quality, but the moving subject is honestly and simply rendered. Homer tells us how, when Zeus could no longer delay the death of his beloved mortal son Sarpedon, fated to fall before Troy at Patroclus' hands, he told Apollo to snatch the body from the battle, wash it in river-waters, and give it to the twin-brothers Sleep and Death. They were to carry it to Lycia, where Sarpedon's kith and kin would rear him a mound and a stone, the dead's due. The scene is occasionally pictured. On a beautiful red-figure cup-exterior of the end of the sixth century Sleep and Death are shown as winged youths, like Love but armoured, one fair, the other—Death, I suppose—dark. On the lekythos, and others like it, the dead is a young soldier and the scene may still be thought of as the legendary story. If so it is used as the antetype of a contemporary death in battle; but it may be rather the contemporary dead who is shown as honoured like the hero; or the distinction may not be exactly made—ambiguity is a characteristic of this art. So, though the tomb is shown, they are not to be thought of as laying the body on its steps. They are rather lifting the youth from the battle-field; and that behind is the stone, the dead's due, which his family will raise above him.

The spirits have changed their nature from the archaic picture and from Homer's words. They are no longer armed and no longer brothers. Sleep at the head is still a boy, but Death has the hooked nose and rough hair and beard of another winged ancient, Boreas, the north wind. Death's tunic is dark, Sleep's particoloured, but the light part has faded, as so often in this fugitive medium.

We have noticed several times that when a new technique is introduced into vase-painting it is apt at first to be used cautiously, in a style evolved for an older one: the first red-figure painters work in a black-figure style, the first white-ground in a red-figure. In the same way the figures on the earlier white lekythoi decorated in matt colours, like this one, have the smooth unbroken contour of those drawn in the traditional thinned glaze. A leaning towards a more broken, impressionistic manner has, however, been glimpsed from time to time. Such a style was perhaps being developed at this period in wall or panel painting, whose influence must be responsible for the introduction of matt colours into vase-decoration; certainly in the following generations it becomes apparent in the pictures on white lekythoi.

This phase belongs to the years of the Peloponnesian War. The league of Greek states which Themistocles and Cimon had led against Persia had become under Pericles an empire whose tribute went to enrich and beautify Athens. The discontent bred of this change was fostered by the Spartans, who feared Athens' growth of power, and in 431 a war broke out in which almost the whole of Greece was at one time or another involved, and which lasted, with a period of uneasy peace in the middle, till the decisive defeat of Athens in 404 B.C. In the arts this period is marked by a tendency to prettiness and elaboration, in architecture and sculpture as well as in red-figure vase-painting; but it is an age of great names in painting, and evidently of renewed experiment and struggle. The best of the white lekythoi, like the best of the carved grave-stones of this time, have a bigness and power as well as a strength of feeling which shows that prettiness was not all. They have also a freedom of handling which must reflect developments in great painting, and the latest use more colour too.

The two best painters of lekythoi in this technique belong to the beginning and end of the phase. The painter of the vessel shown on p. 152 was a pupil of the Achilles Painter. His work is mainly red-figure (among the best of the time), but if he has left us few white lekythoi, this one at least is of unsurpassed quality. We are at the tomb again, bound with fillets, a woman approaching with another, head bent, a mourner. In front of the tomb steps is a rock, on which a woman sits, chin sunk on hand; but the rock is not surely, in the graveyard: rather in the Underworld, and this is the dead. She is one of the finest embodiments of the 'Polygnotan' type of figure noticed in the last chapter; another example of the absorption and retention of satisfying creations. The handling, however, is wholly new, reminding one of a charcoal sketch. It may be no chance that the first painter of whom it is recorded that his sketches or drawings (on panel and parchment) were preserved by later artists belongs to this time: Parrhasios, to whom we shall return.

We know from a reference in Aristophanes' *Ecclesiazusae* that white lekythoi were still being painted in 390 B.C., but the joke makes the best sense if we suppose that only one old man was still producing them then, and one would guess that the finest late pieces we have are a little earlier than that, nearer to the end of the Peloponnesian war. Details of two by the last great painter in this field are illustrated on pp. 154 and 155. Each shows a young soldier seated on the steps of a tomb between two standing figures: the dead between mourners; still, heavy, brooding figures. Like the woman on the earlier lekythos they owe something to 'Polygnotan' creations. Such a seated figure in three-quarter view as the youth in the centre of p. 124 lies behind them, or his models in great painting, as one would guess Hector in the *Underworld*, "clasping his knee with an air of desolation"; but there is a profound change of feeling. Polygnotos belongs, like Aeschylus, to the classical spring-time, when the Persians had been defeated and everything seemed possible to the Greeks. Tragedy then is seen in terms of great spirits and destiny. These works, like the late plays of Euripides, were created against the end and aftermath of a long, ruinous war, when tragedy is inextricably bound up with daily life, immediate, complex and bitter.

ATHENIAN OIL-FLASK (LEKYTHOS), DETAIL. THIRD TO LAST QUARTER OF 5th CENTURY B.C. SLEEP AND DEATH WITH THE BODY OF A YOUNG SOLDIER: DEATH. (H. OF PICTURE 18.5 CM.) D 59, BRITISH MUSEUM, LONDON. (OVER NATURAL SIZE)

ATHENIAN OIL-FLASK (LEKYTHOS), DETAIL. THIRD TO LAST QUARTER OF 5th CENTURY B.C. SLEEP AND DEATH
WITH THE BODY OF A YOUNG SOLDIER: SLEEP. (H. OF PICTURE 18.5 CM.) D 59, BRITISH MUSEUM, LONDON.
(OVER NATURAL SIZE)

ATHENIAN OIL-FLASK (LEKYTHOS), DETAIL, FROM A GRAVE AT OROPOS (ATTICA). THIRD TO LAST QUARTER OF
5th CENTURY B.C. WOMAN SEATED AT HER TOMB. (H. OF PICTURE 18 CM.)
2798, STAATLICHE ANTIKENSAMMLUNGEN, MUNICH.

One calls these figures 'heavy', and they do make a strong impression of volume and weight, but this is achieved entirely by linear means; there is no shading. We saw that a primitive shading does appear on some late archaic works, and occasionally also in the early classical period (see title-page), and later (on the warrior's shield, for instance, on p. 145); and that in other cases a mottling with darker colour is used (pp. 101 and 125) which produces somewhat the effect of shading without being precisely definable as such. The earliest and latest of these examples, however, are little different from one another. The preoccupation with spatial construction seems to have turned the attention of the great early classical painters away from this interest; but what we are told about the masters of the late fifth and early fourth centuries shows a return to it. Apollodoros of Athens was known as the 'shadow-painter', and his younger contemporary, Zeuxis of Heraclea, who was active in Athens and elsewhere at the turn of the fifth and fourth centuries (and perhaps already as early as the twenties) is recorded as advancing further along the same road. Zeuxis' great rival was Parrhasios of Ephesus (he, too, worked in Athens), and the rather obscure accounts of his style suggest that he was opposed to this movement and aimed to produce effects of volume by a nervous contour, rather as did some painters of the Italian Renaissance.

Figures seated in three-quarter view, like those on the lekythoi, are popular at this time, and a very similar one is embossed on a silver cup, made for a Roman about four hundred years later but clearly reflecting the style of the late fifth century. This figure represents Philoctetes. One of Parrhasios' famous pictures was of this suffering hero, whose painful story is told in the great play produced by Sophocles in 409 B.C. It seems not impossible that the figure on the cup is taken from Parrhasios' design, and that the youths on the lekythoi echo his creations, their handling the style of those great painters who were least sympathetic to the development towards chiaroscuro.

Several of Parrhasios' recorded pictures seem to have shown passive suffering; and one may perhaps see him as the heir, in the changed light of his time, to something in Polygnotos' character, though he had another side: the little pictures of erotic deviations which he painted, Pliny tells us, by way of relaxation, one of which the emperor Tiberius afterwards kept in his bedroom. Aristotle compares Zeuxis unfavourably with Polygnotos for his lack of *ethos*, a difficult word to translate. 'Character' is sometimes used, but it is perhaps here rather that sense of inner life, of something implied more than is stated, which is shared by the best works illustrated in the last chapter and in this (and is already present in the Kleophrades Painter's maenads), but is markedly absent from much art of the late fifth century.

Before we turn to look for reflections of the shadow-painters' innovations, we may consider a few pieces which relate rather to the tradition we have been considering. Most interesting is a ruined fragment which by intention and style is linked to the last white lekythoi, but which gives us a glimpse of an art largely lost to us: the painted marble tombstone from Athens illustrated on p. 157. At the top (now broken) was painted in red and brown a fillet like those on the tombstones pictured on pp. 143 and 152, but shown as looped from three attachments. From the left-hand attachment is represented

ATHENIAN OIL-FLASK (LEKYTHOS), DETAIL, FROM ERETRIA (EUBOEA). LATE 5th CENTURY B.C.
YOUNG MAN SEATED AT HIS TOMB. (H. OF DETAIL C. 21 CM.) 1817, NATIONAL MUSEUM, ATHENS.

ATHENIAN OIL-FLASK (LEKYTHOS), DETAIL, FROM ERETRIA (EUBOEA). LATE 5th CENTURY B.C.
YOUNG MAN SEATED AT HIS TOMB. (H. OF DETAIL C. 21 CM.) 1816, NATIONAL MUSEUM, ATHENS.

as hanging also an athlete's gear: the round oil-bottle (like those shown on p. 88), the end of its suspension cord as often divided into separate strands; and the *stlengis*, more commonly known by its Latin name *strigil*, the scraper with which the oil was removed: a long, narrow spoon, its curved bowl or blade appearing below the oil-bottle, the straight handle above. In the centre hangs a pair of shoes, the left seen almost flat on the sole, the right overlapping it in bold and effective foreshortening. At the bottom, above the area left rough for fixing the stone in its base, a lekythos lies on its side, its foreshortened mouth clearly visible on the left; and with forefeet up on it stands a little dog with sharp nose and curled-over tail, of the kind the Greeks called Melitaios (Maltese). These are commonly shown on Athenian vases from about the time of the Persian wars on. Foreshortened vase-mouths like this are found in some vase-pictures of the late fifth and early fourth centuries. This, with the clever and accomplished foreshortening of the shoe, make an earlier date for the tombstone unlikely; but the presence of a lekythos and the total or almost total lack of shading (the dog's coat may have been so treated as to suggest it) mean that it can hardly be much later.

A good many once-painted tombstones survive, from the archaic period as well as this, most with even less to be seen on them, many with virtually nothing. We know that great painters occasionally worked in this field. One at least is recorded by Nikias, contemporary and coadjutor of the mid-fourth century sculptor Praxiteles, who is likewise said to have carved a tombstone; but most of the carved stones certainly, and probably most of the painted, were the work of comparatively humble craftsmen. From the parallel craft of vase-painting, however, we could not have guessed at anything quite like this; and through its ruined state it still shows as a work of rare quality and feeling.

The paintings we have looked at from the late archaic period on have been exclusively Athenian; and through much of this time nothing of any importance survives from elsewhere. There is now a change. In 443 B.C. Pericles had sponsored the foundation of a colony at Thurii in southern Italy, in which perhaps Athenian potters and vase-painters took part at least red-figure vase-painting, at first nearly indistinguishable from Attic, begins to be produced in Italy during the second half of the fifth century. Soon two lines of development, each with its own style, begin to be distinguishable, one located at Tarentum in Apulia, the other in Lucania, perhaps at Heraclea. This Heraclea was probably the place of origin of Zeuxis, though there were other cities of the name in the Greek world. These South Italian styles share in the common decline of vase-painting, but avoid the over-prettiness and triviality of much Athenian work. In the more provincial Lucanian centre, in particular, works of considerable power were produced.

To this class belongs the picture illustrated on p. 159, from a mixing-bowl of the form we have met so often already (pp. 124 and 125 for instance). The picture is something we have not seen before: a burlesque of a heroic theme. Such are not infrequent from the late fifth century on (this must belong about the turn of the fifth and fourth) and some of the best fourth-century vase-painting is comic. There appear to have been elements of caricature in some work of both Parrhasios and Zeuxis. The story here lends itself to such treatment. It comes from the Iliad, and is told there with a hint of cruel

ATHENIAN MARBLE TOMBSTONE, FROM A GRAVE IN ATHENS. LATE 5th OR EARLY 4th CENTURY B.C.
SHOES AND OTHER BELONGINGS HUNG UP; DOG BELOW WITH FOREFEET ON OIL-FLASK. (W. 26.6 CM.)
KERAMEIKOS MUSEUM, ATHENS.

humour which the vase-painter takes up and exaggerates. At a moment of Trojan triumph and Greek defeat and demoralization Hector calls for a volunteer to slip into the Greek camp at night and spy out their intentions. A spoilt boy, boastful and untried, Dolon, offers himself and sets out, with promise of a reward demanded and granted with fatal arrogance. At the same time, in the despairing Greek camp, Odysseus and Diomed, veterans without illusions or pity, are going out on a similar mission. They hear Dolon coming, let him pass, and close on him behind. He hears their steps and hopes it is a messenger sent by Hector to recall him. Caught, he goes to pieces and tells them all he knows, and they kill him. Diomed was Tydeus' son.

In the picture the three figures, their faces unideal to the point of caricature, move in a kind of dance, weaving among trees. Dolon is in the centre, apprehensive, spear at the ready; Diomed behind him, almost repeating his posture but the spear, which he does not need yet to use, in the crook of his left arm, right hand out to apprehend the boy; while Odysseus, with drawn sword, comes up on the other flank in a contra-puntal movement. Figures and trees make an arabesque over the surface of the vase, but the movement represented is partly out of the picture towards us: Dolon is in front of the trees, his pursuers behind them. In Homer all three wear animal-skins for the night operation. The painter gives them all skin boots, and skin cloak and cap to Dolon. Diomed, however, has the flying cloak so popular in Greek painting and relief from this period onwards, and a helmet with crest-support in the form of an animal; Odysseus the pointed travelling cap *(pilos)* which is his regular wear from now on and was first given him, it is recorded, by Apollodoros the shadow-painter. The odd, bare, lopped trees had leafy twigs added in white which has faded, deciduous the two inner ones, the other two evergreen; but they were always jejune symbols of a natural setting, though used with imagination and effect as part of the formal design.

The vessel illustrated on p. 160 bears a burlesque of a different and commoner kind: not a parody of epic but a picture of stage-farce. Connections can be glimpsed earlier between painting and the stage, but direct pictures of scenes from the theatre seem only to become common in the fourth century, such comedy-scenes as this being very popular in several classes of South Italian vase-painting and found also elsewhere. This is on a mixing-bowl of an ugly form derived ultimately from such fine vessels as those of pp. 98 and 118 ff. It is the most popular of all shapes in the later fifth and fourth centuries, and (among large vessels) the vehicle of the worst excesses of mass-production, but better work is often done on it. This was made at Paestum, where a provincial industry, deriving from the class to which the Dolon vase belongs, flourished during the last three quarters of the fourth century and into the next. The work is ascribed to the leading painter of the style, Asteas, whose serious pieces display a dreadfully heavy hand but whose simple fun is quite tolerable.

In a picture which shows an identical episode at a slightly earlier moment he has given the men the attributes of Zeus and Hermes; and the woman is perhaps Alcmena, who became the mother of Herakles as the consequence of this night's work. Here there is nothing to suggest that they are not ordinary mortals, but the action is the same.

ITALIOTE MIXING-BOWL (KRATER), DETAIL, FROM PISTICCI (SOUTH ITALY). LATE 5th OR EARLY 4th CENTURY B.C. DOLON AMBUSHED. (H. OF PICTURE 19 CM.) F 157, BRITISH MUSEUM, LONDON.

The servant carries torch and provisions, the elderly wooer apples, a recognized love-gift, and a fillet, presumably a present also. Masks, padding and appendages are in the tradition of those used in Old Comedy (Aristophanes and his companions) at Athens, but whether these pictures illustrated their plays or local derivatives we cannot be sure. The humour is not over-subtle. On the other vase the lover is bringing up the ladder and seems to have got his head stuck between the rungs. Here, carried away by his eloquence, he seems due for a fall.

This vase, which was made some time about the middle of the fourth century is in red-figure, but with much more added colour than we are used to. The practice leads at this period to the development of a new technique, in which figures are painted in various colours over the black glaze. Something analogous had been done in Athens in the early days of red-figure, but there can hardly be a connection. This technique, known as Gnathia from the place of its first finding, seems to have been principally

PAESTAN MIXING-BOWL (KRATER), DETAIL, FROM SOUTH ITALY. MID 4th CENTURY B.C.
SCENE FROM COMEDY: LOVE ADVENTURE. (H. OF PICTURE 19 CM.) F 150, BRITISH MUSEUM, LONDON.

practised as a sideline by decorators of the red-figure vases known as Apulian, produced in Tarentum which was throughout the most metropolitan centre of the South Italian industry. The best works in the Gnathia technique, however (which runs through the second half of the fourth century and into the third), are both of more intrinsic merit than anything in contemporary red-figure, and show a more direct influence from the developments in great painting; and to these developments we must turn.

Reflections of the shadow-painting of Apollodoros and Zeuxis are rare in Athenian vase-painting, but there are two ruined white lekythoi which show shading on garments and on the skin of men but not on that of women. This same distinction is found in paintings on marble from Herculaneum, lightly drawn in grey and brown on the white stone, academic works of the early imperial age of Rome, but certainly imitated from pictures of this period. Zeuxis is said to have painted 'white monochromes', which perhaps are echoed here. The prettiest is illustrated in *Roman Painting*, p. 104: girls playing knucklebones; a quarrel made up. The scene is an everyday one, but the figures have been given names that attach the story to heroic legend; the disputants are Leto and Niobe, whose later quarrel ended so tragically. Something similar is often found in late fifth-century vase-painting: a bridal scene becomes the wedding of Alcestis, the model wife; and Parrhasios gave a twist to the same idea by naming the figures in one of his erotics Atalanta and Meleager.

The lightly shaded clothes and the outlined shadowless faces and limbs of the girls in the picture of knucklebone players harmonize well enough. In another such marble-painting, with Herakles rescuing Deianira from the Centaur Nessos, the contrast between the flat white body of the woman and the shading on the others makes an awkward effect. That is a poor work, and we may suppose that Zeuxis managed better, but the transition from the lines and flat washes of all earlier painting to the first chiaroscuro is necessarily difficult. The refusal to put shading on woman's skin is a relic of the ancient distinction discussed earlier. It is reflected in the red-figure vase-painting of the time, not by shading men's skin but by sometimes painting women's white, as it had been in black-figure and in some white-ground. The distinction is carried over into Gnathia, as may be seen in the elaborate composition on a fragment of a mixing-bowl illustrated on p. 162.

This was produced at Tarentum towards the middle of the fourth century. The fragment continues, damaged, to the right, and shows beyond the central column an old man in conversation with the traveller in the peaked cap. Beyond again is a second projecting wing balancing this one, also with half-open doors behind and a girl, not peeping out but in front of them. The men's skin is brown with shading, the girls' an unmodulated white, used also for the architecture. The dark door-frame is perhaps meant for wood. On another fragment, however, painted at the same place and at about the same date, the figures are drawn in linear red-figure but a building is added in colour; and in this white is used only for the lit marble, two slightly darker tones representing the parts in shadow. It is Achilles' pavilion, and within it is his armour, and that has not only shading but flecks of white for high-lights, an innovation which is referred to by Pliny as a later discovery than shading. Such touches can be seen on the

FRAGMENT OF TARENTINE MIXING-BOWL (KRATER), FROM TARENTUM (SOUTH ITALY). MID 4th CENTURY B.C.
SCENE FROM A TRAGEDY, SET IN FRONT OF A PALACE. (H. OF FRAGMENT 22.5 CM.) MARTIN VON WAGNER
MUSEUM, WÜRZBURG.

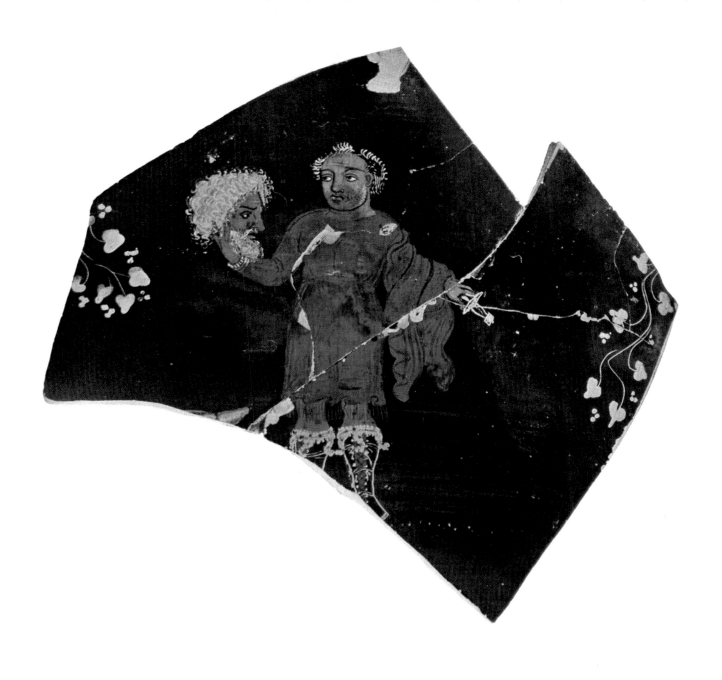

FRAGMENT OF TARENTINE MIXING-BOWL (KRATER), FROM TARENTUM (SOUTH ITALY). SECOND HALF OF
4th CENTURY B.C. TRAGIC ACTOR, COSTUMED BUT HOLDING HIS MASK. (H. 18.7 CM.) 832, MARTIN VON WAGNER
MUSEUM, WÜRZBURG.

fragment, likewise Tarentine of perhaps slightly later date, shown on p. 163: an actor dressed for the part of some old king in tragedy, but holding the mask which contrasts fascinatingly with his own worn face of common humanity. High-lights were perhaps first shown on metal and marble, things where they were most obvious in nature, later on human skin, later still on naturally dark objects. We have always to remind ourselves what a step by slow step exploration of a new world this is. Another fragment, apparently by the same painter as the actor, shows a naked woman, white without shading; but during the second half of the century the practice was extended to women's skin too, perhaps first by that Nikias of Athens who worked with Praxiteles. Echoes of these stages can be found in Etruria, and are illustrated in the later part of *Etruscan Painting* by Massimo Pallottino (Geneva 1953).

The scene on p. 162 must also be from the stage. Here the figures are not given theatrical costumes or masks; the painter has partly looked through the production to the story behind it; but the placing of the principals before a palace-façade (a favourite setting for tragedy), subordinate players (or the leaders of the chorus coming on?) in the background, is surely stage-inspired. The building, with its figured acroteria (Bellerophon on Pegasus in the centre), ornaments in the gable, round masks covering the tile-ends along the gutter, and coffered ceiling, is fascinating and architecturally curious, combining Ionic features with a Doric triglyph-frieze between architrave and dentils.

A problem is raised by the foreshortening. This is arbitrary: there is no vanishing-point or points; no system even partially applied; in fact no perspective, and this is the case with all surviving representations of buildings in recession from this period. The fact of an interest in representing recession, however, is perhaps more significant than the arbitrary character of the representations. It is entirely new; an advance on, even a rationalization of, the first cautious enclave in space established by Polygnotos and Mikon. Moreover the lack of system in the vase-pictures does not necessarily mean that none was worked out in other fields at this time. The vase-painter now borrows erratic-ally from the greater art things which he can adapt to the decoration of his curved surfaces; and systematic perspective would not be among those. There is, in fact, some evidence that some kind of system was envisaged in the late fifth century. Agatharchos of Samos is referred to as a contemporary of Zeuxis, and worked (under duress) for Alcibiades, whose stormy career covered the second half of the Peloponnesian war. This painter is said by Vitruvius, in his treatise on architecture dedicated to Augustus about the turn of the eras, to have been the first to paint a tragic set, and further to have written a book on it which led Anaxagoras and Democritus to formulate theories of perspective. These two, who lived likewise in the fifth century, were philosophers or scientists (there was then no distinction), and their interest will have been in 'natural perspective', how diminution with distance is recorded by the human eye, not rules for the representation of such diminution in art; and it has been argued that there is no evidence that the ancients ever worked out a system of pictorial perspective. Vitruvius' association of the scientists' theories with the scene-painter Agatharchos, however,

and the fact that Agatharchos wrote on his work, prove this mistaken. It does not follow that Agatharchos arrived at the idea of organizing a whole scene or picture on a single vanishing-point, though we shall meet evidence that before the end of the Hellenistic age Greek artists had reached this conception. At this first stage the delineation of isolated objects, or areas of the picture, each on a vanishing-point of its own seems more likely; one could imagine that in the set from which this vase-picture is derived, the upper part of the jutting wing might have been so treated; and an influence back from the optical theories of the scientist-philosophers could have led later painters to the idea of a single construction for the whole picture.

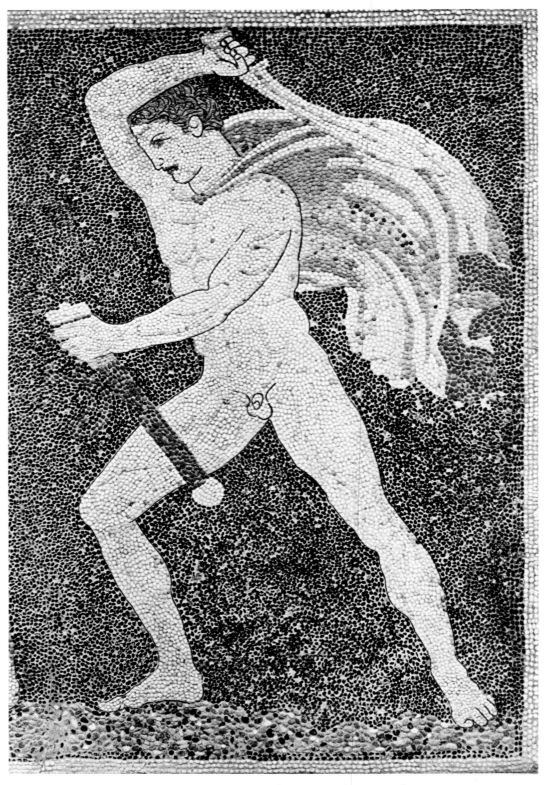

PEBBLE-MOSAIC, DETAIL, FROM PELLA (MACEDONIA). LATE 4th CENTURY B.C.
A HUNTER. (H. 163.5 CM.) EXCAVATIONS AT PELLA.

HELLENISTIC PAINTING

I T was perhaps Nikias of Athens who extended shading in his pictures to the skin of women. One might fairly connect this with the fact that he collaborated with a sculptor, laying the colour on Praxiteles' statues. These will have been pure colours, unshaded; but the effect of natural light and shadow on marble Aphrodites so touched might well have made the artist wish to reproduce it in his pictures. The same practice, of painting statues and marble tombstones, may have a bearing on another fact recorded about him, that he used the 'encaustic' technique; of which Pliny remarks that it was not known who invented it, "but some say Aristeides, and that Praxiteles perfected it." This technique is opposed by Pliny to 'the brush'; and accounts in his work and Vitruvius' show that a wax medium was used for the colours, which were applied with something like a palette-knife and then 'burned in' (the meaning of *encaustic*) with heated metal rods. A picture on an early fourth-century South Italian vase shows the process applied to a statue, evidently of marble. We hear that it was used for some purposes already in the fifth century; and it seems likely (on the inadequate evidence) that it was at first a method of making colours fast on statues and architectural decoration which had to withstand weathering, and was only later regularly employed for pictures. It was evidently a slow and laborious technique, but the result was held to justify the effort.

It is particularly associated with the school of Sicyon, which arose during the fourth century. We saw that Sicyon and Corinth were centres of the earliest Greek painting, in the seventh century. In the fifth and earlier fourth later connoisseurship recognized two 'schools', a Helladic and an Asiatic, i.e. that of the mainland and that of Greek Asia Minor. These cannot, however, have been local schools in the sense of the local schools of the Italian Renaissance, but rather more general divisions, like North Italian and Central Italian, and there was certainly much fusion even between these. Polygnotos of Thasos and afterwards Parrhasios of Ephesus and Agatharchos of Samos worked at Athens with Zeuxis of Heraclea beside native Athenians like Mikon and Apollodoros; so a little later did Euphranor of Isthmia, near Corinth, whose pupil's pupil Nikias of Athens was. Athens, it seems, was a receptive centre of the arts, something perhaps like the school of Rome in the seventeenth century or that of Paris in this. Painters of fame in the fourth century came from other places besides those named: Androkydes of Cyzicus, for instance, and two Aristeides of Thebes (confused in our sources), one of whom Pliny, as we noticed, associated with the 'invention' of encaustic; but Eupompos

of Sicyon alone is credited with establishing a strong local school. His pupil was Pamphilos, who came from Amphipolis in northern Greece but settled in Sicyon. He is recorded as an intellectual painter, who insisted both on the importance of arithmetic and geometry for an artist and on the value of drawing as an element of education, which under his influence it became, first in Sicyon and then more widely (Aristotle rather grudgingly admits it). Among pupils of Pamphilos are named some of the most celebrated painters of the transition to the Hellenistic age: Pausias of Sicyon, Melanthios, whose origin is not recorded but who seems also to have lived there, and Apelles of Kos or Kolophon, resident at Ephesus and principal court-painter to Alexander the Great.

A profound change came over the Greek world during this time. Archaic and classical Greece consisted of small independent states and sanctuaries. The patronage of art was civic and religious, the concepts not clearly distinguishable. After the Peloponnesian War the cities continued their bickering co-existence, more often at war than at peace, now Sparta, now Thebes, now Athens again ascendant; but in the third quarter of the fourth century they were all subdued by Philip of Macedon, a big kingdom to the North, geographically and culturally on the periphery of their world. Greece reduced, the kings of Macedon turned to the East, and Philip's son Alexander conquered the vast Persian empire from Asia Minor, Syria and Egypt to the borders of India and beyond. He died young; and his generals, after ruling for a time as pretended viceroys for his heir, before the end of the century made themselves kings of the huge provinces of his empire, sown with new cities founded on the Greek model among peoples with other traditions. In this changed world some of the old names remain important in the arts: Athens, Sicyon, Rhodes; but the great patrons are now the Macedonian courts of the Ptolemies at Alexandria, the Seleucids at Antioch, the Attalids at Pergamon, the Antigonids at Pella. Delos is important too, later, but no longer as the holy place of Apollo; it is now a free port protected by Rome; for as during the fourth century Macedon swelled till she engulfed the cities of Greece, so during the third Rome was becoming a great power in the West, and during the second and first she spread her empire eastwards and swallowed the Hellenistic kingdoms one by one.

The age from the reign of Philip to the Successors (the generals who divided Alexander's empire) was later regarded as the *grand siècle* of Greek painting. Though none of it survives, accounts and visual echoes can tell us something of its character. Pausias of Sicyon is recorded as a flower-painter, and Pausanias mentions a vessel of transparent glass in one of his pictures. One thinks of such Pompeian Still Life as is illustrated in *Roman Painting*, pp. 133-136. The tradition to which those works belong must certainly have its beginning here. He also painted larger pictures, and Pliny describes one of a sacrifice. Here, he says, the painter, in order to display the size of an ox, drew it foreshortened instead of in side view; and that while others painted things they wished to stand out in bright colours, things they wished to recede in dark, he painted this ox black. These remarks are illuminated by the great mosaic from Pompeii of Alexander's victory over Darius at Issus (*Roman Painting*, p. 69). The centre of this picture is occupied by a struggling horse seen in full back view, its buttocks sharply high-lighted; and the horses

of Darius' car, wheeling round towards us, are painted black. We saw that high-lights were first introduced on light bright things. Here the artist has discovered that to produce the tactility which is part of his aim there is nothing like a dark object with strong high-lights, sharply foreshortened; and that is what Pliny is telling us about Pausias.

The mosaic is certainly a copy of a painting done for Alexander or one of his successors. We need not connect it with Pausias himself, nor strictly with the school of Sicyon; but in its enthusiastic play with shading, high-lights, reflections and cast shadows it shows the accomplishment of the difficult transition we have sketchily traced: from the concept of a picture as purely the flat, linear decoration of a surface to that of it as, at the same time, a feigned window on the world of space and light. One Philoxenos of Eretria painted this subject for Cassander of Macedon; and one Helena of Alexandria treated it too, but we cannot tell if one of these or another created the original of the mosaic. There are other greater names at this time: Protogenes, second only to Apelles, and Aetion; but we can associate nothing with them.

Beside all that is new in the picture, there is also, as almost always in Greek art, a strong strain of tradition. Vase-pictures show us that the battle-pieces of Mikon's time were not conceived so very differently. The foreshortened horse is already there, and the space here is hardly less shallow (only just so much shown as is needed for the figures in action), while the natural setting is given by a single bare tree, reminiscent of those in the picture of Dolon (p. 159); to our eyes an astonishing limitation of interest.

PEBBLE-MOSAIC, FROM PELLA (MACEDONIA). LATE 4th CENTURY B.C. LION-HUNT. (H. 163.5 × L. 336.5 CM.) EXCAVATIONS AT PELLA.

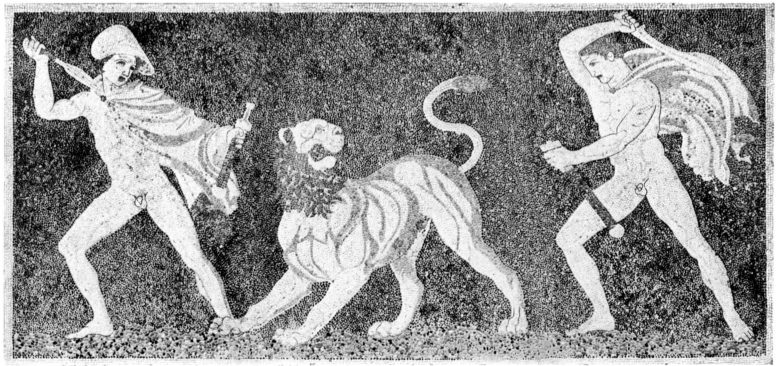

Only the means of rendering the massed figures have been transformed, allowing the artist to organize, with great boldness and subtlety, an infinitely richer and more complex whole. The *Battle of Marathon* in the Stoa Poikile at Athens showed like this the clash of East and West, East yielding, but that (from the descriptions and the probabilities) showed a clear movement from one side of the picture to the other: the Greeks attacking the battle joined; the Persians pursued to their ships. Here there is a double movement: Alexander and his cavalry sweeping from the left; the spears of the Macedonian infantry driving up from the back: the car with the defeated Persian king wheeling out of the right bottom corner.

The original must have been a wall-painting; the long, low composition would suit a portico. The copy is a floor-mosaic, made perhaps in the second century B.C. Mosaic floors of the sixth century and earlier, with patterns of natural pebbles, have been found in Phrygia. The Greeks seem first to have used them in the later fifth, and they are popular throughout the fourth, often with figure-scenes, generally in a light colour against a darker ground of grey-blue or brown. They thus resemble red-figure vase-pictures, or relief-sculpture, with its background washes of red or blue, rather than wall-painting. The finest of them have lately been found at Pella, the capital of Macedonia, and seem to belong to the time of Alexander or his Successors. We have been most kindly permitted to illustrate one (pp. 166 and 169). Figures in earlier examples are most often in simple profile. The more complex setting here suggests the influence of more strictly pictorial ideas; but they remain essentially linear in treatment, with little shading and none of the other developments of contemporary painting.

We have not met a lion-hunt since that on the Chigi vase (p. 49) of three hundred years or more before. That was painted under eastern influence, and the subject returns now with the new mingling of East and West in the Hellenistic world. There is one in relief on the 'Alexander sarcophagus', in which the king himself takes part on horseback; and there was a famous bronze group by Lysippos and Leochares, dedicated at Delphi by Alexander's friend Craterus, and showing the dedicator coming to the help of the king at grips with the lion. That could be echoed here.

The technique is unusually elaborate, including some use of inset strips of bronze; and there is very delicate scroll-work in the borders, parallelled in an entire floor of flower-pattern at the neighbouring Palatitsa. Technical elaboration, and the urge to pictorial design, seem to have led to discontent with the simple decorative technique in natural pebbles of a few colours; and probably during the third century a more elaborate system developed, with many-coloured *tesserae*, cubes of cut stone or moulded glass or paste. This art had, we know, a wonderful future in the formalistic world of Christian Byzantium, and there are fine decorative works from antiquity; but it is not suited to the reproduction of pictorial masterpieces. We must be grateful that a mosaicist recorded the *Battle of Issus*, but recognize that it can only be a clumsy and inept echo of the lost original. Better are the miniature mosaics from Pompeii (one reproduced in *Roman Painting*, p. 96), signed by one Dioskourides of Samos and probably reproducing Greek paintings of the third century. They illustrate scenes from comedy, and the grotesque

actors' masks bear the translation into the coarser medium better than the expressive faces of the fighters. The figures are enclosed in the same narrow space as before, but to the technical virtuosities is added a play with shot colours in some of the clothes. There are decorative mosaics from Pompeii, and from elsewhere in Italy, which seem to belong to the second century and which are closely parallelled in Delos and in Pergamon, one of these signed by an artist Hephaistion. The first famous mosaicist we hear of in literature was a Pergamene, Sosos. It is an art into whose continuous development one can insert no knife between 'Hellenistic' and 'Roman'.

In painting the situation is different, not only because of the paucity of Hellenistic painting, but because domestic wall-painting as we know it in Italian cities from the middle of the first century B.C. seems not to have been a Greek practice. In the palaces, at least, of the Hellenistic age there will have been wall-paintings. Long before, indeed, Zeuxis had decorated the palace of king Archelaos of Macedonia. At the same epoch Agatharchos had painted Alcibiades' house at Athens. There was a scandal because Alcibiades had kept him prisoner till he did it; and probably the very fact of having it done appeared scandalous to Athenians at the time, smacking of the ways of foreign royalty. Houses at Olynthus, built in the later fifth and earlier fourth centuries, have pebble-mosaic floors but no wall-paintings; and even elaborately flowered floors are cited among the extravagances of the creature of the Macedonians who ruled Athens in the later fourth century. It seems probable on the evidence that even in the Hellenistic world figured wall-painting remained largely a royal prerogative. Pausias is said by Pliny to have been the first to paint vaults; a

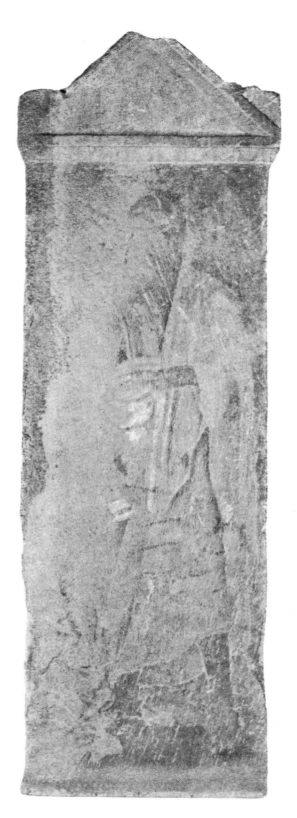

LIMESTONE TOMB-MONUMENT, FROM AMATHUS (CYPRUS). 3rd CENTURY B.C. YOUNG MAN. (H. 91 CM.) 6, BRITISH MUSEUM, LONDON.

surprising statement, not only for the reasons just outlined but because vault and dome are exceedingly rare in Greek architecture. There was, however, a tyrant in Sicyon in his day, and he may also have worked for the Macedonians; and palace architecture and decoration in Greece is something about which we still know very little. We have a small painted dome from probably a little after his time (the end of the fourth century); but in a tomb-chamber, and that is a form of construction which was certainly decorated with wall-paintings from this time on in many parts of the Hellenistic world.

The domed chamber is at Kazanlak in Bulgarian Thrace. The paintings are provincial-seeming work of poor quality, interesting for the careful avoidance of any attempt to break the surface with a suggestion of depth, and on the other hand for the impressionistic freedom of the handling. The figures of the main frieze (well under life-size: a man and a woman feasting; servants, musicians; horses and a chariot waiting) are strung out along the ground line against a flat, white background; only the four-horse chariot-team seen in three-quarter view seems borrowed from the pictorial world of the *Battle of Issus*. There is a tiny frieze of two-horse racing chariots in three-quarter view above, and small battle-scenes in the entrance corridor, but in these too the spatial concepts of the time are ironed out to suit the purely decorative scheme. It is noteworthy that the free handling is particularly marked in the waiting chariot and its groom. This freedom is a feature of Roman painting, but is there often combined with an atmospheric sense wholly absent here, as it is likewise from the battle-mosaic. Seemingly that was something only achieved during the Hellenistic age, while the free handling existed already in some fields of painting at its beginning. The painting is on plaster, as is that in other tomb-chambers at this period (at Alexandria, for instance), and in the later houses of Roman Italy. We saw that most Greek wall-painting was probably on panel. Plaster was perhaps regarded as a cheap substitute, and first commonly used in tombs; and the free handling, which we find attractive, was probably not found in the great painting of this time, certainly not by its nature in encaustic.

All the paintings that survive in Hellenistic tomb-chambers are of poor quality, as are the contemporary painted tombstones, of limestone and marble, found in several places, Alexandria for instance and Pagasae in Thessaly. We illustrate one in limestone from Cyprus (p. 171), probably of the third century, a slight but not unpleasing work. Somewhat similar in character but of better quality is the figure illustrated on p. 174, from the lid of a large and florid clay vessel (p. 173). Red-figure vase-painting continued into the third century in various South Italian centres. A late fourth-century class with a great deal of added colour has hitherto been found chiefly in the Lipari islands. That group was perhaps made in Sicily; at least the style leads on to that of the polychrome vases like the one illustrated, found at Centuripe in that island. They appear to be of third-century date; and are of interest alike as the last blossom on the old stem of pictorial pottery in Greece, and for their very close resemblance to certain wall-paintings from Pompeii and its neighbourhood: those in the Villa of the Mysteries (*Roman Painting*, pp. 51-61), and especially those from the great hall in the Villa of Publius Fannius Synistor at Boscoreale (one figure, *Roman Painting*, p. 64). There as

here the statuesque figures are modelled in lighter colours against a rich, dark ground. The wall-paintings were done in the mid-first century B.C., but those at Boscoreale at least are, I believe, copies of Hellenistic works, perhaps of the late third or early second

SICELIOTE VASE WITH MOULDED AND PAINTED DECORATION, FROM CENTURIPE (SICILY). 3rd CENTURY B.C. WOMEN AT SACRIFICE. (H. 62 CM.) 30.11.4, METROPOLITAN MUSEUM OF ART, NEW YORK.

SICELIOTE VASE WITH MOULDED AND PAINTED DECORATION, DETAIL, FROM CENTURIPE (SICILY). 3rd CENTURY B.C. WOMAN AT SACRIFICE. (H. OF PICTURE 30 CM.) 30.11.4, METROPOLITAN MUSEUM OF ART, NEW YORK.

century; and things like them must have influenced the Sicilian vase-painters. The deliberate rejection of space, the figures set against a dark ground like that of the mosaics from Pella or of red-figure vases, or of marble reliefs, is perhaps a way of preserving or recreating a classical simplicity in this more complicated world. Parallel movements can be traced in sculpture; and this painting, though intensely of its time, has a backward look too. If by the *Battle of Issus* one is reminded in a way of Mikon, so these have certainly something of the character we associate with Polygnotos. Again they are rendered with an entirely different range of representational devices; but there is a real resemblance to the brooding stillness of such figures as those shown on p. 124. One of the figures from Boscoreale sits on the ground, her chin on her hand, another seated above her on a rock: a variant on a composition we saw a favourite in the early classical age. The tenacity of certain traditions across all changes is a feature of Greek art that constantly makes itself felt. The women on the vase-lid of pp. 173 and 174, engaged in a sacrifice, look back in the same way and with the same difference to many of the figures on the funeral lekythoi of classical Athens shown on pp. 136 to 155.

Other rooms in the house at Boscoreale had decorations reflecting other trends in Hellenistic painting. From the dining-room comes the big wall illustrated on p. 177. The upper part is lost, and the division into three sections, with their wooden frames, is due to the cutting from the wall in modern times; it was originally continuous. Vitruvius, in his section on interior decoration, says that for large walls painters sometimes designed stage-sets in the tragic, comic or satyric manner. These he describes in his section on the theatre, saying of the tragic that it is composed with "columns, statues, pediments, and the sort of things one associates with royalty"; an imposing palace-façade, that is. One thinks of the Tarentine vase-fragment (p. 162); and that this wall-decoration, with its great central door (which in actual scenery would be practicable), echoes such a set and illustrates Vitruvius' remarks, is confirmed by the two tragic masks placed on the cornice.

Here, and in a few roughly contemporary works from Pompeii, we find for the first time that many of the lines in the picture recede to a single vanishing point; for the first time, but also, in antiquity, the last. All examples belong to an early phase of Roman illusionistic decoration, in the middle decades of the first century B.C. From the airy fantasies of the enchanting later styles the vanishing-point is completely absent; and even in the early style it is often so, and never used consistently throughout the whole picture. Clearly the Roman decorators were not interested in an intellectually formulated perspective system; but, as clearly, such a system was present in their Hellenistic models, and so is echoed in the works which follow those models most closely. In several passages of Vitruvius there is likewise an underlying assumption that there exists an explicit intellectual theory of pictorial perspective organized on a single vanishing-point. We need not doubt that such a system was worked out during the Hellenistic period. The first step towards it is traditionally associated with a fifth-century scene-painting by Agatharchos; and the evidence suggests that it was in Hellenistic scene-painting that it was fully developed. The lighting in this wall-painting

from Boscoreale is arbitrary, the right side lit from the right, the left from the left; but in other such paintings of this phase it is consistent throughout the picture. In this design, similarly, it is only the lines of the colonnaded court, seen above the façade-wall, which recede to a single vanishing point. The cornice of the wall, with its charming little caryatids in metal, and the bases of the columns in front of it (their capitals are lost) are not co-ordinated. Other such frescoes, in particular the side-walls of the Corinthian *œcus* of the House of the Labyrinth at Pompeii, show a much greater degree of consistency, though always there are intrusive elements that do not conform.

We know the names of some Hellenistic stage-designers. Vitruvius describes an architectural set painted at Tralles in Asia Minor by one Apatourios of the neighbouring Alabanda; and Pliny, in a list of minor painters names Eudoros as known for such a work. In the same list appears a Simonides who painted Mnemosyne (Memory; the mother of the Muses) and Agatharchos. One cannot tell whether Pliny is referring to one picture or two; but to depict a mortal crowned by a divine personification is a popular form of tribute in Greek art. One would like to think that Simonides was one of the artists who developed the theory of perspective, and painted such a picture in piety to the first master.

One has the impression (it is hard to say more) that it was only or almost only in stage-painting that a scientific perspective-system was strictly worked out and applied; perhaps because the painted scene is by its nature conceived as the extension of the actual three-dimensional space of the stage, peopled by living beings. Certainly the many figure-paintings from Roman houses, which seem to derive at least elements of their compositions from Greek works, show empirical spatial arrangements, satisfying but not systematic. They also show, as already noticed, an atmospheric character wholly absent from anything we can associate with Greek painting at the beginning of the Hellenistic age. It is in landscape (*Roman Painting*, pp. 33, 118 ff.) that this diffusion of light is most marked and most at home. The first artist we hear spoken of as a landscape-painter is an Alexandrian, Demetrios son of Seleukos, whom an anecdote represents as working in Rome in 164 B.C. Evidence from architectural remains suggests that several Greek theatres were built or rebuilt in the second century in a form that would have allowed for large-scale painted scenery. We may suppose that it is to this time that belong both these last annexations by Greek painters of strongholds of space and light, whose conquest had been begun in the fifth century by Polygnotos, Mikon and Agatharchos, by Apollodoros and Zeuxis.

That the mythological scenes set on the walls of Italian houses in the first centuries B.C. and A.D. are of predominantly Greek inspiration is clear. How far any of them can be taken as trustworthy copies of particular masterpieces is much more doubtful. It seems likely that certain compositions which recur with little variation, and others which seem of the same classical character, do give us the basic design of lost Greek works. Among Nikias' pictures are listed a *Perseus and Andromeda*, an *Io and Argus*, and two of *Odysseus and Calypso*. These three subjects are represented in compositions, repeated (with certain variations) several times at Rome and Pompeii, which closely

WALL-DECORATION FROM A HOUSE AT BOSCOREALE (NEAR POMPEII). MID FIRST CENTURY B.C., DERIVED FROM A GREEK STAGE-SET OF PERHAPS THE CENTURY BEFORE. (L. C. 45C CM.) MUSEO NAZIONALE, NAPLES.

resemble one another. It is reasonable to see here a reflection of Nikias. The prettiest of the Perseus pictures is illustrated in *Roman Painting,* p. 79. The hero is helping the rescued princess from the rock, the dead monster glimpsed in the sea below, which stretches to a far horizon; and the composition is closed by two nymphs seated on another rock. This is a small sketch of great charm, lightly and atmospherically touched in a way that can have nothing to do with a fourth-century original. A large version, very dull and heavy, shows perhaps a sad effort to retain classical clarity and firmness, things which these painters, with all their merit, rarely compass. Here the second rock and the nymphs are omitted. They may be additions of the first-century painter, but one cannot be sure; such local personifications are common on fourth-century vases.

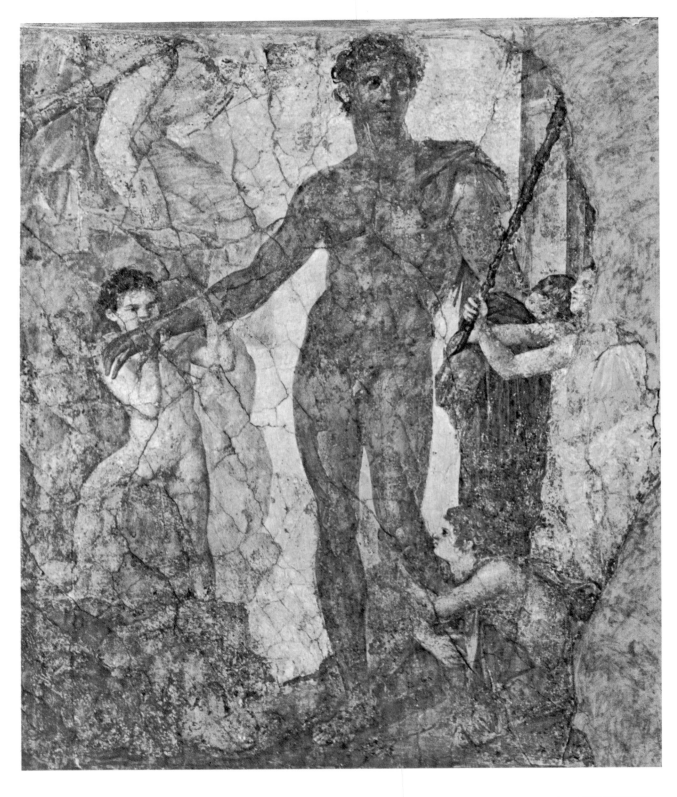

WALL-PAINTING FROM THE BASILICA AT HERCULANEUM. MID FIRST CENTURY A.D., DERIVED FROM A GREEK PICTURE OF PERHAPS THE 4th CENTURY B.C. THESEUS TRIUMPHANT. (H. C. 190 CM.) 9049, MUSEO NAZIONALE, NAPLES.

Both versions show a marked contrast between the bronzed hero and the pale maiden which may well reflect the practice of the first Greek painter to shade women's skin.

We illustrate one of the most truly classical of these Roman pictures: *Theseus Triumphant*. It is a big painting from a slightly curved niche in the Basilica (a large public hall) at Herculaneum. It was probably painted after the middle of the first century A.D., but the figure of the hero is so close to Greek sculptural creations of the fourth century B.C. that it is natural to think it copied from a painting of that time. Nothing in the fine composition seems to me to contradict the idea that the whole work is of such derivation. The head of Theseus is illustrated in *Roman Painting*, p. 67, and shows the fine, free, impressionistic handling; but I doubt if much else in the picture is due to the executant. There is in the drawing a touch of academic weakness, which these decorators' versions of old masterpieces seldom escape entirely; but it is much less marked here than often.

The figure of the hero, leaning on a pillar, dominates the scene from the centre (the right-hand edge as well as the top of the picture is severely damaged, but it cannot have extended much further). At the top right, behind his shoulder, is glimpsed the dark entrance to the Labyrinth; the monstrous corpse, dragged out, lies at his feet, head in the left bottom corner, body running diagonally back into the picture. On a rock above sits a woman, a much damaged figure, bow and arrows in her hand, quiver on shoulder. One thinks of Artemis, as she appears in the Pan Painter's picture (p. 118), but she has no place in the story. This is another personification: the Nymph of Crete, famous for bowmen. The youths and maidens of the sacrifice, peers of Theseus in age by the old story, are here changed to children. Clustering round their powerful preserver, lifting the club he holds lightly in his left hand, looking up at him, embracing his limbs, they recall the child-angels supporting the Titanic body of Christ in Bellini's marvellous picture at Rimini. The spirit, however, is wholly different. Here it is the monster that is dead; the saviour is triumphant. The Christian idea of salvation through defeat and death, though perhaps foreshadowed in some aspects of Greek religion and thought, has no place in the classical heroic tradition to which this picture belongs. The Ganymede, Achilles, Apollo of pp. 98, 116 and 132 are in the ancestry of this Theseus, splendid like him in their bodily pride; but there is tenderness here too. One may remember at the same time the Hermes of p. 125, handling his little charge so carefully; and the girls of pp. 104 and 147, one with her kindness for suffering, the other with her sorrow. The heroic idea did not prove able to meet all the needs of man. By the time that this was painted it had far passed its prime; but there was enough strength in it for the artist, looking back to a picture created when it was still vigorous, to make it live. His work will serve to close our story.

SELECTED BIBLIOGRAPHY
INDEX OF NAMES AND SUBJECTS
LIST OF COLOURPLATES

SELECTED BIBLIOGRAPHY

1. GENERAL

M. H. SWINDLER, *Ancient Painting*, New Haven, Connecticut, 1929.
> A useful survey of Near Eastern and Mediterranean painting up to the time of the Roman Empire.

2. BRONZE AGE

There is no book devoted to Minoan and Mycenaean painting as such. There are a few monographs on particular finds, and aspects of the subject are treated in general works, some of which are listed below:

H. BOSSERT, *Altkreta*, Berlin 1923.
> (English edition): *The Art of Ancient Crete*, London 1937.

J. CHARBONNEAUX, *L'Art Egéen*, Paris 1929.
A. EVANS, *The Palace of Minos at Knossos*, London 1921-1936.
E. J. FORSDYKE, *Minoan Art*, London 1929.
F. MATZ, *Kreta, Mykene, Troja*, Stuttgart 1956.
J. D. S. PENDLEBURY, *The Archaeology of Crete*, London 1939.
G. RODENWALDT, *Der Fries der Megarons von Mykenai*, Halle 1921. *Tiryns* II, Athens 1912.
C. ZERVOS, *L'Art de la Crète Néolithique et Minoenne*, Paris 1956.

3. GREEK PAINTING

Most of the following works contain much vase-painting, but viewed primarily as evidence for the development of painting in general; those in section 4 are concerned with vase-painting on its own merits and as the decoration of pottery. The best and most readable general picture is given by PFUHL's *Masterpieces*; the fullest account in RUMPF's *Malerei und Zeichnung*, where the information derived from ancient authors is brillantly integrated with the surviving remains. Some of the conclusions are summarized in an article by the same author: *Classical and Postclassical Greek Painting* (*Journal of Hellenic Studies*, vol. 67, 1947).

W. KRAIKER, *Die Malerei der Griechen*, Stuttgart 1958.
G. MÉAUTIS, *Les Chefs-d'œuvre de la Peinture Grecque*, Paris 1939.
E. PFUHL, *Malerei und Zeichnung der Griechen*, Munich 1923. (A shorter version, translated by J. D. BEAZLEY, *Masterpieces of Greek Drawing and Painting*, London 1926; reissued 1955).
G. M. A. RICHTER, *Greek Painting*, New York 1952.
A. RUMPF, *Malerei und Zeichnung* (Handbuch der Archäologie, VI), Munich 1953.
J. WHITE, *Perspective in Ancient Drawing and Painting* (Hellenic Society, Supplementary Paper no. 7), London 1956.

4. VASE-PAINTING

A very small selection of the vast literature is given here:

BUSCHOR, LANE and VILLARD are general accounts; BEAZLEY's *Development of Attic Black-figure*, *Attic Red-figure Vases in American Museums* and *Attic White Lekythci*, KÜBLER, PAYNE, RICHTER's *Attic Red-figured Vases*, and TRENDALL are accounts of particular classes of figured pottery; BEAZLEY's *Attic Red-figure Vase-painters* and *Attic Black-figure Vase-painters* lists only. The rest (apart from BEAZLEY's *Potter and Painter*, RICHTER's *Craft*, and RICHTER and MILNE's *Shapes and Names*) are well-illustrated monographs on particular Athenian painters of the sixth and fifth centuries.

There are many more monographs on painters and classes of pottery, as well as publications of particular finds and collections. The internationally sponsored *Corpus Vasorum Antiquorum* is intended ultimately to compass the publication by collections of all vases, but its fascicules vary greatly in quality and character. One must also mention FURTWÄNGLER-REICHOLD's *Griechische Vasenmalerei* (Munich 1904-1932): full-scale drawings by K. REICHOLD of the pictures from selected vases, with discussions first by A. FURTWÄNGLER and after his death by other scholars.

J. D. BEAZLEY, *Attic Red-figure Vases in American Museums*, Cambridge, Mass., 1918.
> *Der Berliner Maler (Bilder griechischer Vasen 2)*, Berlin 1930.
> *Der Pan-Maler (B.G.V. 4)*, Berlin 1931.
> *Der Kleophrades-Maler (B.G.V. 6)*, Berlin 1933.
> *Attic White Lekythoi*, Oxford 1938.
> *Attic Red-figure Vase-painters*, Oxford 1942.
> *Potter and Painter in Ancient Athens*, London 1946.
> *The Development of Attic Black-figure*, Berkeley, California 1951.
> *Attic Black-figure Vase-painters*, Oxford 1956.

E. BUSCHOR, *Griechische Vasen*, Munich 1940.
H. DIEPOLDER, *Der Penthesilea-Maler (B.G.V. 10)*, Berlin 1936.
S. KAROUZOU, *The Amasis Painter*, Oxford 1956.
K. KÜBLER, *Frühattische Malerei*, Tübingen 1950.
A. LANE, *Greek Pottery*, London 1948.
H. G. G. PAYNE, *Protokorinthische Vasenmalerei (B.G.V. 7)*, Berlin 1933.
G. M. A. RICHTER, *The Craft of Athenian Pottery*, New Haven, Connecticut 1923.
> *Attic Red-figured Vases*, New Haven, Conn., 1936.
> and M. MILNE, *Shapes and Names of Athenian Vases*, New York 1938.

A. RUMPF, *Sakonides (B.G.V. 11)*, Berlin 1937.
W. TECHNAU, *Exekias (B.G.V. 9)*, Berlin 1936.
D. TRENDALL, *Frühitaliotische Vasen (B.G.V. 12)*, Berlin 1938.
F. VILLARD, *Les Vases Grecs*, Paris 1956.
T.B.L. WEBSTER, *Der Niobidenmäler (B.G.V. 8)*, Berlin 1935.

5. HELLENISTIC PAINTING

The following are publications of particular finds or classes of Hellenistic painting and mosaic.

Analogous finds from Delos are published in the French publication of the excavations there, *Délos* vol. 14, and in *Monuments Piot*, vol. 14.

The vases from Centuripe are also discussed by G.M.A. RICHTER in *Metropolitan Museum Studies* III and IV.

A. Σ. 'Αρβανιτόπουλος, *Γραπταὶ στῆλαι Δημητριάδος-Παγασῶν*, Athens 1928.
B. R. BROWN, *Ptolemaic Paintings and Mosaics*, Cambridge, Mass., 1957.
G. LIBERTINI, *Centuripe*, Catania 1926.
V. MICOFF, *Le Tombeau antique près de Kazanlak*, Sofia 1954.

6. ANCIENT WRITINGS ON ART

J. OVERBECK, *Die antiken Schriftquellen zur Geschichte der bildenden Künste bei den Griechen*, Leipzig 1868.
> An invaluable collection of passages.

K. JEX-BLAKE and E. SELLERS, *The Elder Pliny's Chapters on the History of Art*, London 1896.
> Text, translation and notes.

PAUSANIAS, ed. Hitzig und Blümner, Leipzig 1896-1910, with German commentary.
> English translation and commentary by J. G. FRAZER, London 1898. German translation and notes by E. MEYER, Zurich 1954.

VITRUVIUS, ed. Krohn (Teubner), Leipzig 1912.
> Ed. Granger (Loeb), London 1931-1934. With an English translation.

INDEX OF NAMES AND SUBJECTS

LIST OF COLOURPLATES

For Athenian black-figure, red-figure and white-ground vases, references are given to Beazley's lists in *Attic Black-figure Vase-Painters*, Oxford 1956 *(ABV)* and *Attic Red-figure Vase-Painters*, Oxford 1942 *(ARV)*.

LONDON, BRITISH MUSEUM (continued):

PUBLISHED AUGUST 1978

PRINTED BY

IMPRIMERIES RÉUNIES SA

LAUSANNE

The works reproduced in this volume were photographed by Hans Hinz, Basel (pages 18, 21, 22, 23, 24, 26, 27, 29, 31, 32, 34, 39, 41, 42, 44, 45, 48, 49, 50, 52, 55, 56, 58, 59, 60, 62, 63, 65, 69, 70, 71, 74, 76, 77, 78, 79, 80, 87, 88, 91, 92, 93, 94, 97, 100, 101, 102, 104, 107, 110, 115, 116, 125, 126, 127, 136, 138, 139, 144, 145, 152, 154, 155, 157, 162, 163, 166, 169, 177, 178 and title-page), by Henry B. Beville, Washington (pages 38, 118, 119, 123, 132, 141, 147, 173, 174), by Zoltán Wegner, London (pages 64, 66, 73, 82, 86, 89, 113, 129, 130, 131, 143, 150, 151, 159, 160, 171) and by Louis Laniepce, Paris (pages 98, 124).

PRINTED IN SWITZERLAND